Heritage

Heritage

Management, Interpretation, Identity

PETER HOWARD

continuum
LONDON • NEW YORK

Continuum

The Tower Building, 11 York Road, London, SE1 7NX

370 Lexington Avenue, New York, NY 10017-6503

First published 2003

British Library Cataloguing-in-Publication Data

A catalogue record for this book is available from the British Library.

ISBN 0-8264-5897-1 (hardback)
 0-8264-5898-X (paperback)

Library of Congress Cataloging-in-Publication Data

Howard, Peter, 1944–
 Heritage: management, interpretation, identity/Peter Howard.
 p. cm.
 Includes bibliographical references and index.
 ISBN 0-8264-5897-1–ISBN 0-8264-5898-X (pb.)
 1. Historic sites–Management. 2. Cultural property–Management. 3. Historic sites–Interpretive programs–Handbooks, manuals, etc. 4. Historic sites–Europe–Management. 5. Historic sites–Interpretive programs–Europe–Handbooks, manuals, etc. 6. Cultural property–Europe–Management. 7. Interpretation of cultural and natural resources. 8. Interpretation of cultural and natural resources–Europe. I. Title.

CC135.H69 2002
363.6′9–dc21 2002025934

Typeset by BookEns Ltd, Royston, Herts.

Printed and bound in Great Britain by MPG Books Ltd, Bodmin, Cornwall

Contents

Preface

Heritage Studies has emerged, with very little fanfare, to be a subject of considerable importance in many universities. It has emerged from, and sometimes remained within, a variety of departments including art history, built environment, tourism and leisure studies, archaeology, geography and history. At a meeting of seventeen leaders of heritage courses, they were found to submit their research effort to sixteen different units within the UK's Research Assessment system, and yet the literature quoted on the various reading lists for their students showed remarkable similarity and cohesion. So Heritage Studies knows what it is, but is not sometimes very clear about why it is, or the essential structure of the subject. This book attempts to address that gap. It is less a textbook, summarizing all the knowledge required by the undergraduate heritage student, and more a guide to a sensible way of locating and organizing that knowledge. It is a filing system rather than the files themselves.

The ideas derive from the author's experience in running heritage courses for a decade at the University of Plymouth, at both undergraduate, and latterly, postgraduate levels, and in examining other courses both in the UK and Russia. Editorship of one of the main journals in the field, the *International Journal of Heritage Studies*, has ensured that ideas have come from a very wide spectrum, both of heritage areas, and from different countries. Four main strands are common, three of them represented in this book. These are theoretical issues of identity, practical issues of management, and the problems of communication or interpretation of the heritage to its visitors. The fourth – the study of conservation techniques – is largely outside the scope of the structure offered here, and may form the links between the specialist heritage student and the experts in many other fields, including architecture, ecology, art and ethnography.

The inclusion of nature within a field that is more often regarded as cultural can be ascribed to the author's background in landscape studies, and his geographical training. The numerous international references reflect his conviction that heritage has to be seen as a worldwide phenomenon, shared by all sorts of people, not just a few rich Britons. The fact that those references are largely European reflects a sad lack of experience of the rest of the world, as well as a conviction that the development of a common European heritage is a fascinating ongoing project.

Acknowledgements

The structure of Heritage Studies which has emerged in this book is the fruit – good or bad – of many years of discussions with colleagues, students and others. Some of those teach or study on the heritage courses in Exeter, run by the University of Plymouth, but others are colleagues from other institutions with whom co-operative links are maintained. These especially include Groningen, Göttingen, Cottbus, Mendel University at Lednice, Réggio di Calábria, Zaragoza and Nantes. In Britain, I am indebted to staff at Bournemouth, and to Bill Lonsdale and Magnus Fladmark at Robert Gordon University, Aberdeen. The ideas have often been debated with members of the Association of Heritage Interpretation, and the European Network for Heritage Interpretation, based at Freiburg. Authors submitting articles for publication in the *International Journal of Heritage Studies* have been a fertile source of ideas, most of which I hope I have successfully referenced. I wish I could say the same of the numerous ideas that have sprung from students' essays and projects. Some have been credited here, but more have been too elusive. Lastly, members of my family have often been the ones whose comments on places we have visited have been most illuminating. The good ideas thus come from many sources. The rickety framework trying to hold them together can be blamed only on the author.

1

What Is Heritage?

SUMMARY

Heritage is taken to include everything that people want to save, from clean air to morris dancing, including material culture and nature. It is all pervasive, and concerns everyone. Much of it divides people, but this book tries to indicate the common areas of study between all these disparate things. The management of heritage tends to apply only to the public heritage, but there is an even more meaningful, unmanaged heritage, behind the scenes in people's lives. Identities are made both of public and private heritages, but only the former are the field where professional managers and interpreters become involved.

The evening when I write this is not particularly unusual. The main UK news tonight is from a suburban housing estate in Northern Ireland, where police and troops stand by their barricades to prevent a group of people marching down the main road, with banners flying and drums playing, and wearing orange sashes. They claim that this is their heritage, that they are celebrating a battle which took place 300 years ago, and that it is the right of every free people to walk where they wish on public rights of way. The residents of Garvaghy Road, of a different religious persuasion and owing allegiance to a different identity, claim that because they have indeed had their identity insulted frequently in the past is no good reason for it to happen in the future. If it had not been Northern Ireland it might have been Kosovo or Chechnya or the Basque territories or Corsica or Notting Hill. Everywhere heritage matters; identities are being fought over; traditions are being insulted. Heritage is of concern to all people who believe in something, or who simply believe they are different.

On the same evening there is an hour of television, with an academic presenter, in which the Wars of the Roses Society is re-enacting the Battle of

Bosworth Field, where in August 1485 Henry Tudor defeated Richard III to gain the throne of England, or at least men who owed allegiance to the one defeated men who owed allegiance to the other. On the field of the re-enacted battle no-one gets hurt, or at least not seriously, and they all clearly have an enormous amount of fun, though whether anything useful in the historical sense will be discovered is doubtful. Perhaps people are embarrassed about just having fun, so they want to legitimize their enjoyment with a serious purpose. I can turn to the local evening paper to see a report on a vintage vehicle rally held in the grounds of a nearby castle (open to the public), or read a report of a lady arrested and charged with defacing the Cenotaph in Whitehall; or I can turn on the local news and discover that a local area of moorland has been declared a National Nature Reserve, and that a successful application for lottery funds has enabled it to be better managed. There is a lot of heritage about; everyone seems to want to save something. In Turkey an organization has just been formed to prevent the distinctive Turkish coffee being ousted in the cafés by espresso and cappuccino. In France, hundreds of ancient avenues are being felled because the trees kill motorists.

Given the fascination for saving things, one need not be surprised to see Heritage Studies or Heritage Management or Heritage Conservation becoming popular subjects in universities. Neither is there a shortage of books on heritage matters. For anything you might want to save or collect there will be a detailed text describing its history and characteristics, on how to save it, what to look for and, probably, its price. A glance at the list of the excellent little handbooks published by Shire raises a curtain into the extraordinary world of specialist collectors. Often a complete academic discipline will be involved with the study of the thing concerned; archaeology, ecology, history and history of art are only a few of the academic university disciplines which are devoted in large proportion to examining things that people want to save. Many such university departments have their own collections or take an active role in the local museum, national park and scheduled monuments. So what is the point of another one, another academic discipline called Heritage Studies and another text like this one? The answer is, simply, because these other subjects do not deal with the similarities between Orange Order marches, national nature reserves, the Cenotaph, battle re-enactments, castles, steam engines, coffee and roadside trees.

This book proposes to do precisely that – to examine the heterogeneous collection of things that people want to save, and set out a series of ideas by which they can be usefully studied, more effectively managed and interpreted.

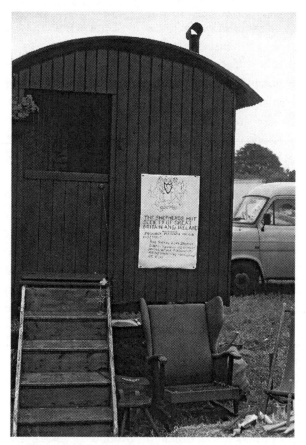

Figure 1.1 At a local steam-engine rally, the Shepherd's Hut Society announces its existence. Gypsy caravans are now beyond the financial reach of many, but these huts have not long fallen out of use and can still be found. People create new heritage all the time.

This book does not concern itself much with techniques. Readers seeking the best method of restoring watercolours or how to release zoo-bred animals into the wild will be disappointed, though they may end by asking themselves why they should wish to do these things. Generally, the book does not ask 'How?' The main questions it asks are: 'What is heritage?' 'Who wants to save it?' 'For whom?' 'Who is expected to pay for it?' 'Where is the best place for this heritage?' 'Which is the proper period to which this heritage should be returned?' The one technical question which is asked is: 'How is this heritage best interpreted and presented, and to whom?' The techniques of conservation are best left to experts from within the discipline traditionally associated with the object, but the other questions are common to all, and by answering them

together, as a single subject, we might at least prevent all these different areas having to find the same answers independently.

Heritage benefits someone, and usually disadvantages someone else. It is most commonly accepted that there are two levels at which heritage works: the family and the nation. Indeed, the idea of national heritage is so common that the two words are frequently used together, as with, in the UK, the Department of National Heritage, from 1990 to 1997, and it is sometimes overlooked that there may be other kinds of heritage. Family heirlooms or photograph albums may not be always considered as serious heritage, and they probably fall outside the remit of government agencies concerned with official heritage. However, if people are asked what they regard as the most important thing they intend to pass on to their children they are likely to cite some family heirloom or photograph or item of little financial value. Official heritage tends to be national, unofficial tends to be familial; but it is because these two major platforms for heritage are so dominant that this book proposes to look at others; in particular the local, regional and the international. Attempting to construct a heritage for Europe, for example, throws a very clear light on how heritage is formed and what it does. In the European case this has scarcely been attempted. The same is true of other continents and, to a surprising extent, of the local level. Despite a great deal written about local identity there are surprisingly few studies which take this further than a study of building materials and vernacular architecture, except for the projects promoted by Common Ground.[1] Professional and aspiring managers and interpreters of heritage to whom this book is primarily aimed, may reasonably suggest that they are unlikely to be employed conserving and protecting private family heritage. That may be the case, but they also need to be aware that almost every heritage item has another set of personal meanings to someone, and that every visitor to official, managed heritage arrives with a personal baggage containing a heritage which they regard as much more important.

The rise of an academic discipline that concerns itself with heritage, and the development of some concepts that throw some understanding on a complex field, should not be so academic as to be divorced from reality. There are a number of well-argued books that raise all the difficult questions that concern this particular aspect of culture.[2] Heritage can indeed be perceived as a dangerous concept; it is frequently nationalistic, exclusive, sexist, elitist and backward-looking. Quite often it is all too easy to see the desire for heritage as a conspiracy by the rich to acquire the property of the poor. Although, to a

great extent, these arguments apply as much to the natural as to the historical heritage, they have not been raised so forcibly in that forum. Heritage Studies, though, has developed with a practical edge to it, often indicated by the words 'heritage management'. There are a great many people employed to protect and present the heritage, and a great many more do so in a voluntary capacity. This book is for them also, and I do not want them to return to work disillusioned, or feeling guilty about their deeply held passions for those things which they devote their lives to protect. Undoubtedly, there are problems with heritage conservation and preservation, and no book can avoid dealing with them. The problems are not unique to the national forum, for local heritage can be every bit as exclusive and divisive. It is almost impossible to say anything about any object without upsetting someone, but that is not an excuse for doing nothing; we can be pragmatic and say that while the ideal is unattainable, we can at least indicate the road towards it. Those who spend their time in heritage businesses should be able to return to work having developed some idea of how to do it better.

Of one thing we can be certain: so long as heritage can be used for profit, or to produce group pride or identity, or to subjugate or exclude someone else,

Figure 1.2 Norwegian heritage legislation is so demanding that only the wealthy can afford to maintain the old farms as required, so the homes of the comparatively poor transfer to the rich, in a process referred to by Olwig as the Midas Touch.[3] Photo courtesy of Kenneth Olwig.

then someone is going to use it. Perhaps some agreement on how to do so wisely, reasonably and well is in everyone's interest. If nationalists and Orangemen, Serbs and Kosovars, Blacks, Whites, Hispanics, Asians and native Americans can accept agreed limits to their pride in tradition, that would itself be a major step.

What is heritage?

The word 'heritage' has a clear and relatively simple relationship with the concept of inheritance – indeed the French word *héritage* is still used exclusively to mean 'legacy'. One dictionary gives two definitions of the English word: 'That which has been, or may be, inherited' raises the interesting area of heritage that is not yet owned, but may come into ownership at a later date; the other definition, 'circumstances or benefits passed down from previous generations', keeps the close contact with the concept of inheritance, but opens it beyond immediate ownership to include group heritage and heritage which may not have a physical form. It may not be a 'thing' but may, for example, be an inherited title. Indeed, the word is now frequently used in a biological sense to refer to our genes. The other feature here is the 'benefits'. Although all 'circumstances' are accepted as heritage, disbenefits are not given the same weight as benefits. There is a sense in which this is clearly illogical; the idea that we only inherit good things from the past is nonsense – so riches are heritage but poverty is not. But the definition raises an issue of profound importance. Actually, it is widely assumed that heritage is 'good'; everyone should have some. People are quite capable of obliterating, forgetting and disowning heritage that they would rather be without. This does not mean that all heritage is pleasant; Auschwitz (Oswiescim) is a World Heritage Site that people have decided they do not wish to disown or to forget; Auschwitz is conserved because at least some people want it to be. Equally, there will be many things that could be conserved but about which no one will care enough to ensure that they are.

Heritage has been described as 'anything you want'. Volition is critical; things actually inherited do not become heritage until they are recognized as such. Identification is all. Heritage can be regarded as anything that someone wishes to conserve or to collect, and to pass on to future generations. Traditionally, the scholars who study heritage come from those disciplines that study some of the phenomena and artefacts that are commonly collected and

conserved. Indeed, quite often these objects first became heritage as a result of such scholarly interest. However, a focus of interest on the motivation for conservation and on the visitors to conserved things demonstrates immediately the similarities between otherwise disparate objects. The museum curator and the warden of a national park have much in common, as do the civic conservation officer and the antiques collector.

The above definition has the advantage of putting the emphasis firmly on people. People collect heritage for their own benefit or for the perceived benefit of others, although the nature of those benefits is very various. They get passionate about some quite extraordinary things and circumstances. Chapter 4 lists some of those things, but while such a list is an interesting and useful way of exploring the weird labyrinth of people's obsessions, it is not a definition of heritage. Such a definition cannot be based on the various bits of it; people and their motivations define heritage. Not everything is heritage, but anything could become heritage. A librarian friend has a notable collection of toilet paper, but the heritage nature of some ephemera does not mean that all ephemera are recognized as heritage.

On my desk there is virtually nothing I consider as heritage, though it is not impossible that someone somewhere would like to add the old typewriter to their collection; so to them it might be heritage. Similarly, the computer on which I am working is not heritage, or not yet. Some computers which until a few years ago were just computers, now fetch a good price because of their rarity value – they have become heritage. Beside the computer is my mug, a souvenir which I bought on a visit to Hershey in Pennsylvania, famous for its chocolate. I am sure that this doesn't represent heritage to anyone else, but it is at least of sentimental value to me. The relationship between heritage and the memento is sometimes quite close, even where, as in this case, the memento has little real relationship with the memory. I may have bought the mug in Hershey, but it was made in China. Nostalgic memory is certainly one motivation for saving.

Ownership is another vital concept. Modern management practice frequently uses 'ownership' to describe the feeling of responsibility for a policy by the group, without which the policy is likely to fail. This usage is very similar in heritage matters, where either groups try to persuade others to take ownership of a heritage, or they themselves aspire to such 'ownership', even, perhaps especially, when there is no legal basis for that ownership. Recent legislation about access to the land uses such terminology all the time, as does the language of nationalism – our seas, our airspace.[4] The usual French word

Figure 1.3 Gathering dust on the author's bookshelf is a collection of mugs all made to celebrate national events, such as coronations or victories, or royal weddings, and saved by various members of his family. This personal relationship between private inheritance and national heritage is very common, and has only a marginal relationship with the value of the objects.

for heritage is *patrimoine,* and the Spanish *patrimonio* comes from a similar root, stressing the concept of familial (and patrilineal) descent, but also the national patrimony, the holdings of the group. The difference between patrimony and matrimony is itself worthy of study, and work by Pearce has indicated that within the family home it is the woman who is chiefly responsible for maintaining the family identity and heritage, which often is inherited through the matrimonial line.[5] This book takes the firm view that any individual's heritage is likely to be a mixture of things that define a group identity, often a national group, and those which define a personal and familial one.

In Germany, the word *Denkmalpflege* (monument restoration) stresses another aspect, and highlights the significance of the built artefact and the notions both of conservation and commemoration. Very frequently, heritage disputes may be between those who wish to conserve a place or a building and those who wish to commemorate it. As early as September 2001 there was newspaper speculation as to whether the twin towers of the World Trade Center were to be rebuilt (a form of conservation, surely) or to be

commemorated with a memorial park. However, to restrict the concept of heritage merely to the built environment, or even to material culture, simply does not resonate with most people's concerns. People usually feel more strongly about things they do rather than things they own.

Although the definition of heritage as 'anything which someone wishes to conserve or collect' is sufficiently all-embracing, a slight exception may be made to exclude the one who collects purely for economic gain. Although acknowledging that monetary value must rank among the many values which motivate collectors and conservers, and with which heritage specialists have to deal, simply buying things for no purpose other than to make a profit on resale does not seem to be a heritage activity. Clearly, however, many parts of heritage have very significant monetary value, and there are many markets for heritage. The UK television programme *Antiques Roadshow* would certainly be a very different affair without any mention of money.

Heritage objects have not only value; many also have entirely mundane functions. Most of us do not want our house to be destroyed because we have nowhere else to live. If we were asked to calculate what compensation we would accept for the loss of our house, we would start from the cost of replacing it with a similar property and its contents. Then there would be an amount to compensate for all the inconvenience, as well as the loss of our time and earnings. Finally, there would be something for sentimental value. Perhaps the heritage value of things is the sum of everybody's sentimental values.

Intellectual context

Much literature on heritage is concerned with the details of those objects that are the subject of collection and conservation. Of course, there is no shortage of literature on the history of architecture, or antique collectors' price guides, or spotters' guides to the wildflowers of a district. Just as a geographer or an historian needs to understand the whole classification system used in any library, so does the heritage scholar. Material on conservation techniques for anything from folklore to buildings or animals is also plentiful, and very widely distributed around the library. However, material that examines the concept of heritage as a unity, which concentrates on questions of ownership of heritage and its purposes, is much more limited, and comes from a very wide range of authors, including geographers, cultural scholars, town planners and art historians, as well as departments of museum studies. The following are

significant starting points: Robert Hewison led the attack on heritage in the late 1980s and posited that it was a reaction to economic decline, largely foisted by nation-states onto their weaker citizens in order to legitimize their activities. David Lowenthal's contributions did not entirely dissent from this view, though they examined, with a wealth of detail, the complexities of people's attitudes to the past. Patrick Wright's well-known work *On Living in an Old Country* also took a post-imperialist view of heritage, with a concentration on Britain's nostalgia for a lost past. To a considerable extent, Raphael Samuel's two published parts of a planned trilogy take a different approach, not least through the concentration on personal heritage and local groups as well as official organizations. He rebutted forcefully the idea that heritage was restricted to the dominant group, and showed its universal appeal, although the definition of heritage changed; it was just as active in the second-hand-record dealer at a car boot sale as it was in Sotheby's auction house.

The practice of interpretation, which is now a significant profession, has been much described though not much analysed. The work of Tilden[6] in the United States has been seen as critical by many, especially by and for those working within the natural environment. Some of the papers in Uzzell's collection,[7] the fruit of the 1988 Warwick conference, raise points of intellectual interest, and the volumes emanating from the annual conferences held in Scotland and edited by Magnus Fladmark also contain many useful examples, though the scope of these volumes is much broader than a concentration on interpretation.[8]

Another distinctive group consists of geographers, Ashworth from Groningen, Tunbridge from Ottawa and Graham from Coleraine. Both independently and jointly they have provided many of the ideas concerning the built heritage and its dissonant nature, and their work on issues of national identity provides very useful summaries of a large range of material from many different disciplines.[9]

Museum studies have been another fertile source producing a stream of material including that by Pearce, Hooper-Greenhill and Greenfield.[10] The ideas of a new museology, following the title of a book by Peter Vergo,[11] can be traced clearly through much recent work, and has turned the accepted purpose of the museum very largely from one of curatorship and preservation to one of education and even entertainment. Underlying much of this is also a new morality, concerning not only issues of access and social exclusion but also the return of control of cultural objects to their origins.

There are now at least two academic journals central to the field, although

there remain many fine articles published elsewhere. *The International Journal of Heritage Studies*, published by Routledge (which also has a formidable record of book publication in the field), takes a very broad and largely non-technical look at the field. As the editor is also the author of this text, some overlap of ideas is inevitable. *The Journal of Cultural Heritage*, from Elsevier, is more technical and conservationist.

Structure

Identity, interpretation and management are not only in the title but are also themes running throughout the book. Regarding heritage as reflecting someone's or some group's search for identity ensures that people's intellectual needs remain firmly in view. Identity may largely be a theoretical area of concern, but considering the shifting interpretations of heritage ensures that an eye is kept on the contingent nature of heritage, as well as the practical problem of what to say to whom. This practical edge to the subject is reinforced because that heritage which comes into the public domain will need management, making heritage an intensely practical business. This trinity of theory, people and practice should be integral to the entire subject.

Heritage Studies as a discipline is new, and Chapter 2 looks at its development and, inevitably, examines the differences between heritage and the other disciplines from which it draws some of its ideas or with which it is sometimes confused. Heritage Studies emerges as almost anti-academic, differing from history or biology less in what is studied than in the practical purposes to which the study is put, and accepting that people put values on heritage, rather than values being intrinsic to objects.

Chapter 3 is more theoretical and examines some of the concepts that are useful in the study of how heritage works. Samuel's contention that heritage is as prominent and important at the level of the individual and the powerless as it is at the level of the nation and the powerful is here taken further to propose heritage as a demand-led, customer-led activity. Quite simply, heritage is not, and never can be a rare commodity, because we will always invent more as we need it.

This theory is followed by an attempt to investigate the extraordinary extent of heritage, looking at some of the more esoteric aspects of people's apparent obsession in collecting and saving things. While devising categories of heritage, defined in part by the divisions between academic subjects, these are

seen to be interesting as an examination of human ingenuity, but not particularly useful as categories for investigation.

Having discovered that there are very few things, people or even ideas that cannot be turned into heritage, Chapter 5 turns to the stakeholders. Who wants heritage and why? All sorts of organizations are interested in heritage, many of them investing considerable amounts of time and money. These range from auction houses to university departments, from government agencies to tourists, from owners of historic property to treasure-hunters and even thieves. Such a division into markets becomes a valuable tool in understanding disputes.

Identity is the focus of Chapter 6, which looks at varieties of identity, from the personal to the international. Our own families are part of our identity and heritage, but many would consider that J. S. Bach (who is surely European, if not universal, heritage), for example, is another part. How do these levels interact with each other? Which are more important, and to whom? There appears to be some correlation between level of identity and the type of heritage involved. Personal, family and local heritage seems to put much more emphasis on activities and people, while national and international levels, or at least their official representatives, concentrate on more solid and conservable objects.

All of these ways of dividing heritage – by type, by market and by identity level – only serve to reinforce that heritage is a process rather than a product, and Chapter 7 starts to discuss how that process begins and continues. Certainly heritage comes into being and develops from recognition, inventory and designation. Is it a full cycle? Does heritage have an end? Does it die?

The heritage process depends on the values that people invest in the heritage phenomena, on the different kinds of ways in which things are viewed. Such values are examined in Chapter 8, suggesting that they will differ between people according to a whole range of lenses that give biases to particular views of attractiveness. To understand the heritage value of any particular item we need to grasp where all the stakeholders are 'coming from' and what values they bring to it. Only then can a sensible interpretation policy, the subject of Chapter 9, be formulated. Heritage managers can choose to create discord or harmony among their visitors; they can be inclusive or exclusive. Chapter 9 concludes that there is no objective judgement of heritage interpretation, only judgements based firmly on ethical positions; simple honesty may indeed be the best policy.

Exercise 1

To act as a clear reminder that heritage is about people, write a list of the things which you regard as your most precious heritage – the things which you are keen to pass on to your legatees. These things may be as universal as clean air, or as personal as your stamp collection, as concrete as a house or as abstract as a philosophy. What matters so much you take active steps to conserve it?

NOTES

1 A. King and S. Clifford, *Holding Your Ground: An Action Guide to Local Conservation* (Hounslow: Temple Smith), 1985.

2 R. Hewison, *The Heritage Industry: Britain in a Climate of Decline* (London: Methuen), 1987. D. Lowenthal, *The Heritage Crusade and the Spoils of History* (Cambridge University Press), 1998. R. Samuel, *Theatres of Memory: Volume 1. – Past and Present in Contemporary Culture* (London: Verso), 1994. P. Wright, *On Living in an Old Country: The National Past in Contemporary Britain* (London: Verso), 1985. J. E. Tunbridge and G. J. Ashworth, *Dissonant Heritage: The Management of the Past as a Resource in Conflict* (Chichester: Wiley), 1996.

3 K. Olwig, *International Journal of Heritage Studies*, 7(4), 2001.

4 M. Shoard, *This Land Is Our Land* (London: Paladin), 1987.

5 S. Pearce, 'The construction of heritage: the domestic context and its implications', *IJHS*, 4, 1998, 86–102.

6 F. Tilden, *Interpreting Our Heritage* (Chapel Hill: University of North Carolina Press), 1967.

7 D. Uzzell (ed.), *Heritage Interpretation* (London: Belhaven), 1985.

8 J. M. Fladmark (ed.), *Heritage: Conservation, Interpretation, Enterprise* (London: Donhead), 1993. J. M. Fladmark (ed.), *Cultural Tourism* (London: Donhead), 1994. J. M. Fladmark (ed.), *In Search of Heritage: As Pilgrim or Tourist* (Shaftesbury: Donhead), 1998.

9 B. Graham, G. J. Ashworth and J. E. Tunbridge, *A Geography of Heritage: Power, Culture and Economy* (London: Arnold), 2000. G.J. Ashworth and J. E. Tunbridge, *The Tourist-Historic City* (London: Belhaven), 1990. G. J. Ashworth and P. J. Larkham (eds), *Building a New Heritage: Tourism, Culture and Identity in the New Europe* (London: Routledge), 1994. B. Graham (ed.), *Modern Europe: Place, Culture, Identity* (London: Arnold), 1998. G. Ashworth and P. Howard, *European Heritage Planning and Management* (Exeter: Intellect), 1999.

10 S. M. Pearce, *On Collecting: An Investigation into Collecting in the European Tradition* (London: Routledge), 1995. E. Hooper-Greenhill (ed.), *Museums and Their Visitors* (London: Routledge), 1994. E. Hooper-Greenhill, *Museum, Media, Message* (London: Routledge), 1995. J. Greenfield, *The Return of Cultural Property* (Cambridge University Press), 1996.

11 P. Vergo, *The New Museology* (London: Reaktion), 1989.

2

Heritage as a Discipline

SUMMARY

The characteristics of Heritage Management as a separate field of study are discussed, and it is best understood as an applied humanity, with an emphasis on the present day and on people's needs. The relationships between heritage studies and other, sometimes more established, disciplines such as History, Cultural Studies, Leisure and Tourism, Art History and Geography are described.

One of the first principles to expound is that Heritage, or Heritage Management, can be best regarded as a discipline in its own right, and studied as a whole. To do so is the only way, effectively, to keep a distance from those disciplines that study the phenomena which are collected or conserved. Heritage is not a branch of archaeology, architecture, art history, history, geography or ecology, all of which are concerned, at least in part, with the study of phenomena often considered heritage. There are scholars within those disciplines who concern themselves not only with the study of those phenomena, but also with their conservation, and some go further and consider issues of public access, interpretation and impact on visitors. However, such studies always lie eccentric to the generality of their disciplines, while remaining central to heritage specialists' interests. Thus the *Journal of Garden History* certainly does contain some articles concerning garden conservation, and even a few which touch on issues of access and management, but these constitute less than 10 per cent of the journal's material.

While Heritage Studies is developing as a discipline in universities, this does not imply that people's attitude to their heritage is a particularly academic one, nor should it be. When psychologists study human behaviour they do not propose that the psychologist's own behaviour is somehow the right one. In the

case of heritage there is some evidence that the attitude of many people to it is not only unacademic but actually anti-academic. When people re-enact battles or save steam trains, this can be interpreted, at least in part, as a reaction against the kind of history and other subjects they learnt at school. They may be saving the past from historians. When people attend a medieval banquet there is a danger that the academically trained historian will feel that it ought to be authentic, or as realistic as possible. Very often the person attending is well aware that the relationship with medieval reality is very tenuous indeed, but he doesn't care. The intention is not to attend a history class but to enjoy an evening out. Historians have long had to fight for control over access to and interpretation of the past. Just as film producers keep making films that annoy historians with their disdain for reality, so many heritage crusades can be regarded as yet another challenge to such academic control.

Figure 2.1 People practising for an English Civil War re-enactment event. While taking a great interest in getting the details right, they are also keen to have a good time.

Most universities have faculties of science and of applied science. There is obviously a quite close relationship between the two, but the difference is also generally understood, though by no means subject to a simple and unequivocal rule. Pure scientists are interested in the physical, chemical and biological laws by which the universe acts. Their research is driven by a logic that is within the set of ideas itself and may or may not have a direct application at present in the commercial world, or to anybody's direct benefit. The engineer and the medical practitioner are differently motivated. The knowledge they need to acquire, and the research that needs to be done, is that necessary for curing this person or building that bridge – the outcome rather than an internal logic drives the discipline. In this sense heritage is an applied discipline. It may, on occasion, be considered an applied science, especially when dealing with a zoo, a geological park or a science museum, but is more properly an applied humanity, as the emphasis is so heavily on people rather than things. Occasionally, it is even an applied art, in the field of interpretation, but always applied. The questions at issue are always about the means by which things could be conserved, or how and why information should be transmitted and to whom. Some of the questions that come to heritage managers are not really theirs to answer. Who painted this picture? What is the history of this field? What is the difference between a butterfly and a moth? These are questions that properly lie within the province of the art historian, the landscape historian and the zoologist respectively. The heritage question is: What is to be communicated about this picture/field/butterfly, and to whom? Why? For whose benefit?

The connection between a subject like heritage and the subject of education is obvious. At Oxford there is a Department of the Public Understanding of Science, which sounds like another applied humanity. Like the teacher, the heritage specialist often wants to say 'Don't blame the messenger.' Heritage centres are very often accused of presenting a false history, and, indeed, if heritage specialists have failed to understand the complexities of the historical record or have presented it too narrowly or have used inappropriate illustrations, then it is their fault. Often, however, closer examination shows that the historians have not done the research properly; that the conclusion presented by the consultant historian is not supported by the evidence. That is an historical error, not a heritage one. In the early days of computers there was a favourite saying: 'Garbage in, garbage out'. So, too, heritage experts depend on the quality of the information they have at their disposal.

Partly because heritage is an applied discipline, it is also a positive one.

At the beginning of the twenty-first century the concept of truth seems much more problematic than a century ago. After modernism ran its course, we became very aware that for almost any event or object there are so many truths, and that holding fast to any one of them is likely to be offensive to someone holding to another aspect. This does not of course mean that anything is true – the world seems as full of lies as it ever was, but we are now aware that almost any statement is political and even that making no statement is also political. Almost any idea can be deconstructed, including this one. The heritage specialist will be aware that any form of conservation or presentation will be political; someone will be advantaged by it and someone else will be disadvantaged. Everyone has an agenda, which is often hidden. But all over the world, not just in western European or anglophone cultures, all sorts of people are busy conserving and presenting their identities and heritages. Heritage managers have a duty to ensure that it is done as well as possible, hurting as few as possible, but, unlike the 'pure humanities', they cannot withdraw from the debate. The deconstructionist argument is, of course, a splendid excuse for withdrawing from the real world because anything can do damage, and anything has an ideology. There are certainly occasions when the proper solution to a heritage issue is to do nothing. In the middle of Dartmoor, six kilometres from any road, are some stone rows, originally Bronze Age, but much restored and even re-erected (see Figure 2.2). For most visitors the stones are the chief focus of a long and quite arduous walk. Most navigate by compass and map, and it is quite a challenge. Large welcoming signboards, perhaps with a manned heritage centre, would completely destroy the feeling of remoteness and achievement that many seek. Most would agree that the best management of the site is to do nothing. But negative management is a form of management; a proper response to people's needs, as opposed to a refusal to get involved.

The problems lie everywhere. Fundamental is the balance between conservation and access. In every field of heritage there are debates between the case for things to be 'pickled in aspic', to be passed on to another generation undamaged and untainted, and the case for things to be used, to be available to various people for various purposes. Should a Stradivarius violin be kept in a bank vault or played? Should everyone be able to 'have a go' on it? Do the current ropes set 100m from Stonehenge allow too many people to get too close or should everyone be allowed, as they once were, to touch? Is it reasonable to close off the nature reserve to the public in order for the ground vegetation to develop? People have a need for identity, but this often impinges

Figure 2.2 Cawsand Hill, Dartmoor. The erection of interpretation panels and other paraphernalia would destroy most people's pleasure in having got to this remote spot.

on someone else's identity. While it is possible to create sets of guidelines to assist in resolving all these problems, there must be no doubt that they can only be based on a foundation of ethics and morality. The heritage manager cannot take an amoral point of view. The decision will be, and can only be, made from a political position that, for example, democracy is better than autocracy, or that peaceful coexistence is better than war. If all that sounds trite and pointless, consider the current debate in many countries about multiculturalism. The American heritage interpreter who is determined to forge a single nation from the many groups of native and immigrant peoples will inevitably produce quite different solutions to the problems from someone who is determined to prolong each group's distinctiveness. In the British Isles the current move to four nations creates a different heritage agenda, and one with which some groups feel uncomfortable.

Heritage is, therefore, closely related to education, and indeed deeply involved in education in the broad sense - education for all ages. Heritage, in its public form, at sites and museums everywhere, is a vital ingredient in that modern favourite, lifelong learning. The desire on the part of many curators in the museums of the nineteenth century to refuse admittance to everyone except the experts - 'If they can't understand the objects they shouldn't be

here' - was fundamentally anti-educational. Public education has been universal in most western countries for more than a century, and the case for refusing access to anyone, as well as the case for restricting information, is clearly elitist. There may be occasions when 'no entry' or 'no interpretation' are the only possible policies, but there has to be a presumption against them. To follow such a course generally means (and frequently has meant in many areas of heritage) that a whole area of life and experience is reserved only for the cognoscenti. That said, the desire to be one of them, to be one of those 'in on the secret', is a powerful motivation for learning, of value for educators and interpreters. The girl at the Bayeux Tapestry, loudly demonstrating her ability to read the Latin inscription, may be vain, but her belief in the value of her Latin lessons was surely also enhanced.

However, public education is also compulsory. Neither children nor parents can opt out of education until a given age. In defending people's rights to be educated into their heritage, should we also be making it compulsory, or is that compulsion restricted to school? There are certainly many fine heritage sites where the only means of visiting is the tour guide, where the visitor has no option but to shuffle from room to room having the place's importance revealed, usually from a specific perspective which may or may not resonate with this visitor's interests. Traditional attitudes to environmental interpretation have certainly presumed that the interpreter has the right to educate the visiting public, more or less compulsorily, into ecological attitudes. To what extent has the visitor, especially the paying visitor, the right to opt out and be merely entertained, or just to get out of the rain?

Before examining the relationships between heritage and other subjects with which it becomes involved, we may note that all the above discussion is about the present and the future, not the past. The discussion is based on people's rights and responsibilities today, and the balance between jam today or jam tomorrow. Heritage is not about the past. Of course, many of the objects and the ideas with which it deals come from the past, but heritage issues are always about what we do with them now. That is not to deny that there is a history of heritage - people have been concerned with conserving and collecting for many centuries, but the distinction between the interests of the heritage manager and the historian is really that simple.

History

Surprisingly few of the heritage courses in universities have emerged from within history departments, although that is the subject with which it has been most closely related, especially in the critical literature of the 1980s and 1990s. Rather more have a close relationship with that other historically based discipline, archaeology, which may use different types of evidence but is also concerned with discovering and explaining the past. The most obvious distinction between history and heritage, of course, is that by no means all heritage is, in any normal sense of the word, historical. Among the many things that people wish to collect and conserve are many with which historians do not normally get involved – rocks, animals, plants and the physical aspects of scenery. One of the basic duties of the heritage manager is to maintain a sense of balance in just such areas. In the churchyard of the author's village lie the remains of a fourteenth-century undercroft – rare but far from unique. Would the local history society be justified in removing all the ivy to reveal the stonework more clearly, thereby disturbing the owl's nest and the bats?

Figure 2.3 In the grounds of a church are the remains of the undercroft of a medieval manor, the arches of which are just discernible within the shrubbery. Should this be fully exposed to the weather, at the risk of disturbing considerable wildlife?

There are also cultural artefacts and activities that people are very keen to conserve, that are contemporary rather than historical. Of course, everything is in the past once it is made, but many things are made to be put into collections, which applies not only to modern works of art destined for galleries but also commemorative mugs and even postage stamps destined for and designed for the collector. Such things are rarely the concern of the historian, but are very much the concern of the heritage manager.

So one distinction between heritage and history is that a very considerable number of heritage items are of little or no interest to historians. The other difference has already been hinted at: heritage is an applied humanity, whereas history is a pure one; history is interested in the past, heritage is interested in how the past might be conserved and interpreted for the benefit of the present and the future. Of course, some historians are interested in that also, and overlap is always fertile. There is one important area of considerable overlap – that of history as writing. In an important sense history is not 'that which happened in the past' but 'that corpus of work written by historians'. Historians write history books and heritage managers produce, sometimes, exhibitions about the past. The purposes are in so many ways similar, even if the markets are different. Even within historical publishing there is a considerable gap between history written as research, history textbooks written for educational purposes and histories written for the more general reader. The textbook writer would be well advised to enlist the help of education specialists; likewise, the historian wishing to produce an exhibition for a wider public, and partly for entertainment, would be well advised to consult a heritage specialist.

There is no reason for different attitudes towards truth-telling. All written history is, inevitably, biased by the time it is written, but despite all the recent understandings that truth is a much more complicated concept than we once thought, Simon Schama (BBC Radio 4, 21 March 1999) still supposes that the distinction is fairly straightforward, that historians are always seeking to explain the past truthfully and that writers 'know when they are making it up'. Some commentators suppose that heritage can be equated with bad history,[1] as if somehow the standard of honesty acceptable in a heritage centre can be lower than that acceptable in a history book. Such a lower standard may indeed be the case far too often – though the standard of truth-telling of some history writing has not always been an example to emulate – but heritage cannot accept, or be saddled with, a 'licence to lie'. Heritage presentations may simplify and generalize; they may contain omissions in order to avoid offence, but there is no excuse for lying or for getting

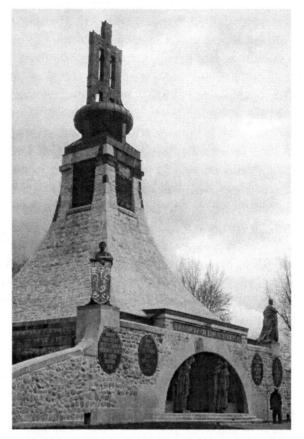

Figure 2.4 The monument at the site of the Battle of Austerlitz, 1805. Near Brno, Czech Republic.

it wrong. Heritage exhibitions may even present fictional accounts, honestly presented as such, but the heritage manager should join forces with the historian in condemning presentations intended to deceive. Historical fictions are fine, provided the audience is aware of their fictional character.

With historical events the distinction can be quite clear, and may carry a date. The Battle of Austerlitz occurred on 5 December 1805. The events leading up to that battle, and the events of the day, are matters for the historian. The historian may join the heritage specialist and be interested in who erected the memorials and when, but is not likely to be concerned with current visitor numbers and their motivations, nor how well the shop is managed, nor the extent to which the car parking interferes with an understanding of the battle. So until 5 December 1805 Austerlitz is the province of the historian; after that the heritage manager takes over.

Heritage is a present-day business (though it, too, has its own history) which is involved in using and quarrying - from histories, from things, from nature, from culture - to create something new for today. Heritage scholars quarry the material unearthed by historians and archaeologists. The relationship is similar to that between engineers and physicists. Just because engineers use the laws discovered and propounded by physicists does not make engineering bad physics.

Exercise 2
Find a local heritage site, perhaps a building or a place open to the public, and write two accounts - one of its history and one of its heritage. The first will concentrate on how and why the place is significant, and may include the history of architecture or art as well as political, economic and social history; the second will concentrate on how it has been conserved, interpreted and managed. This should give you a clear picture of both the differences between the two subjects, and of the need for each to support the other.

Cultural studies

The relationship between heritage and cultural studies is also a close one, except, once again, that many of the collected and conserved phenomena are natural in origin. However, the major distinction, yet again, is the applied nature of heritage which, inevitably, must include a substantial practical element. There is a resource management job to be done, and this includes an understanding of communications and design, curatorship and conservation. In the United States this distinction is made very clear by the use of the title Cultural Resource Management, which is also the title of the journal produced by the US National Park Service. There are, of course, many varieties of cultural studies, but most have a very strong theoretical basis closely allied to sociological ideas, and this input, which raises all the questions about the ownership of heritage, is vital. Heritage scholars also need to ask questions such as: Whose heritage? Conserved for whom? At whose expense? In answering these, the theoretical insights of Habermas, Bourdieu and others are central, and these ideas are discussed in Chapter 3.[2]

Another group of different cultural disciplines is now emerging which are much closer allies because they, too, have a practical basis of study. They are

variously called Cultural Practice, Gallery Management and Cultural Management, and there are close links between such students and museum management, but such courses do not normally consider the management of the outdoor heritage, and are much concerned with managing events, exhibitions and concerts. Some such events may well be staging significant heritage materials – musical, artistic or theatrical – but, presumably, not every new band nor every new play has enough support for its conservation to be regarded as heritage. Cultural management also tends to be concerned with culture as art, rather than with the culture of everyday life. In some situations 'culture' is viewed as the sum total of human activity and achievement, however mundane, whereas in other situations culture is virtually synonymous with arts, and, therefore, cultural management becomes taking 'culture' to the people. Nevertheless, a holistic view of heritage makes some unexpected bedfellows, and people seriously interested in the conservation and preservation of buildings or the countryside may well find that highly relevant ideas are those coming from experts in the management of concert halls. We are all putting on a show, and those interested in the employment of guides in a historic building will need to take note of developments in the theatre. Indeed, the area of live interpretation of heritage relates very closely to drama outside the theatre and is often staffed by actors.

Leisure and tourism

A few Heritage Management courses and a considerable proportion of the literature emerge from scholars working in departments of leisure and tourism, sometimes referred to as Tourism Management. Heritage issues are deeply involved in most such courses, and this, too, is a subject which has a considerable practical element, an applied study which accepts that there is a job to be done and that the students need to progress beyond theorizing. Indeed, in the case of tourism there is a very large industry; a worldwide and very diverse one with many employees. The same case has been made, rather less convincingly, for heritage. Both subjects share an interest in both nature and culture, though many of the factors that attract tourists would not usually be classed as either natural or cultural. The quality and standards demanded of the local hotels by tourists may indeed be fascinating insights into their own culture but are not usually regarded as a cultural facet of the receiving country. Green tourism and heritage tourism are now much discussed features

of tourism, much more closely related than one might gather from most of the literature. The wishes both to tread lightly on the environment and to leave the local culture undisturbed are closely related, often practised by the same people, and are equally impossible goals. Those who consider themselves 'heritage tourists' almost certainly damage more heritage than those who go to theme parks.

At least Tourism Management takes a serious interest in the 'who' of heritage, the nature of the visitors and the facilities there for their benefit. Inevitably, however, tourism scholars are concerned with tourists and, to a lesser extent, the euphemistically named 'host community', as if most of them had been consulted. But heritage is not only for tourists, it is also for pilgrims, for insiders, for members of the family who never leave home (inheritance is an important root), and it is for academics and for governments of many levels. Heritage has many markets, only one of which is the tourist. The tourist market may have a deep pocket, but much heritage is not designed for them. There is a widespread presumption that tourism and heritage are inextricably linked, but this does not represent either the history of conservation nor its purpose. The acceptance by the UK government that it would be appropriate

Figure 2.5 Part of the new World Heritage Site on the coast of Dorset and Devon. If designation results in a major tourist influx, the conservationist aims of the designation may be further compromised.

to submit the coast of east Devon and west Dorset (the 'Jurassic Coast') to UNESCO for consideration as a World Heritage Site has been greeted with jubilation by the local press as a 'massive boost to the tourist economy'.[3] Such designation is intended, of course, for the protection of the site, and it would be rash to assume that its long term conservation is compatible with a huge increase in visitor numbers. Such a conflation of ideas, 'heritage = tourists', needs to be resisted. Already many communities have had their local customs and costumes watered down or degraded for the dubious benefit of visitors.[4]

Geography

The two disciplines that have shown most interest in expanding into the field of heritage are geography (together with urban and regional planning) and history of art and design. Many of the academic staff in departments of Heritage Studies emerged from those two broad disciplines. Geography has long been a discipline which is difficult to keep within bounds. Its interests include all those things that differentiate one place from another, and this applies to a huge range of natural and cultural phenomena. Indeed, very considerable elements of the outdoor heritage have been identified and designated by geographers, both those from physical geography (national parks) and those from human geography (conservation areas), including the extension of those ideas into a practical and applied area of work in town planning and urban design. Indeed, geography shares with heritage at least three significant elements in its ethos. First, both subjects are entirely happy dealing with both natural and cultural material and see considerable advantage in combining these things. A considerable amount of geography is concerned with describing the variety of ways in which the physical world impinges on the cultural. Second, both subjects are quite practical or have clear practical applications, concerned as they are with people's needs today. And third, both subjects find it very difficult to define their subject matter. Geography was once famously described as being a 'point of view',[5] and the application of that point of view to historical material gives rise to Historical Geography, and to Medical Geography when applied to medical material. In the same way heritage specialists are always discovering new things that 'someone wants to save', and they find themselves, therefore, applying their conceptual understandings to these new phenomena.[6]

However, certain 'points of view' of geographers are closely involved with

place, and, not surprisingly, that concept has led geographers into heritage as one of the defining differences between place and mere space, or placelessness.[7] But there are clear limits to using place as a defining element of heritage. Certainly, most outdoor heritage helps to define place, and a substantial amount of the material housed in collections and museums has a considerable influence on place identity, but not all. A great deal of cultural heritage is international rather than local in its application, and museums would be stripped almost bare if every item was to be returned to the place where it was made – which is becoming a popular demand. Many new communities, such as those forming on the internet, have either no common place or very loose place connections – *Coronation Street* (the popular UK soap opera) fans are found all over Britain. Equally, for many items that have become heritage, the question 'From whence does this item come?' is more or

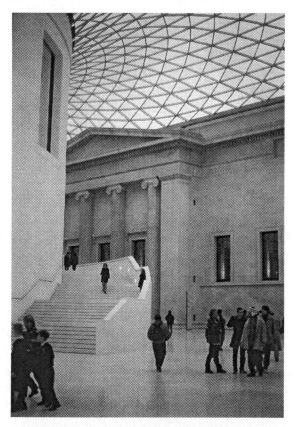

Figure 2.6 The British Museum may be an important reason for visiting London, and its presence in the capital is connected with British power and prestige, but it displays artefacts from all around the world and is not place-specific.

less irrelevant. Stamp collectors are not really concerned with or representative of their locality, and in the case of zoos, for example, much of the point is to exhibit exotic species. So while place is an important concept for heritage students it does not have the same centrality as it does for geographers.

Art history

Art history (including the history of architecture and design) is the other discipline from which many heritage scholars have come. It has extended to include Museum Studies – for example in the British classification of subjects for research purposes, which refers to the 'History of Art, Design and Architecture (with Museum Studies)'. This may be to the annoyance of many curators of ethnographic, natural history and of other collections where the aesthetics of presentation are not a primary issue. Indeed, there is a long literature about the problem of exhibiting workaday objects or religious icons or objects with a clear function as if they were works of art intended primarily for aesthetic display.[8] Quite often these arguments concerned the display of material from overseas cultures that had quite specific, often religious, functions, without reference to or respect for those functions, and treated as though they were 'merely' applied art. There is a real danger in these circumstances that 'aesthetics' can become 'anaesthetic', that is the enjoyment of the aesthetic qualities can actively deflect attention from the practical function, which might not be intended to give pleasure at all.

In recent years art history has enlarged its normal discourse to include the meanings of objects (semiology) as well as their aesthetics, and this has largely solved the problem of exhibiting meaning and function in a museum context. Nevertheless, one of the defining characteristics of Heritage Studies is the direct relationship between theory and practice. Having discovered that almost any view of almost any phenomenon presented to any target audience can be deconstructed, its completeness shown to be flawed, its silences deafening and its serving the needs of the hegemonic culture only too evident, the heritage student is then expected to go and do better. Equally, too, art historians are rarely very interested in the conservation of wetlands or geological strata, and architectural historians have a tendency to overlook the bats living in the roof space or the lichens on the walls when recommending conservation practices for buildings.

Figure 2.7 Artefacts may have many meanings. Many of these native American 'ghost shirts' have been displayed as objects with aesthetic and ethnographic scientific meanings, but to native Americans their meaning is also spiritual. The lady holding the shirt is privy to another set of meanings, as it belonged to her ancestor. Photograph courtesy Stephanie Pratt.

Conclusion

Heritage is perhaps the first post-postmodern subject. Cultural studies (and many other disciplines too) accepts the basic premise that identity, with which heritage is so closely concerned, is manipulated, even completely fabricated. The bricks of the wall of heritage can be made with very little straw, though whether they can be made without any raw materials at all is debatable. National identity, for example, is almost entirely contrived, usually deliberately contrived for clear political purposes. Such assumptions are essential to

postmodernism, but the heritage student accepts this premise and then proceeds to accept the challenge to manufacture an identity, to create a heritage, but with an overt agenda and a transparent policy. In so doing the subject has to be both practical and positive, to be creating new heritage while always being concerned for the dissenting voice, for the inevitable disinherited ones. If every heritage development disinherits someone then we need to be constantly aware that with whatever we say, we are treading on someone's dreams and memories. We need to tread very softly, and we cannot allow ourselves the luxury of dispensing with an ethical stance. Heritage policy, as many would claim of foreign policy, has to be ethical, and preferably rather more transparent than the Foreign Office.

This is a formidable challenge. One can be quite certain that many students of other disciplines, especially those with a longer history, will be dismissive of such a modern upstart, and will take great delight in demonstrating their superior understanding of their own narrow field. The excitement, however, is in working across a vast range of phenomena, natural and cultural, and developing common sets of ideas and solutions to common problems. From time to time, there will be the thrill of watching enlightenment or understanding, or just plain enthusiasm, dawn on the face of someone looking at your exhibition, or you will have to accept the thanks of someone for whom you have just succeeded in conserving something of deep significance. That is when it is useful to remember that the academics from those other, derisive, disciplines are merely one market sector, or one stakeholder, bidding in the heritage arena. Frequently, the discipline has controlled for very many years the conservation and presentation of the bit of heritage in which it is interested, and it will certainly not welcome your investigation into its stewardship.

Exercise 3

This is a bibliographic exercise. Take an area of heritage that interests you particularly and for which your library is well equipped. You need to scan the contents lists and abstracts of two or three major journals in that field published during perhaps the last decade, and distinguish between those articles that have a significant heritage slant and those that do not. Record those that do, as you will need to be developing your own bibliography. For example, you might be looking at journals in the history of art, the history of architecture, ecology, geography or tourism.

NOTES

1 D. Lowenthal, *The Heritage Crusade and the Spoils of History* (Cambridge University Press), 1998.
2 J. Habermas, *Legitimationproblem im Spatkäpitalismus* (Frankfurt: Suhrkamp), 1973. P. Bourdieu, *Distinction* (Cambridge: Cambridge University Press), 1990.
3 *Exeter Express & Echo*, 22 September 1998.
4 A. Orbasli, *Tourists in Historic Towns* (London: Spon), 2000.
5 This is attributed to Professor L. Dudley Stamp.
6 B. Graham, G. J. Ashworth and J. E. Tunbridge, *A Geography of Heritage: Power, Culture and Economy* (London: Arnold), 2000.
7 E. Relph, *Place and Placelessness* (London: Pion), 1976.
8 P. Vergo, *The New Museology* (London: Reaktion), 1989.

3

Heritage for People: History and Theory

SUMMARY

The chapter introduces the major themes of debate. The history of heritage is shown to be a very long one, although it has been much strengthened in the last two centuries. Theoretical ideas are introduced which enable students to grapple with the problems of management. These include dissonance, which results in part from the concept of Cultural Capital, and from the need for legitimation, not least by a dominant ideology and by its opponents. The concept of the circuit of culture also helps to understand the changes through time, and a study of groups and societies can help articulate these differences.

This chapter introduces some of the major debates of the last decade concerned with the commodification of heritage and its relationship to various political ideologies and various people. The argument, or accusation, put forward by Hewison, among others, begins that heritage is largely controlled by and for a small intellectual group who represent a hegemonic interest, and who commodify and commercialize heritage artefacts to provide an identity, usually a national identity.[1] This is countered by the proposition, most forcefully argued by Samuel,[2] that although many of the levers of power lie in the hands of such a group, nevertheless all groups within societies celebrate a whole range of heritages in very many ways. While powerful interest groups tend to give prominence to valuable objects, other people are equally obsessive about traditional activities, hobbies and folk genealogies. Similarly, while official heritage is dominated by masculine ideas of heritage (revealed by the use of *patrimoine* in French), there are also major feminine interests that tend to circulate around a more private heritage. Heritage is customer-led, defined

by the user and not by authority. Hence an understanding of basic economics, of demand-and-supply relationships, is fundamental to heritage and its management.

Heritage is for people; not just for a small minority of specialists and experts, but for everyone. Not only is it often intended to be for everyone's benefit, as most museums would claim, but also everyone is doing it. Not only are there motor museums, but lots of people spend their weekends carefully preserving old cars, from 'bangers' to Rolls-Royces. This sounds such a truism that it is hardly worth stating let alone devoting a whole chapter to. Yet, in any absolute form, it is a comparatively new idea and there are still many conservators who would find this a debatable concept. Indeed, there are some parts of heritage conservation that seem to provide a refuge for those people who are not happy in the company of people. Stamp collecting may attract those who want a hobby which does not involve all the complexities of reacting with others, just as it attracted this author for several years as a teenager, and there are many train spotters and others interested in collections. Such people are often the butt of jokes among those who think life should be continuously exciting, but Ben Elton reminded people that train spotters were not usually violent warmongers, and perhaps the world could do with more people with such peaceable and harmless hobbies.

Similarly, at a professional level, one of the pleasures of being a librarian or curator may also be the ability to spend sufficient time in the back room cataloguing, classifying and restoring things that don't answer back and which don't make unreasonable demands. So the statement that 'heritage is for people' is not necessarily welcomed unreservedly by all heritage specialists. One group of conservators who spent many hours at a conference explaining the techniques used in the restoration of a nineteenth-century tomb looked quite bemused, and failed to answer the question 'For whom are you doing it?' Similarly, an enquiry about the inhabitant of the tomb was greeted with 'She was not important.' If even our graves can be regarded as depersonalized objects, then perhaps the reminder is still needed.

It was not always so. The movement for heritage conservation is often attributed largely to the nineteenth century,[3] to the new republican government in France after the Revolution who wanted to conserve certain buildings and convert some of them into museums open to the public, in order both to demonstrate the legitimacy of their position and to underline their difference from the *ancien régime*. Elsewhere, the creation of royal academies and royal societies and the establishment of national museums during the

Enlightenment was not the result of an upwelling of popular sentiment. The movements for the restoration of buildings *à la mode* in France and elsewhere, under the ideas of Viollet-le-Duc, and the later reaction to this by John Ruskin, William Morris and their followers, were led by a small cadre of specialist enthusiasts, often blending the scholarship of the academic with the interests and money of the aristocracy and moneyed classes. The Society of Dilettanti in Britain sums up a very common element in early heritage seekers, and many antiquarians came from a similar mould. This combination of academic interest with the fascination of the connoisseur (far from disinterested in the value of the objects), often closely involved with the aristocracy, remains a deep vein within heritage studies. It was perhaps seen at its most obvious in the work by Lord Kenneth Clark, including the UK television series *Civilisation*, which would seem to be of interest to a very small stratum of the people.[4] The dominance, in England at least, of the heritage agenda by the perceived need to conserve the country house lasted at least 30 years, and showed the extent to which such aristocratic interests could be sold as being 'in the national interest'. Even in the field of nature conservation it would be a mistake to perceive the early nineteenth-century

Figure 3.1 The castle at Foix in the Pyrenees was restored in the 1840s by a student of Viollet-le-Duc. The extraordinary castellations, and most of the details, date from then.

origins as a populist movement. This could scarcely be said to be the case until the period between the two world wars, when the mass trespass on Kinder Scout was a very public demonstration of a new demand for landscape heritage opposed to the old guardians and owners.

History of heritage

While the origins of official heritage conservation, by government decree, may be dated to the Enlightenment, there is also a much older history. In the accounts of the ancient Greeks visiting Egypt there are references to the self-appointed guides who would show you the relics. There may have been little conservation, but there was certainly interpretation.[5] The cult of relics, prominent throughout the middle ages, is essentially a heritage movement, and involved protecting, conserving and, of course, selling and faking artefacts from the past which, supposedly, gave special powers to their possessors.[6] Somewhat later, the Renaissance was based on the use of the styles from Ancient Greece and Rome. While Renaissance architects were less interested in conserving the old than in building anew, they certainly knew how to promote the antique. Emulation of a building style is obviously not the same as conservation, but it certainly demonstrates an interest in the past. Imitation may indeed be the most sincere form of flattery.

The small band of nineteenth-century enthusiasts believed that they were conserving things for the benefit of the wider public. It was not only the French revolutionaries who were from the political left, as, most notably, was William Morris, and such people ensured that the tradition of free entry to museums and many other heritage places and buildings was deeply entrenched. However well-intentioned, they were sometimes frightened at the prospect of the popularity of their hobbies. Wordsworth's well-known demand that the Lake District be regarded as a 'kind of national property'[7] was later overtaken by his realization that the railways were likely to destroy the peace he took for granted. Perhaps the most obvious example from landscape heritage was the publication of *Britain and the Beast* in the 1930s.[8] This was a plea for planning laws and conservation of national parks and countryside for the benefit of the public, but also that they should be protected from the public which is the eponymous beast, destroying the thing it sets out to visit.[9] It is perhaps difficult, 60 years on, to remember that when Sir Richard Acland gave his huge estates to the National Trust in 1944, he was coming

Figure 3.2 Killerton House was the centre of the huge estates of the Aclands, given to the National Trust in 1944 by Sir Richard Acland, a left-wing politician who wished his lands to be used for public benefit.

from a very left-wing political position, having founded the Common Wealth Party and later becoming a Labour MP. He assumed that the National Trust was itself an organization well to the left of centre, and was determined to preserve the past for the erudition of the comparatively dispossessed.

Conspiracy theory

In England a great deal of the heritage efforts in the decades following World War 2 were devoted to saving the heritage of the landed aristocracy and gentry, though not ostensibly for their direct benefit. The National Trust, which had started very largely as an organization involved in the conservation of landscape, began to collect country houses, especially under the secretaryship of James Lees-Milne, and it was not long before heritage became inextricably linked in the public imagination with mansions, their grounds and their contents, together with the national museums and great works of art and architecture, such as cathedrals. This is the stage that forms the background for two key works – Hewison's *Heritage Industry* and

Samuel's *Theatres of Memory*. Hewison was far from alone in viewing the rapid development of new museums, heritage centres and theme parks with alarm and as symptomatic of a declining economic status. This was exacerbated by the use of cheap labour on manpower schemes designed to get people out of sight of the lengthening dole queues of the 1980s. New museums were opening weekly. The Ministry of Public Building and Works became English Heritage (CADW in Wales and Historic Scotland in Scotland) with a demand to become more commercial.

In such circumstances, to regard most heritage enterprise as a trick designed to persuade the entire population to pay for the pleasures of the few was entirely plausible. The UK comedy series *Yes, Minister* ran an episode to display the sophistry with which tax income should be used to subsidize grand opera but not the local football team. Experts decided that the loveliest and rarest works (and thus the expensive works) of art were heritage. Owners of such properties could threaten to export them and thus raise money inside the country. Owners of great houses could get significant tax relief by agreeing to open their properties to the public, although the opening hours were not blazoned from the rooftops.[10] On all sorts of advisory committees, at national and local level, there was a predominance of titles, either academic or inherited.

But the tempting analysis of a conspiracy theory omitted some very significant features. The most obvious was the exclusion of the natural heritage, although there, too, the visitors to national parks and nature reserves remained predominantly white and middle class, if not middle aged. Zoos remain the outstanding exception. But throughout the 1960s and beyond there has been a significant move towards heritage of lesser monetary value. Vernacular architecture began to be appreciated (and to appreciate), and the process known as gentrification gathered pace. At first it was country cottages and, later, town houses which went upmarket and gained new owners with substantial incomes. The process was circular. The demand for such property gave it heritage status that in turn inflated the demand. Sometimes the results were obvious. For a local thatcher, who had barely survived the 1960s, the 1970s was a happy time. For the first time the new owners asked for a whole roof to be done; previous cottagers had never been able to afford more than patches.

But the vernacular movement was not restricted to thatched cottages, and soon there was the development of industrial archaeology, an attempt to save the remains of the heavy industries which were dying. Of course, this was certainly heritage 'in a climate of decline', but its popularity was not restricted

Figure 3.3 This small rural cottage is typical of the kind of property, only eight kilometres from a town, now much sought by those who are not agricultural tenants.

to the academic or the wealthy. Local steam fairs became commonplace, with re-enactment societies, collectors of bric-a-brac and even the Shepherd's Hut Society (see Figure 1.1). People who could not afford to collect paintings collected photographs, and those who could not afford photographs collected postcards. Elements of the counter-culture, such as underground pop music, develop their own heritage and spawn collectors and re-enactment performers. These, no doubt, start in casual venues such as the car boot sale, but before long specialist shops are opened. The same phenomenon was found throughout the United States, and was no longer largely the prerogative of wealthy, white Americans. The boom in genealogical research that had once been a search for aristocratic ancestors, or Pilgrim Fathers, now became a search for the poor and needy. Heroic victims were the ideal, and some events, such as the Irish potato famine, provided them in abundance, and perfect sets of ancestors.[11] At different paces in different countries the same fascination was sweeping throughout the wealthier nations. Samuel recognized this, and demonstrated that while heritage had hitherto been taken over by the wealthy within society, by the controlling group for their own benefit, it was no longer necessarily so, and groups which were traditionally excluded from power,

whether women or ethnic minorities or the comparatively poor, could now use heritage as a powerful weapon with which to be heard. The conspiracy theory could only hold water if the concept of heritage was restricted to those things designated as such by governments, not the materials in the car boot sale. The National Trust not only opened up the kitchens of the great country houses, but it also purchased 20 Forthlin Road in Liverpool, the boyhood home of Sir Paul McCartney. Of course, part of the process is that the dispossessed come in from the cold and become the heritage elite. Paul McCartney is now Sir Paul, thus confirming his own heritage status.

Exercise 4
Make a list of heritage items changing hands in the local high street. This might include some estate agents, shops selling collectables, many items in the car boot sale and some of the second-hand-car showrooms.

Heritage societies

If all heritage is about people, with almost everyone involved in some aspect, and is conserved or collected for somebody by somebody, then the groups such people form are themselves rarely cohesive. The list of voluntary and charitable societies devoted to collecting and conserving is endless, and if the voluntary sector is particularly strong in the United Kingdom, it is certainly far from confined to it. A study of these societies is most revealing. One of the most common characteristics is a tension between a purist group who often form the core of activists, and whose agenda is significantly different from the 'cannon fodder' of the bulk of the membership. In the political world the difference of view between the party workers and activists on the one hand and the ordinary voters on the other is most obvious, with the former tending more to the extreme left or right as appropriate. They tend to stress the core values of the organization and may sacrifice the chance of power rather than compromise those values.

Such divisions exist in many groups. At one extreme is a small group of highly active members with clear, often political, usually campaigning, ideas, whose interests lie much more in 'getting things done' than in recruiting new members. It is their energy that gets things conserved, raises the money to keep an object in the country, lobbies Parliament for a change in the law, perhaps even results in them chaining themselves to trees or lying down in

front of bulldozers. The other extreme is a much larger group, a periphery, who are in the organization partly for what they can get out of it. They like looking at country houses but they are not prepared to campaign to save them; they go for walks in the country but they are not prepared to smash down fences to do so.

Another way of looking at groups is to categorize those which are top-down and those which are bottom-up. The National Trust is a top-down society, with its national trustees at the core of the organization. They are responsible for most decisions, and the organization itself plays in a national stadium for the benefit of all. They certainly listen to local residents, and have a much increased policy for doing so. A property conserved in the Lake District is clearly regarded as a national, not a local, asset, its interpretation strategy is not aimed at locals particularly, nor to foreign visitors, but to the nation.

Other societies work the other way round; from local, often county-based roots which then find that they need a national umbrella organization. Such are the civic trusts or the historic gardens trusts.

In Britain the voluntary sector is actually given legal rights. National Trust land can be declared inalienable, out of the reach of a local authority's power of compulsory purchase without parliamentary approval. Some other organizations, such as the Victorian Society or the Ancient Monuments Society, have been given the status of amenity societies, entitled to call in relevant planning applications for their comment. The Society for the Protection of Ancient Buildings (SPAB), founded by William Morris, is one such, armed with a clear manifesto that has to be signed by all members. The decision-making group in such organizations rarely represents a cross-section of the public, and can be viewed either as an effective way of harnessing expert opinion over heritage matters without significant cost, or as an effective way of promoting academic and specialist control of the heritage.

Exercise 5
There are a very large number of charitable heritage organizations, and they are well worth studying. You should select two, preferably within the same broad field and write a comparative essay showing how they differ in membership, aims, achievements, publications, etc. British examples include the Landmark Trust, Common Ground, the Twentieth-Century Society, the Georgian Group, the Woodland Trust, the International Tree Foundation, the Open Spaces Society, etc.

Theory

Ashworth suggests that there are perhaps three theoretical ideas that are the core of understanding heritage attitudes, and that help to explain the considerable debates of recent years.[12]

The first of these theories is the motivation that underlay the desire of the new revolutionary government in France, and later in Russia, not to destroy the palaces of the old regimes but to adopt and adapt them to the new order. This was to legitimate their right to govern. Legitimation, much discussed by the German sociologist Habermas, is common at all levels of government,[13] from the commune to the United Nations (which has a flag and a uniform), and in many other spheres. For example, some humanist groups in the 1930s suggested that the great gothic cathedrals should be turned into museums and other places for the education and entertainment of the populace. Few suggested pulling them down. Indeed, some might suggest that exactly that outcome has occurred, as happened rather more obviously in Russia (see Figure 3.4). Such action legitimates the new governing force, in this case the triumph of education over religion.

Such legitimation is most obvious in the 'national museum', and it has been argued that such institutions were themselves a kind of western cultural event which became exported, so that each colony sprouted a quasi-national museum in emulation of the home country.[14] Such institutions became as much part of the newly independent states' right to power as their national airlines. The sovereign's orb and sceptre fulfils a similar role, and the ancient Norman font in the medieval parish church is the same, preserved when the old church was destroyed in order to prove the right to baptize and the sanctity of the ground. Gruffudd's discussion of the history curriculum in Wales makes the same point.[15] Not only does the curriculum give a particular slant to the teaching of history, but it stresses the Welsh right to do so.

Not only is the historic cultural heritage used for purposes of legitimation but nature is also brought into play. Perhaps the most frightening example of this has been described by Groening and concerns the use of landscape architects in World War 2 whose job was to decide, from looking at the landscape, whether the place was sufficiently German or not. If it was not, then it should be re-landscaped, first disposing of the local population.[16] At a much more innocent level, the map of Europe is littered with 'little Switzerlands', such as Suisse Normand in France, Sachsen Schweiz in eastern Germany and

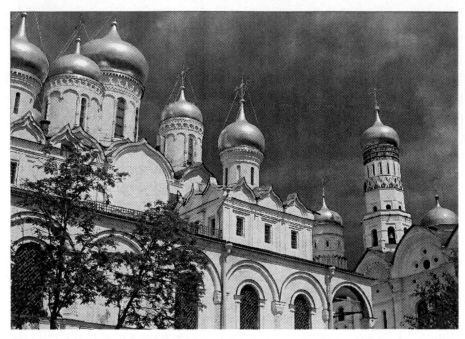

Figure 3.4 The Soviet regime did not destroy the cathedrals in the Kremlin; they turned them into museums. They thus acquired both legitimacy and control.

'the English Switzerland', an epithet for Lynmouth in Devon (see Figure 3.5). Such terms may be harmless, but they are much needed to relate one place to known standards of beauty, thus transferring legitimate beauty from the original to the new. The Venice of the North is another such example. Indeed, any attempt to introduce a new place onto the tourist map almost inevitably results in legitimating comparisons being made.

The need for continuity, inherent in the concept of legitimation, leads to the version of history that has been labelled 'inevitable progress'. History and, perhaps even more so, the history of art, was traditionally often written as a march of progress leading up to the present. The present is presented as the outcome of past events which all culminate in the current perfection. Many works dealing with modernism in art used the technique to present modern abstraction as the crowning pinnacle of a long artistic progress. Even more bizarre were the descriptions of modern town planning, usually in the 1940s and 50s, that presented the changes to be imposed on many cities as the natural result of past glories of planning. Needless to say, such versions of history are preferred by victors rather than victims. They are more likely to be found in the United States than in Serbia, and countries which have lost

Figure 3.5 Despite its picturesque thatch, this building in Lynmouth, north Devon, clearly relates to the idea of this part of Exmoor being the English Switzerland.

empires, such as Russia and Britain, may regard previous ages as being special. Many countries have such a concept of a Golden Age that is persistently used whenever decisions about what to conserve are made, or even those decisions about to which period a property should be 'returned'.

To the concept of legitimation should be added the idea of 'cultural capital' proposed by Bourdieu,[17] the second of Ashworth's three theoretical foundations. The idea, of course, is in contrast to the concept of economic capital. Cultural capital may have a concrete form, and be valuable, and thus also part of economic capital, such as a musical instrument or an old building or a book. However, it may also be experiences, and when we go on an exotic holiday or to an art exhibition we are busy accumulating cultural capital. More importantly, it may be the standards of taste, discrimination and judgement that are acquired through education and reading. In fact, 'cultural capital' is, at least in part, the raw material of snobbery, a powerful force in heritage. It is being deployed when a connoisseur talks about a painting, or a discussion takes place about decor. The incident at the Bayeux Tapestry, when the teenager translated the Latin inscription, has already been mentioned. The smug expressions of the parents demonstrated very clearly that cultural capital was being deployed – the cultural version of waving money in the air.

Sometimes cultural capital is deployed negatively. One of the most obvious manifestations of this is the person without a television. No doubt the judge who famously asked 'Who are the Beatles?' was also credited with considerable cultural capital, whether his ignorance was real or not.

This capital, just as with monetary capital, tends to find its way into comparatively few hands, and much of heritage, being saleable, is in the hands of the already wealthy. Those in power have more cultural capital as well as more money. But this is not a direct relationship and there is a significant group who may be among the leaders of taste but not among those with economic power. Indeed, many teachers, artists and musicians may have very limited wealth, which they have traded for cultural capital - their prestige is greater than their pockets. Nevertheless, in most societies the relationship between those with taste and those with wealth is a very close one, and in Britain the relationship with those with long family connections is also striking. Long-established and aristocratic families send their children to expensive private schools to acquire cultural capital and they then enter those trades, typically in and around the media, design, arts and politics, where they acquire economic capital also. Those who have economic capital without culture, whether through labour or the lottery, tend to enter the same circuit, the key to which is special education. The road from businessman to country squire in England has traditionally been three generations,[18] and it is still surprising to find how many people with new wealth, such as pop stars, for example George Harrison, immediately acquire that most potent symbol of cultural capital in England, the large country estate. The pop star Madonna has been particularly assiduous in the acquisition of cultural capital which she clearly views as existing largely on the eastern side of the Atlantic.

This cultural capital is, of course, envied and contested. New groups produce new forms of culture - whether it is punk rock or land art - of which they then take possession and acquire the cultural capital arising therefrom. Exactly the same happens with collections. Veteran cars are now well beyond most people's pockets, so vintage cars and those merely 25 years old are now paraded at fairs throughout the country. Steam engines remain popular but so now are 1920s diesel pumps, and collections of paintings are replaced by stamps, matchbox covers and postcards. Quite often these new cultures are successful at replacing the old, or at least providing a viable alternative. BBC Radio 3 now gives air time to jazz and even to rock and roll. The thatched cottage may not quite have replaced the castle in terms of social cachet, but it ranks alongside much larger villas of more recent vintage.

Exercise 6
Content analysis is the technique of scanning the media to quantify output. Look at the detail of one week's television and radio output and measure the amount of time given to programmes that are devoted to the acquisition of cultural capital. The holiday programmes and the cookery and gardening programmes are an obvious start.

Thus groups in society compete for cultural capital, which is itself a valuable, perhaps vital, part of any attempt to legitimate the right to rule. The third area of theory is involved with identifying the group that controls the cultural capital. In most societies such a group can indeed be recognized, if somewhat hazily. This is the dominant ideology or even the hegemonic group, the group whose ideas are generally those on which society is motivated. They have their hands on most of the levers of power, including, of course, the power to conserve the heritage that is necessary for their own legitimation. In the USA this group is traditionally known as the WASPs – white, anglo-saxon Protestants. Each country will define its own group differently, and in the United Kingdom there have been some significant changes in the last twenty years. Traditionally, this would have been Eton/Harrow and Oxbridge, and recognized as the Establishment, but Margaret Thatcher's administration presided over a significant shift of power which was continued by both the Major and Blair administrations, which are markedly more meritocratic. Nevertheless, the dominant ideology remains largely white, reasonably well educated, southern English (or sometimes Scottish, but not Welsh, Irish or northern English) and still largely male. This group remains less than half the population of the country, and such a situation is far from uncommon in most countries.

Colonized people developed a multiplicity of means of coping with their disenfranchisement and disinheritance. In several countries, under the communist system, there was a method of discounting authority. The Czechs would take to the hills and forests at weekends and holidays, would studiously avoid using power and water provided by The System, would cut trees to light fires and would wash in the stream. Indians, led by Gandhi, developed extraordinary techniques of passive resistance against the British. In both cases these methods are now part of the heritage of those countries. Those who are culturally disenfranchised do the same. First, they simply avoid the dominant culture. They do not visit the opera-house, nor the art gallery, nor, frequently, the university. In England they would once have avoided rugby and

Figure 3.6 The large country house has been at the forefront of English heritage ideas. This one, Killerton House in Devon, owned by the National Trust, was for long considered too small and insignificant to be opened to the public.

gone to soccer matches, but here the dominant ideology has taken over football also. The dominant group builds universities to teach the dominant group to regard itself as a dominant group. Perhaps the British tradition of sending eighteen-year-olds away to university (just as once on the Grand Tour) was concerned with the invitation to intelligent young people to join the dominant group and to be trained to take their place in it. Of course, when some of them arrived they found that the power and privilege there was unacceptable to them, just as 200 years ago French people going to see Versailles, now wrested from the Crown, may have been disgusted as well as impressed. People do not always take away from heritage sites that which was intended. The intention at Auschwitz, set up by liberal intellectuals, may have been to provide an experience of commitment to peace and sorrow for all humanity, but this does not mean that all visitors receive that message. Messages received at heritage sites, as in newspapers, depend as much on the prejudices of the recipient as on the content of the message (see Chapter 9).

There are, of course, other theoretical ideas that are of considerable value in studying heritage. One is the notion, referred to variously as Rubbish Theory or the Circuit of Culture,[19] where artefacts become obsolescent and

are categorized as useless rubbish, until they become revalued and take their part in heritage developments. This will form an integral part of Chapter 7.

Robert Mugerauer has contributed a particularly useful text about ways of understanding historical architecture, which can usefully be enlarged to cover many other historical artefacts and their explication.[20] He describes three major ways of looking at such works, from the traditional means, with Kant as an important figure, and largely in vogue throughout modernism, to the two major postmodern approaches; that of deconstruction, following Derrida, and that of hermeneutics, largely following Heidegger.[21] Critically for heritage, the more recent methods of analysis do not accept that there is one 'proper' explanation of a cultural phenomenon – usually that of the maker – but that all the viewers of the object bring to it entirely relevant meanings.

Around these theoretical ideas lie the problems with heritage at the beginning of the twenty-first century. Over the last two centuries, but especially since the 1960s, most countries have enacted legislation to protect the items held to be precious by the dominant group. Cathedrals, palaces, great country houses and the town houses of the wealthy have been satisfactorily designated and, to a considerable extent, conserved. There are rules preventing the export of works of art deemed to be part of the national heritage. National parks protect the kinds of landscapes the dominant group likes to visit. There are substantial subsidies for art exhibitions, performances of opera, ballet and music, and for the theatre. As that group and its interests have widened, so film has become subsidized, thatched cottages protected and town centres conserved. Names of poets, novelists, composers, playwrights, scientists and politicians are recorded on plaques and on memorials. The next challenge is twofold: first, to extend the range of conserved things to include those that are important to people other than the dominant group, and to see them in a different light; and second, to extend our ability to conserve things, objects, into an ability to conserve ways of life, languages and dialects, sports and activities.

There are certainly many attempts at community culture, but these are all too often top-down. The dominant group defines what is meant by culture, and then these ideas are transmitted to other groups. Socially excluded groups are brought into the museum, for example, or artists attempt to stimulate local artistic talent. The education is all too often one way, and thus not true education (i.e. a drawing out) at all, but instead an indoctrination into defined culture. On occasion this is made quite overt by reference to 'taste' and the suggestion that when taste has been acquired aesthetic qualities (and values)

Figure 3.7 The main square in Siena, Il Campo, is carefully conserved, but it is the conservation of the famous horse race which is more important to many inhabitants. Activities are therefore as important as artefacts.

will become obvious. But there are real moves to widen the base of the heritage, for good or ill. On the one hand it can be seen as a genuine attempt to conserve the heritage of a group other than the dominant one, but, on the other, it could be viewed as an attempt by the dominant group to take over the heritage of others. An organization such as Common Ground, which encourages local people to conserve the local things of real importance to them, often becomes dominated, at the local level, by exactly this new dominant ideology displayed by residents who are anxious to acquire the cultural capital of 'local identity' but who have not met the basic requirement of living in the locality for a few generations. Genuine attempts to preserve the heritage of other groups can also be seen as patronizing. Just as the very idea of the national museum was a western concept, so the very notion of heritage, in the sense of listings, designations, preservation and conservation, could be seen as authoritarian. The gypsy community, for example, is divided between those who are keen to set up a gypsy museum and blazon gypsy culture for all to see, and those who regard that as giving in to a dominant group's wish for a picturesque day out, and regard the gypsy heritage as being marginal and largely invisible.

The second task is even more difficult. In a fascinating case in Ryhope, Co. Durham, in 1998, the local Labour MP intervened in a dispute about new development planned for an area that included pigeon lofts, or crees. In the mining villages of Durham, and elsewhere, the keeping of racing pigeons has long been a local hobby. The crees were often self-made and usually brightly coloured, a very distinctive item on the landscape. Some of these are now listed buildings, a clear case of the system designed for the great building being applied to little structures for which they were certainly not intended. Most would agree that this is a lot better than nothing, but pigeon fancying is in decline, for complex social reasons. While it may be true that the peregrine falcon, a carefully protected heritage bird, may take a few racing pigeons, that is not the major factor. Many people would wish to see the activity conserved, not just the shell. The methods at hand for doing this are few and not necessarily effective. They rely on voluntary societies and almost never on state support and funding. Indeed, such activities are often contested by others, and pigeons are regarded as a health hazard by some. How to conserve local traditions, rather than merely their relics, is the next major problem.

Activities – whether sports and hobbies, religious practices, performing arts

Figure 3.8 Beach chalets are typical of the new minor buildings that are becoming conservable, but the desire is to keep the activity as much as the structure, and rules designed for grand works of architecture do not adapt well to such minor buildings.

and routines of life – tend to carry deeper meanings than things, especially meanings connected with other people; people tend to be the chief interest of people. Conserving a cricket ground seems to be of little point if the game has died. In the parish church many who show little concern about the conservation of the building can become very agitated at the suggestion of changing the traditional liturgy.

So heritage is about people. Some of those people are tourists, but enough has been said in this chapter to make it quite clear that tourism is, to an extent, peripheral to heritage. It is a very important periphery, particularly as regards money, but heritage is conserved first and foremost by people for themselves, whether they are owners of heritage, governments protecting heritage for legitimating purposes or the local town conserving something it values. Tourists then come along and want to see it, but no-one supposes that if tourists stopped visiting the Tower of London we would demolish it. Tourism often involves the process known as commodification, the packaging of the heritage item to make it saleable, which in turn makes it self-conscious. Some heritage is easily packaged – a building may have specific opening hours, a leaflet, a guide and a fixed price for a tour. It is more difficult to commodify, say, a local dance, but local hotels and tourist organizations will pay local performers, and it is not long before the dance becomes a fixed routine of the same length, available at the same time on fixed days for a fixed price. It still looks like the local dance, except that the dress code will now be strictly enforced; but it has little to do with local people, except with their pockets. Heritage always has been about people, but the challenge today is to make it relevant to a much wider section of people, and that emphasis will not necessarily be on the conservation of concrete objects.

Exercise 7
Look at a local area of rapidly improving fortunes – one that is being gentrified – which may be in town or country. What are the outward and visible signs which indicate this change? How is cultural capital displayed by the dominant ideology? One obvious case is the motor car. See if you can distinguish resistant displays.

NOTES

1 R. Hewison, *The Heritage Industry: Britain in a Climate of Decline* (London: Methuen), 1987.

2 R. Samuel, *Theatres of Memory: Volume 1. Past and Present in Contemporary Culture* (London: Verso), 1994.

3 See D. Harvey, 'Heritage pasts and heritage presents: temporality, meaning and the scope of heritage studies', *International Journal of Heritage Studies*, 7(4), 2001, 319–38.

4 K. Clark, *Civilisation: A Personal View* (London: BBC), 1969.

5 K. Dewar, 'An incomplete history of interpretation from the Big Bang', *International Journal of Heritage Studies*, 6(2), 2000, 175–80.

6 D. Harvey, 'Heritage pasts and heritage presents'.

7 W. Wordsworth, in *A Guide to the Lakes*, quoted in J. Dower, *National Parks in England and Wales* (London, Cmd 6628, 1945), p. 19.

8 C. Williams Ellis (ed.), *Britain and the Beast* (London), 1937.

9 D. Matless, *Landscape and Englishness* (London: Reaktion), 1998.

10 For a list of tax-exempt properties available to be visited by the public see http://www.cto.eds.co.uk/ .

11 E. Crooke, 'Confronting a troubled history: which past in Northern Ireland's museums?' *International Journal of Heritage Studies*, 7(2), 2001, 119–36.

12 G. Ashworth and P. Howard, *European Heritage Planning and Management* (Exeter: Intellect), 1999.

13 J. Habermas, *Legitimationproblem im Spätkapitalismus* (Frankfurt: Suhrkamp), 1973.

14 D. Dolan, 'Cultural franchising, imperialism and globalisation: what's new?', *International Journal of Heritage Studies*, 5(1), 1999, 58–64.

15 P. Gruffudd, D. T. Herbert and A. Piccini, 'Learning to think the past: heritage, identity and state education in Wales,' *International Journal of Heritage Studies*, 4(3/4), 1998, 154–67.

16 G. Groening, 'The feeling for landscape: a German example', *Landscape Research*, 17(3), 1992, 108–15.

17 P. Bourdieu, *Distinction* (Cambridge: Cambridge University Press), 1990.

18 W. G. Hoskins, *Devon and Its People* (Exeter: Wheatons), 1959.

19 T. Bennett (ed.), *Culture, Ideology and Social Process: A Reader* (London: Batsford), 1981.

20 R. Mugerauer, *Interpreting Environments: Tradition, Deconstruction, Hermeneutics* (Austin: University of Texas Press), 1995.

21 D. Krell, *Martin Heidegger: Basic Writings* (New York: Harper & Row), 1977.

4

Fields of Heritage

SUMMARY

The things that people want to save are usefully considered in seven categories or fields, some of these being also represented by the official organizations that conserve heritage. But managing heritage is made more difficult because many things fall into more than one field, and some are difficult to place anywhere. Most heritage sites are conserved by the guardians of one field of heritage who can threaten the sensible conservation of other kinds of heritage on the same site, which they may not have noticed. The more one examines these traditional fields, the more they aid sensible thinking but impede sensible management.

The kinds of heritage that are officially recognized and conserved by government organizations, also tend to be those with less meaning for people in their daily lives. Traditional boundaries of heritage need to be swept away in order to provide a more comprehensive heritage management, and one more meaningful to people.

This chapter and the three following represent the core of the ideas that this text expounds. Here we examine (1) the kinds of things that people conserve and collect, and in the following chapters we examine (2) the types of people who do it, (3) the levels of identity at which the activity takes place and (4) the process involved in heritage. The first three can be regarded as the faces of a cube (see Figure 4.1). Each individual dispute of heritage management can be imagined as existing somewhere within the cube, there being frequent difficulties between fields, between levels and between markets. As we examine and attempt to classify all the things (many of them not really objects at all) that can become heritage, we are forced to the conclusion that such a classification is not a very useful analytical tool with which to study heritage, because too many things do not fit comfortably into any one category, and

other things fit into several categories. The attempt is nevertheless valuable, as heritage is revealed as one of those subjects that includes almost the whole of human experience. Geography and history, similarly, are subjects with very wide boundaries. If the job of heritage management is made more difficult by the complexities of deciding what heritage actually is, the job of the interpreter is often made easier as the similarities between the categories are seen to be much more significant than the differences.[1]

Any study of heritage conservation reminds us that people care. We are by nature, suggests Afshar, preservers not destroyers.[2] When the house is on fire 'We rescue babies, pets and family albums.' We do so, probably, in that sequence; first ourselves, then other people, animals and things. Which things we save will depend heavily on our culture and our own interests. No doubt good financial sense would prompt us to rescue items of portable value, perhaps money and jewellery. But many of us are far from rational and might well select things of 'sentimental value'. That concept of sentimental value is very close to the idea of heritage. This author's list would include diaries, which are fondly believed to be of interest to his offspring, the old shoe-box of family photographs and the few small things inherited from grandparents. These are not likely to make a fortune at an auction sale.

Figure 4.1 The heritage cube

So what do people wish to conserve or collect, to protect from the ravages of time? The simple answer is 'everything'. A colleague has what he claims to be the world's largest collection of toilet paper, all in mint condition, labelled and recorded in a series of albums. He has appeared in a television programme devoted to unusual hobbies, in which collectors and preservers were much in evidence. So there may seem little point in making a list of phenomena so diverse as to include cathedrals, ducks, dances and toilet paper. Nevertheless, some attempt to categorize the various areas does lead to unearthing many of the most significant questions in the discipline. Identifying regions in geography or periods in history inevitably makes us realize the limitations to the concepts of regions or periods, and also provides the opportunity to examine the similarities and contrasts that are fundamental to those disciplines. So this study of fields of heritage will perform the same valuable task. Seven fields are suggested here, but the purpose can never be to create watertight compartments; many items could easily come into more than one category, either because of their complexity or because of the vagueness of such boundaries. The sectors are listed in Table 4.1.

Table 4.1 The fields of heritage

Heritage fields		
Nature	nature reserves, zoos, museums	fauna, flora, geology, habitats, air and water
Landscape	national parks, AONBs, natural areas, heritage coasts	gardens and parks, cultural and archaeological landscapes, mountain chains, plains and coastlines
Monuments	listed buildings, scheduled monuments, conservation areas	buildings, transport lines, archaeological remains, sculpture
Sites	national battlefields, historic markers	battlefields, mythical sites, *lieux de memoire*
Artefacts	museums, galleries, outdoor museums	museum artefacts, family albums, artworks, ships
Activities	clubs and societies, legislation, *appellation contrôlée*	language, religion, performing arts, sports, diet and drink, calendars, customs, crafts
People	atrocity sites, plaques, graveyards, obituaries	saints' relics, heroes, victims, celebrities' possessions

The classification inevitably reflects the author's national bias. Most countries, including Wales and Scotland, do not draw a distinction between places conserved for nature and those conserved as landscape in the same way as is common in England. However, the original motivations for the two were quite distinct, and the distinction between the fields of English Nature and the Countryside Agency was dignified as 'The Great Divide'.[3] Similarly, the whole enterprise of seeing heritage as a single field of study, now common, at least in Britain, Australia and Spain, may not be shared everywhere. The country house and estate has been a central feature of the conserved heritage in the United Kingdom for at least 50 years. Such country houses were 'buildings', surrounded by 'landscapes', which provided the context, and they contained a collection of 'artefacts' for which the houses provided a context. They were often significant for 'nature' conservation, and the inevitable restaurant was busy serving food and drink which tried to recreate previous meals in that place – the heritage of 'activities'. There was even some attempt to preserve the 'people' of the house. Such a British focus on country houses as heritage was important in leading people to consider heritage as a whole. In the USA, the American decision to have a single National Park Service to cover both natural environments and buildings tended to the same conclusion. Each country's emphasis on different aspects of heritage may have had different effects, as discussed in Chapter 7.

Nature

The most obvious feature of the new emphasis on heritage as a single field of enquiry is to include the natural with the cultural heritage, and to recognize that whatever the differences between the two (which are not as dramatic as might be supposed) there is much to be gained in common study, if only to ensure that each group stops neglecting the other aspect. There are plenty of examples of architects removing rare lichens in order to protect buildings, while from the United States come reports of rare buildings crumbling within national parks.[4] In many countries, governments, groups and individuals have conserved species of plant and animal and geological and geomorphological features for over a century, and even international activity has a long history. The development of disciplines has meant that nature conservation is studied in different departments, and that government ministries and fund-awarding bodies have clear briefs that exclude crossing that line. However, the

management of real places will often mean ignoring the dividing lines of scholars, to consider all aspects of a site.

Most accept that saving birds, mammals or plants is worthwhile, but their study is perceived as being separate from the rest of heritage; in England it is even separated from the conservation of landscape, and certainly from the museum sector. Similar distinctions are made in most European countries and in most British local authorities. Even where the natural and cultural are treated within the same organization - as with the UNESCO World Heritage List, they are subject to different rules and specialist panels - International Committee on Monuments and Sites (ICOMOS) for the cultural heritage and International Union for the Conservation of Nature (IUCN) for the natural. In the United States, where the National Park Service has a clear brief both in historic preservation and nature conservation, well-informed rumour has it that 'the Smoky Bears don't talk to the Tea Sippers, you know'. The joke has the added dimension that the guardians of the cultural heritage are not only regarded as effete, probably Easterners and not worthy of wearing the khaki drill and hat of the ranger service, but also of faintly doubtful loyalty to American values (since the Boston Tea Party).

Nature and science

One of the origins of this split between nature and culture is the division between the arts and the sciences. The cultural heritage has been studied mainly by scholars from the humanities - either from those with interests in the past - historians, archaeologists, art historians, even ethnographers - or from those with an interest in aesthetics. Indeed the historical interest and the aesthetic interest often seem indivisible. Most people within nature conservation, however, were trained as scientists, within biology, ecology and geology. For many years they regarded their decisions to conserve certain things as objective, scientific responses to demonstrable factual situations. Many conservationists still hold to that. They have been successful in persuading the politicians, who hold so many purse strings, that their scientific conservation was in a different league from the aesthetic decisions of the cultural heritage lobby; it was more objective, more justifiable and largely outside the political arena. So conserving wildlife was put on the same moral plane as preserving clean air and water. Recent developments to conserve biodiversity have strengthened that moral position.

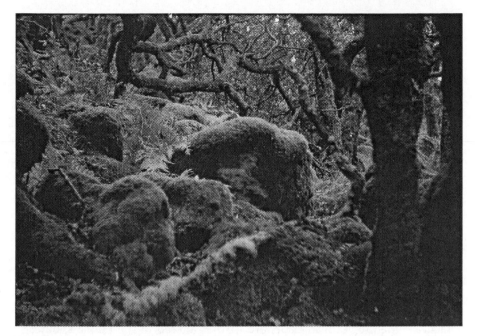

Figure 4.2 A typical Site of Special Scientific Interest, being a relatively small area where a particular habitat, or ecosystem, in this case oak woodland, has survived. It is managed to maximize biodiversity, not access.

But scientists are, of course, human, and we may all be grateful for that. Their whole education and learning environment has led them to research certain issues and not others; even where they wished to study areas outside their tradition, the masters of the purse strings would often not oblige with the funds. If a scientific enquiry is unlikely to lead to profit, and may question accepted values, it will have difficulty getting funded. Worster's work on the history of environmentalism[5] makes it abundantly clear that scientific disciplines themselves are responses to social needs, that the priorities and methodologies that those disciplines set and approve are also largely socially driven. The science museum and the nature reserve are driven by human values, just as the conserved cathedral or the art gallery are.

Larsen goes so far as to argue that nature is simply a cultural concept.[6] In Britain, as in most of Europe, there is almost nothing natural, since the land has been intensely occupied for so long that natural habitats scarcely any longer exist – all nature is cultural. All plants and animals exist either because they were bred or planted, or because they were deliberately allowed to remain, as a result of a cultural decision by humans. Even in America the concept of wilderness, fundamental in the history of American conservation, is

largely a product of nineteenth-century writers and artists, notably Thoreau and the Hudson Valley school of painters.[7]

Nature is therefore conserved very largely according to human priorities. Even geology is officially conserved only where humans value it being so. If an individual decides to conserve a cat as a pet, despite its destructive effect on the local mammal and bird population, it is because of certain values that the owner believes will accrue to himself or his family. The same is largely true of more official nature conservation at national level. The admirable principle of two of every species, with no favouritism, as demonstrated by Noah, is not normally followed. Zoos specialize in certain animals because people like them; nature reserves are managed to promote one plant in preference to another, because scientists believe that these are 'native' or because they wish to promote 'biodiversity', which may not be a particularly natural thing to do – many naturally occurring vegetations are far from the most biodiverse possible in that climate.

Some animals are dramatically more equal than others. Scientific priorities, which are themselves man-made, are further altered in the public sphere, so that, for example, large, woolly mammals, especially babies, get a particularly good deal in terms of conservation, with small poisonous spiders ranking near the other extreme. There is little public pressure to conserve the rat, or the flu virus or the tapeworm. Only recently have the wolf and the shark been considered conservation-worthy.

Similarly, dramatic geomorphological features, such as the Grand Canyon or Niagara Falls, may not be the most scientifically interesting landscapes in North America but they merit conservation more than visually boring places that are of enormous scientific importance. In Europe there are more calls to conserve the Alps than the North European Plain. The geological conservator perhaps faces this problem at its most obvious. Many sites of great significance to the geological record are of little interest to the general visitor, so there is a great need for careful salesmanship to provide the funds for geological conservation, except perhaps for the display of precious stones in museum displays, and for sale.[8]

This anthropocentric basis of nature conservation is evident in national policies for the conservation of particular animal (or even plant) species. These concentrate on a species' rarity in the country concerned. Hence the Dartford warbler is much mentioned in the heathlands of southern England, despite being fairly common in much of France and Spain, while Norway has now decided to cull wolves, taking note of local farming preferences rather than of international conservation pressure.

Figure 4.3 Not so long ago this little piece of Pennsylvania would have been considered a dismal swamp, and certainly not heritage. Now it is a protected part of a precious wetland.

Most nature conservation is human-centred. Habitats, animals and plants may be preserved so that they can be studied, used in experiments, be a source of genetic material, aid agriculture and forestry as biological controls, and for many other reasons including human emotional attachment. The argument that we should preserve all species for the sake of the gene pool – the biodiversity argument – has been particularly successful in recent years. One no longer has to argue that we have a vague moral duty to strive to keep alive all species of life, however lowly (animal rights become a bit of a problem with fleas or nematodes); one can now argue with scientific objectivity that the genetic material may be needed (for human needs, of course). This can create a real conflict between the scientific heritage and the cultural one. Rare breeds can now be kept, for all potential scientific uses, deep-frozen in a test-tube. But the numbers of people interested in Gloucester old spot pig embryos in a test-tube remains limited, while keeping rare breeds is becoming quite a hobby, and one cannot exclude the need for a hobby from the list of human needs being provided by nature conservation.

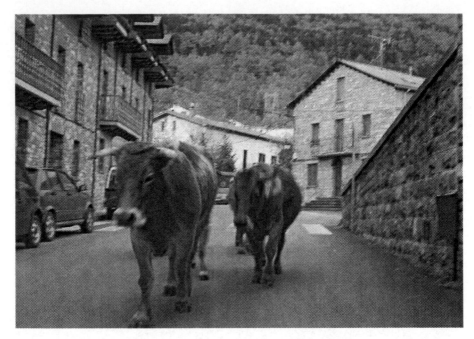

Figure 4.4 Local breeds of domestic animals are often the best adapted for local conditions, but ensuring their survival needs more than the conservation of embryos.

Nature and culture – differences and similarities

So there is no good reason for treating the conservation of nature as a different discipline unconnected with the cultural heritage. Both affect each other; both can learn from each other. There are some areas, however, where there are different emphases within the two traditional heritage fields.

CONSERVATION TECHNIQUES

The most obvious difference lies in techniques. The techniques for the conservation of brown bears are different from the techniques of conserving frescoes or tarantulas. Conservation techniques are inevitably the preserve of specific experts, with detailed understanding from other disciplines, whether architects, zoologists, ecologists, art historians or geologists. They probably have highly specific training even within those disciplines. The heritage manager can answer the questions of 'What should we conserve, why and for whom?', but the question of 'How should we conserve?' must be left to others.

Even this difference applies only to the physical techniques themselves. The

legal frameworks, the concepts of zoning and listing, of dealing with pressure groups and attracting funding, and of international convention show considerable similarities for both natural and cultural features. So do the techniques of interpretation, and indeed all the techniques of marketing and public relations. Ideas developed in one area often have implications elsewhere, and the park manager needing to develop a nature trail would be well advised to study the work done in museums on routeing visitors.

AUTHENTICITY

UNESCO's criteria for inclusion on the World Heritage List make a significant distinction between sites listed for their natural and their cultural importance. In the cultural criteria, considered by ICOMOS, there is an insistence on authenticity, while IUCN, in considering the natural sites, insists on comprehensiveness or integrity. A glacial site, for example, will not be inscribed unless it shows a large range of glacial features, not merely a spectacular hanging valley.[9] Natural habitats, if not rock formations, can usually be created anew, provided the species are still extant, so that a newly created wetland habitat in an old gravel pit can be as authentic a habitat as an ancient pond. The cultural heritage, by contrast, cannot be recreated without losing some elements of authenticity. However, authenticity is a very slippery concept, and there are several kinds, which are discussed in Chapter 8.

In addition, some recent work has suggested[10] that authenticity is damaged in the restoration of natural sites, just as it is for cultural ones. The time taken for nature to produce the same ecosystem complexity in a newly created site can be very long. In the case of individual species, authentic animals can be restored to the wild from breeding programmes – but the process is not without difficulties, both ecological and social. Restoring otters to the wild has led to ecological shortfalls of habitat and food (BBC, 23 July 1997) while restoring wolves has met with social resistance in several countries. The animals may be authentic, but the relationship with people may well not be. Scientific conservators sometimes avoid such problems by simply not informing local people. Genetic manipulation of species, already commonplace in many plants, also opens a new debate about authenticity of species.

MOTIVATIONS

Motivations for conservation may also differ, although motivations are notoriously difficult to examine, as most collectors and conservators are

Figure 4.5 In the Kampinos National Forest (Poland) elk have been restored, but local farmers are less happy about the plan to restore wolves.

far from sure of their own, probably mixed, motivations, and have little intention of divulging them to others. Many scientific conservationists believe that they are not conserving a species for the benefit of humans but for the sake of the species itself, whatever the motivations of those who fund them. Actually, this is not very different from the position adopted by those archaeologists, for example, who feel that ancient structures have a right to be conserved irrespective of their ability to attract human visitors. Certainly a glance into the attics and store cupboards, let alone the gardens, of many houses will reveal a heap of things that have no further use, but which the owner could not destroy. David Lowenthal has studied this phenomenon in some detail and discovers a greater unwillingness in Britain to throw things away than in America.[11]

PUBLIC ACCEPTANCE

Although the deliberate destruction of the cultural heritage (iconoclasm) was once widespread, and remains so in many war zones, there has long been a general public acceptance of the need to conserve cultural property. This has taken much longer in the case of nature. Some nature conservation

regulations have been on European and American statutes for more than a century but the natural heritage has had more difficulty in establishing the unacceptability of destructive behaviour. Indeed nature has been much destroyed by its friends who have loved it to death. The collecting of birds' eggs, for example, has only recently been considered antisocial, and there is still considerable debate over butterfly collections. In the United States particularly, the bounty of the land meant that the destruction of predators, even in national parks, remained routine.[12] Only recently has the collecting of wild flowers been outlawed. All this is doubtless because nature can be reconstituted and replenished, and was viewed as inexhaustible.

Even geology is now under threat. There is now a debate on the coast of Dorset, near Lyme Regis, as to the wisdom of allowing people to hunt for fossils in the cliffs, and there must certainly be some important cliff faces and some tender moorland or dune habitats where the hammers of the geology students or the boots of the ecologists are significant elements in the erosion. There are military training areas where naturalists' organizations find that the guns and tanks of the military are less destructive than access by nature-lovers.

Figure 4.6 The Šumava Biosphere Reserve, Czech Republic. This reserve, lying on the Czech side of the border with (formerly West) Germany has been inaccessible to all except the military for 50 years. The lynx has been reintroduced, and there is now much debate concerning the opening of the area to visitors and the likely impact on the wildlife.

Widening the context of conservation

Nature is not the only heritage field in which there has been a marked trend to extend the context of conservation, to expand from the designation and conservation of individual species of plant or animal, of individual buildings or even individual folk arts, to a much wider policy, encouraging the conservation of whole areas, in order to give context to the individual, or even as the only way to secure survival. Often this has resulted in increased debates with landowners and other interested parties, and hence more political difficulties. Persuading people in liberal democracies to vote for government interference with one's property rights has never been easy, and it gets progressively more difficult as a greater part of the electorate own property and as governments want to protect larger areas. Property owners are not always sympathetic to the need to have controls on greater areas of land or more buildings which are not obviously of outstanding quality.

In the nature sector there has been a move from merely designating certain species of animal or plant that must not be killed to the designation of the habitats in which they can thrive. Nominating certain species of duck that could not be shot was politically much easier than protecting huge areas of the wetlands where they live. Not only is wetland liable to have many competing uses – both industrial and leisure – it has not, as a landscape, caught the public imagination. This move has brought the conservation of nature much closer to the landscape sector, so that England is now unusual in maintaining the distinction. A further move has come with the protection of bats in the UK, where owners are obliged to take active steps to conserve and not merely passively to protect.

Nature: the participants

Heritage managers are likely to be involved with an official level of conservation, largely the work of governments and environmental organizations, and especially those which practise conservation *in situ*, as at Sites of Special Scientific Interest, nature reserves, bird reserves, geological parks and biosphere reserves. There are many private attempts to conserve nature, however, entirely apart from the keeping of pets, with bird feeders hanging in many gardens where bushes are planted to encourage butterflies and ponds

are dug for the frogs – a fairly extreme form of natural heritage conservation. Just as in the built heritage, the private landowner may well spend more on conservation than all the various government authorities, though whether it is well spent is quite another issue.

Similarly, nature is not all *in situ*; nature conservation and its interpretation to the public is the primary purpose of zoos and safari parks, and forms the *raison d'être* of many national museums and large collections in most regional museums. To discuss the conservation and interpretation of nature in Britain without reference to the Natural History Museum or the London Zoo would be as bizarre as discussing regional museums without reference to their natural history or geological collections.[13] It frequently happens, however, and one of the hopes of this book is that such strange failures to debate with people within the same business may be lessened.

Project
Within a local government area, perhaps the size of a British county, map the areas conserved primarily for nature conservation. In Britain these will include Sites of Special Scientific Interest, nature reserves (both local and national), perhaps a marine nature reserve, and probably bird reserves run by the RSPB. The websites of the major organizations will be very useful here – English Nature, Scottish Natural Heritage and the Countryside Council for Wales. The SSSIs will have management agreements that detail the reasons for the designation, and the prohibited activities. Investigate links between these sites and natural history collections in museums and heritage centres.

Visit some sites, concentrating on those with large numbers of visitors and maximum pressure on land use for other reasons. Some may have visitor centres. How are priorities of usage decided? How are visitors of different kinds catered for?

Landscape

Many outdoor areas are conserved for reasons quite apart from their value as habitats or as examples of geological or ecological phenomena; rather they are conserved for very human purposes of leisure or enjoyment, for their aesthetic appeal rather than for the species they contain. Large parts of the United States are designated as National or State Parks; in Britain there are national

parks and Areas of Outstanding Natural Beauty, and in France Parcs Naturels Regionaux. All of these official designations are supplemented by countless hectares conserved by individuals as gardens, or by landowners and even farmers, who manage them with a careful eye on their appearance. To distinguish between heritage sectors on the grounds of motivation is unusual, but the history of landscape protection is largely separate from that of nature conservation, at least in Britain and the United States, even though (with the need for habitat protection noted above) the two sectors have come much closer together recently. Most national parks are designed to conserve landscape rather than nature, though most do both and one might find it difficult to distinguish between the two. The early American national parks, which were the first and, largely, the model for others, were selected on the basis of their astonishing landscape features, as at Yosemite or Yellowstone. The British national parks were charged to preserve natural beauty and to encourage access.

Landscapes come in many sizes. At one extreme, the sector clearly includes gardens, which are usually associated with buildings, and which are thus often managed by the same agency responsible for buildings and monuments, e.g.

Figure 4.7 The wish to conserve the extraordinary landscapes of the Yellowstone area of Wyoming, among others, was the main incentive for the creation of national parks, first in America then elsewhere. Photography courtesy Alan ?????????????.

English Heritage. Indeed the most effective French law for garden protection is that protecting the surrounds of buildings.[14] However, there are significant problems in trying to conserve growing gardens by a set of rules designed for buildings. Concepts of 'original design' and 'preserve as found' simply will not work. Many gardens, of course, do contain listed buildings within them – temples, dovecots, walls, sculptures and outhouses – but these are far from the whole, especially in those gardens where the plantsmanship is the principal feature. Before the advent of garden registers, in most European countries, there was a distinct feeling among the garden conservationists that their interests were very secondary to the buildings, and were frequently misunderstood by architectural conservators who were not used to things which kept growing and dying. Perhaps the best reason to retain landscape as a separate sector is that the gardens are otherwise doomed to be the poor relation either of the monument sector or the nature lobby. All too often the landscape setting is largely ignored, whereas good management can add significantly to a site's attractions. At St Fagans, near Cardiff, the reconstructed buildings have now been supplemented with reconstructions of the kinds of gardens which would suit the buildings and their dates.

The most usual scale for official landscape designation is the state, regional or national park. In many countries, following the American originals, national parks are state-owned land, devoid of permanent inhabitants, but in others, such as crowded Britain, they are merely lands designated as being of special value. The title which most clearly indicates the landscape purpose of such designation in the UK is Area of Outstanding Natural Beauty, although in many cases the beauties which are conserved there are very dubiously natural – field patterns and hedgerows and even villages, for example, are often mentioned in the supporting documents.

The double-edge of designation

The fact that there are always two sides to a line designating an area is at its most obvious within the landscape sector. There is not only a protected area within the line, but also an unprotected one outside it. The same is true for any system of designation of landscapes or buildings or any other kind of heritage, especially when it goes beyond the very exceptional case and begins to be quite commonly applied. The boundary of the national park not only decrees that within that line the landscape is special, but that outside the line it is not –

and, therefore, developers may be forgiven for thinking that 'anything goes'. This can have most unfortunate consequences, with such places, perhaps very close to a designated national park, coming under heavy development pressure, even when such places constitute the view from the park or where the landscape quality is very little less. Many buildings are judged to be not quite of the quality needed for listing, or do not quite reach the next higher category. The presumption that these buildings are of little consequence is very difficult to dispute, especially at a time when attitudes to what is conservable are changing very fast.

Views from the site may be of great significance, and management needs to ensure their survival. A reading of the tourist literature for the Lincolnshire Wolds, for example, an Area of Outstanding Natural Beauty, shows that the most outstanding beauties are the views from the Wolds over the coastal plain and the vale. These are, however, outside the protected zone, and great care needs to be taken to ensure that the whole purpose of designation is not destroyed, even by well-intentioned tree planting.

There have been at least two ways of tackling the problem of designation. One is to use 'nesting categories' of designation, such as the three zones used

Figure 4.8 Woodbury Common is part of the East Devon Area of Outstanding Natural Beauty, but the views from it look out over largely undesignated countryside. Areas are more easily designated than views.

in the Šumava National Park in Bohemia. Inside the protected landscape region (largely farmland) is the national park (largely moorland and forest) and within that is the biosphere reserve (largely free of public access). Another way to tackle the problem is to shift the emphasis away from absolutely defined designations and to stress the special qualities of every landscape type. The combined effort by the Countryside Agency and English Nature to distinguish Natural Areas in England, each of which has a character to be conserved, is one such attempt, but it has so far failed to become a major planning tool. Lawyers and planners find clear-cut designations easier to handle. Studies of the opinions of developers have shown their consistent wish to be told clearly where they can build and where they cannot.[15] Character assessments and design guides[16] demand a much more subtle control over design and function, and are seen by developers as more intrusive. Similarly, the concept that 'all buildings are historic in their own way' is not one to appeal to most owners of property. Attempting to make such all-embracing systems work will be a major challenge to heritage management.

Association

Some landscapes associated with famous writers and artists also bring this sector very close to the 'people sector'. There are parts of Brittany, the Forest of Fontainebleau or the Luberon in France which are beloved by French painters and are now regarded as particularly special. In England we have Hardy Country and Constable Country, the latter being designated an AONB. More recently, film and television have given significance to many landscapes, not least those associated with classic Westerns in south-west USA. In recent years the hill country of Yorkshire has done particularly well from *Last of the Summer Wine, Heartbeat* and the books by James Herriot. Great landscapes are likely to derive their importance through their human associations as well as directly through the eye of the current observer, a fact recognized by UNESCO in their category of Cultural Landscapes.[17] Such landscape significance can be created very easily. A reporter (BBC TV, 10/2/01) was recently given a tour around a Russian village, near the Estonian frontier, which President Putin had visited. The reporter was shown every tree by which the President had stood. Plaques may follow.

International landscapes

There is an international scale to landscape conservation. Some areas are major causes for concern across several countries, the most obvious European example being the Alps. At least six countries (France, Switzerland, Austria, Italy, Liechtenstein and Germany) have to co-operate to maintain a balance between tourism, agriculture, industry and nature as well as to conserve water resources in this huge area. Throughout the world people are beginning to consider that the most important elements of heritage, which they should be conserving for the next generation, are such landscape features as fresh air, clean rivers and seas free of rubbish. The heritage enterprise must underline its commitment to such vital areas of international action. With the very existence of some islands under threat from rising sea levels, consequent upon global warming, and the laying waste of northern Venezuela, and great swathes of French forests and gardens in the storms of Christmas 1999 and the floods of 2000, the conservation of the landscape heritage takes on a new

Figure 4.9 This piece of heathland, near Bockhampton in Dorset, acquires its heritage significance much less from its natural features than from its cultural importance, for this is Egdon Heath over which Hardy's reddleman strode.

urgency. The commitment of all heritage managers to sustainability must surely be a bottom line of all policy. The National Trust, for example, regards itself as being an exemplar of good practice as a major landowner, including experimenting with reed-bed sewage works, and in discouraging car-borne visitors. The latter is a particular challenge, as many conserved landscapes lead to a considerable increase in traffic.

Project
Using the same area as for the previous project, map all the official landscape designations. In Britain these may include national parks, national scenic areas, areas of outstanding natural beauty, areas of great landscape value (a local designation with various names), country parks, environmentally sensitive areas, heritage coast, special areas of conservation, registered gardens, cultural landscape (UNESCO) and natural areas. Which of these can nest with another? What are the purposes of each? What kinds of development are allowed, and who is responsible?

Monuments

The monument sector concerns immovable human works – buildings, archaeological remains and perhaps some sculptures. The term 'monument' to include a building that has been declared to have heritage value is a useful extension from the Dutch and French usage, which is finding its way into English usage also. In many countries and in many books and organizations the word 'heritage', or its equivalents, such as *patrimoine*, is immediately taken to refer to the historic built environment. The only governmental organization in England now with the word 'heritage' in the title – English Heritage – has within its remit listed buildings, scheduled monuments, conservation areas (of towns) and registered gardens. However, north of the border, the Scots use the word in their organization for landscape and nature, Scottish Natural Heritage, a difference that may have some significance in the two countries' thinking. Heritage Studies is often translated into German using *Denkmalpflege*, literally 'monument restoration'. Similarly, most American courses known as Historic Preservation are concerned primarily with buildings. While none could deny the importance of works of architecture and archaeology in giving reality to the heritage of a place, the tendency for this sector to regard itself as the sole significant repository of heritage values

has to be challenged. Professional heritage managers are very likely to be employed within this sector, just as government agencies, both local and national, make much of the built environment, not least because it is often the best organized sector, but it may not be the sector in which the deepest personal meanings are embedded. Similarly, managers of the built environment should not assume that the most significant values within the building are those of architectural or archaeological history.

Motivations and values

Many monuments have achieved their heritage status because of their significance within the field of archaeology or architectural history. But there are many other values that may have led to their conservation, and many buildings incorporate at least two values. This author's house is a listed building, largely because it was the home of a writer of some significance, Eden Phillpotts. In the official description of the building, however, the architectural detail 'typical of its period' is noted. So buildings and monuments may incorporate other meanings, or have these added. Stonehenge has a whole variety of quite different values to various groups, especially to pagans, which have little to do with the history of the monument. If buildings can be conserved as repositories of values that might more strictly be ascribed to the people sector, then the same is true of other sectors also. Buildings might have significant bat colonies, or be of vital importance in a landscape or garden view. They might be the location of a major historic event, so that the site value is greater than the architectural, or they might house great frescoes or other collections or be involved with activities, as at Stonehenge.

Indeed, quite often the conservation of the building begins as an attempt to conserve the memory of what once happened there. In a meeting with a group of academic architects the point was made that in some countries beer was considered a more important part of the heritage than buildings. One architect immediately suggested we could conserve breweries. Indeed we could, and perhaps should, but it was the beer not the buildings for which people showed concern. Perhaps the conservation of churches and cathedrals is supported by non-churchgoers for the same reason – admiration for a culture that they feel they have lost. Some people are concerned that the English determination to conserve country houses represents just such an admiration and nostalgia for a way of life that many would nowadays find very distasteful, as did most

Figure 4.10 The penguin pool at London Zoo, designed by Lubetkin, has been listed as an historic building. It contains, of course, items of the natural heritage, and modern zoo-keeping methods demand larger accommodation for the penguins. A classic example of two fields of heritage in opposition.

Figure 4.11 This is the A303 trunk road past Stonehenge, which still awaits a second carriageway. But the entire area surrounding Stonehenge is a World Heritage Site, with dozens of monuments, most of them below ground level. Widening the road cannot fail to damage very significant archaeological heritage. Not all monuments are visible.

people who suffered under it. So turning buildings into monuments may be a nostalgic last resort. In such cases the building may have become a memorial, for example, the carefully preserved ruins of buildings damaged by war action – the Gedächtnis-Kirche in Berlin or the buildings at Oradour-sur-Glane, to name two such instances.

Such multiple values – the meanings of the built environment to a whole variety of people – are perhaps most commonly noted in churches, but the number of buildings which are conserved solely within the technical interests of archaeologists or architects are few.

From grand to vernacular

A major shift of emphasis in recent years has been the conservation of the typical, rather than only the extraordinary – a feature shared with the landscape sector. At first, during the nineteenth-century rise of conservation, the tendency was to designate great medieval and classical buildings, notably cathedrals, castles and palaces. Later this developed to include grand buildings by well-known architects, known as polite architecture. Indeed, the development of an architectural history, predicated, as was art history, largely upon a series of names (a history of architects as much as of architecture) to an extent obviated the need to judge quality too carefully. Great buildings were those by great architects, and great architects were often those who had been most studied. Most of these buildings had been designed to be looked at, not merely to be lived in; they were conscious works of art. Designating vernacular cottages broke with this tradition. Since then there have been successful attempts to protect derelict industrial buildings, and, more recently, exemplars of nineteenth- and twentieth-century domestic architecture. Not only are thatched cottages and log cabins designated, but so also are some buildings in New Towns, high-rise suburban estates and postwar pre-fabs. In part this represents a continuation of the tradition of designating works by famous architects, which may be in municipal housing. But it is also concerned with a postmodern extension of interest into other meanings than the aesthetic, so that a semi-detached house may be as interesting a social document as a medieval church.

This move, most obvious in the built environment, is clearly related to the move towards 'natural areas' in the field of nature and landscape. There has been much recent concern for places that are not carefully designated or made

self-conscious and tidied – a concern for ordinary landscapes.[18] As part of the postmodern emphasis on meaning, and a lack of faith in intrinsic aesthetic quality, places that are in no accepted sense beautiful are found to be the repositories of deep meanings for many people. There is a real danger that in conserving remote landscapes for the few intrepid travellers and the rich, we condemn landscapes that may be important to many others to a lack of support. One small organization in Britain, Common Ground, has been very active in persuading people in rural areas of Britain to be careful of the ordinary landscapes in which they live, to protect the orchard, to record the field names, to mark the crossroads. The Getty Conservation Institute has given cameras to poor, young, dispossessed people in Los Angeles, Mexico City, Mumbai, Cape Town and Paris to photograph what they take to be their heritage, only to discover that the landmarks and landscapes they want preserved are totally different from those conserved by governments.[19] Landscapes and buildings that are strenuously conserved are by no means necessarily the first choice for people's private heritage.

Increasing scale

Shadowing this development, the scope of conservation has also widened to include whole areas, just as the move towards habitat conservation was noted within the field of nature. Typically, in a city centre or village, only a few individual buildings might be worth listing individually, but the ensemble, with its minor buildings, its plan, its open spaces and its planting, is seen to be greater than the sum of its parts. In Britain this has led to the designation of conservation areas. French *secteurs sauvegarde* are a similar response. The effect in the UK has been to try to prevent the historic building being left stranded in a sea of recent development, so that a similar set of regulations which apply to both exterior and interior, front and back, of the listed building are applied at least to the exterior front façades of all the buildings in the conservation area.[20] Quite frequently this has led to 'heritage districts' in many cities, which are distinct from the Central Business Districts, such as in Limoges. In other cases, known as gem cities, the entire settlement is regarded as so precious that the heritage values overwhelm all others.[21]

Figure 4.12 In much of Mediterranean Europe, change in rural areas has been very recent and rapid, leading to abandonment of such places as this, a Greek-speaking village in Calabria. This vernacular heritage now faces a quite different future as a holiday village.

Interpretation

The built environment sector is unusual in that the motivation for its conservation has not been much generated by governmental recognition of the importance of monuments in manufacturing identity, nor by the demands of tourism. Clearly, some buildings are significant markers of identity, but they are not necessarily designated. Much interwar semi-detached suburban housing, for example, is outstandingly British, or even specifically English, while much American suburbia is equally distinctive, but both go largely unrecognized in terms of protection. More obvious national monuments, such as the White House, Shakespeare's birthplace or the Sagrada Familia, are more likely to be conserved.

Similarly, interpretation for visitors is noteworthy by its absence in most towns. Just as museums had a long history before coming to regard interpretation to visitors as perhaps their primary aim, so with buildings, and even more obviously with archaeological monuments, conservation has

preceded interpretation and public access by many decades. It now seems impossible to imagine a museum collection or a nature reserve without abundant interpretation for visitors; in the majority of towns the built heritage is scarcely interpreted, and rarely at a less than academic level. Individual buildings such as great houses and churches, especially where there is paid admission, will probably be the subject of detailed interpretation, but most towns provide surprisingly little information to help visitors or even residents to look at the buildings, the outsides of which are a free gallery. Perhaps because they *are* free, and no-one stands to make a profit, they remain a surprisingly under-used resource. Although many cities recognize the importance of their historic quarters[22] they concentrate on conservation rather than presentation. There may be little or nothing in the Tourist Information Office, and enquiries in the local library are likely to lead to excellent, detailed scholarly monographs of limited use to anyone except the professional.

Perhaps because the conservation of buildings was the main focus of heritage interest by the enthusiasts of the nineteenth century, the specialist or connoisseur has remained in firm charge of this sector. Many museum curators whose training for the post was almost exclusively concerned with the protection and conservation of the artefacts, must sometimes regret the 'new museology' with its emphasis on education and social inclusion, on the presentation of the collection rather than its conservation. But this 'new museological' attitude has scarcely penetrated the sector of the built heritage, where the emphasis is still very firmly on expert decisions about what should be conserved and how, with presentation issues firmly in the background. There are signs, however, that this is changing, and that tax payers' representatives are no longer content to have splendidly conserved buildings and monuments, but want to use them for advancing the public relations of the city, not only with regard to tourists but also to residents.

This sector shows many areas of overlap, and problems of definition. Systems of protection devised within this sector are used sometimes in areas where their relevance is more questionable – as noted with the case of Registered Gardens. Whether a canal, which is, after all, little more than a ditch filled with water, can be properly classed as a building or a monument has been one recent issue among many, with neighbouring local authorities taking different views on the matter (see Figure 4.13). There are also collections of buildings, such as the Weald and Downland Museum, at Singleton in Hampshire, after the original at Skansen in Stockholm. Are

Figure 4.13 Exeter ship canal is partly sixteenth century in date. It is entirely owned by Exeter City Council, though the newer part of it lies within the area of another council. The latter have seen fit to recommend it for designation, but the owning council have not taken the same view within their own jurisdiction.

these properly within the monument sector or the artefacts sector? Does it matter? The answer to the latter question might well be 'no', provided they are properly looked after. However, Linda Young, in an Australian context, suggests that often they are not, and she coins a whole new sector of In-between Heritage to cover items which are movable rather than portable – small buildings, machinery, ships etc.[23] She demonstrates how easy it is for such items to fall between different authorities, none of which is prepared to take unequivocal responsibility. One of the great strengths of seeing heritage whole is that appropriate solutions can be devised for all parts of it.

Project

Examine the system of monument protection in a town. In the UK this will involve mapping those buildings which are listed, in Grades 1, 2* or 2, and looking at the reasons for those listings in the official documents. There may also be scheduled monuments and conservation areas. Planning Policy Guidance Note 15 will explain the rules. In your study pay particular

attention to the following: What are the percentages of Listed 1 (nationally about 1%), 2* (nationally about 10%) and 2? What do these differences mean? What is the distinction between a scheduled monument and a listed building? Is a distinctive 'Heritage District' emerging? Note evidence of the control of development, including advertising, within the conservation areas. What evidence is there of modern or vernacular buildings being designated? What material interpreting the built heritage is available at the Tourist Information Centre, at the library, out on the streets?

Sites

Some places are important without containing any artefacts, species or monuments. Little or nothing is visible on the surface, as around Stonehenge, and sometimes there is little beneath the surface either. Death sites are obviously significant here, with people throwing wreaths into the sea at the site of sinkings, and visits to many battlefields, in only a few of which are there any physical remains which have survived. The surface material is likely either

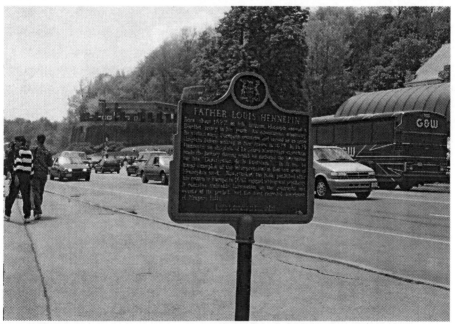

Figure 4.14 An historic marker at Niagara Falls, Ontario. This is a very common method of commemorating people and events in North America. In Britain this is done largely with plaques on houses and battlefields.

to be reconstructed – for example, trenches from the First World War – or memorialized, such as the great monuments at the site of the Battle of Austerlitz or, together with a museum, at Gettysburg in Pennsylvania. Sometimes there are simply interpretation panels, as at Sedgemoor and throughout North America, which is littered with historic markers (see Figure 4.14).

Not all death sites are battlefields, of course. Graveyards are of the greatest importance to many, and while the methods of memorialization may differ by country and by religious practice, it is likely that the emotional investment is similar. The church that some note as a building is regarded by a small number as the site of the graves of close relatives. So some buildings are sites quite as much as monuments.

Quite often, a vital site is merely the place where some event occurred, sometimes closely connected with a heritage person – where Christ ascended into heaven, or where Princess Diana was killed. Whether the place is authentic or not, is scarcely relevant. Empress Helena's identification of the sacred sites of Christ's life is probably wrong, but that is of little consequence. In Paris an entirely irrelevant memorial, not very far from the site of Diana's death, has become a shrine.[24] Actuality is not important. Indeed, whether there really was an event seems of little consequence either. Loch Ness is a vital heritage site in the Scottish Highlands, the truth of the monster legend being hardly more significant than that of Father Christmas to Rovaniemi in Finland. To concern oneself with the truth of whether Christ visited Glastonbury is to miss the point. The mythical heritage is very powerful, and can be taken quite seriously, though that does not excuse untruthful interpretation. Literature provides many of these sites. The heritage of Bran Castle in Romania is more concerned with being the home of Dracula than any element of reality.[25] Interpretation at such sites can be quite honest in quoting a legend, just as one can interpret an event from a work of literature. The castle at Helsingør is entirely proper in making reference to Hamlet, just as there is no problem in pointing out the place on the Cobb at Lyme Regis where Laura Musgrave fell. The only problem arises when legends and literature are confused with reality.

Heritage sites occur at various levels, not all national. Most of us have places that have been important in our lives, sometimes the place of our first romance, or an accident, or where the dog is buried. They may mean nothing to other people, but they are very redolent of memory for us, and we feel involved in any attempt to make changes in these places. Whenever we are planning new heritage events and signs, it is wise to tread softly, for we tread on someone's dreams.

Indeed, management of such sites is often a matter of layout and interpretation. A particularly good example is that of Lidice, near Prague, the site of a Nazi atrocity. The museum, telling the story graphically, lies beside the car park, but to visit the actual site, with its cross and sculpture, is a 500-metre walk, and to visit the cemetery is at least a further 500 metres. So relatives can visit the graves largely undisturbed by tourists (see Figure 9.8).

Not all sites are of such poignancy; some are merely celebrations of latitude and longitude. Events are organized on board ship to celebrate 'crossing the line' at the equator. At Cabo da Roca, in Portugal, is a marker to indicate the westernmost point of the European mainland, while the line of 0° longitude is celebrated not only at Greenwich, its origin, but at a point on the motorway between Barcelona and Zaragoza where the prime meridian is 'carried over' the road in a bridge. At Greenwich Observatory the sense of history is so palpable and the display so well managed that it is easy to forget that the prime meridian is only an imaginary line, much disputed in its time.

Other sites are lines, not points, and the conservation of essentially linear features is becoming quite popular. In some cases the actual hardware is part of the conservation, so that the Pennsylvania Turnpike is a National

Figure 4.15 Visitors to Greenwich Observatory almost inevitably want to stand with a foot in each hemisphere.

Monument, and Hadrian's Wall is a World Heritage Site, but in other cases it is the line that is important, not the authenticity of the remains. Nature conservationists are very well aware of the vital importance of a network of hedges and tree belts in providing corridors for wildlife. For more mundane purposes the network of footpaths in England is carefully maintained and much fought over. To these have been added long-distance trails, such as the Pennine Way. More recently the Council of Europe have been involved in promoting heritage trails, such as the Silk Route and – much the best travelled – the Camino de Santiago del Compostela.

Interpretation: markers and re-enactment

If the simple way of indicating the heritage significance of a site is the historic marker, which can range from a mere plaque ('Queen Elizabeth slept here') to a major monument, as at Austerlitz or Waterloo, then the more complex way is re-enactment, which can be considered to relate to events and sites much as restoration does to buildings. Re-enactments, usually by committed amateurs, are now significant parts of the interpretation of many sites, especially on castle ruins or old battlefields, where there may be nothing physical to conserve, preferably in the summer when it is warmer and there are more visitors. Considerable numbers of people now spend their spare time dressed up to re-enact the past – most commonly the bloodier aspects of the past – so that war is now a very important part of heritage. Others are members of dance troupes and early music groups, or take part in parades and pageants. Re-enactment (or live interpretation) is often the only way to celebrate the perceived heritage where there are no, or few, artefacts, and its strengths and problems are discussed later.

Project
For this project you will need to concentrate on your local area. Mark on a map the 'sites' of significance. These are places where there is nothing very obvious to see related to the heritage event, but the place is important nonetheless. Some of these may well be 'offical heritage', and memorialized by a marker or a plaque or even regularly re-enacted, but many others will be known only to the local community. Your own family may be able to nominate many of the sites, but older members of the community will also be able to add to them. Be sure to ask people whose voices may not always

be heard – ethnic minorities for example, or school children. There may be battlefields, graveyards, Roman roads, the carnival field, the place where a terrible accident happened or where a plane crashed.

Artefacts

These are the objects fashioned by human beings that form the stuff of museums and collections, public or private. They may be works of art held in galleries or on my dining-room wall, or the raw materials of ethnography, anthropology and archaeology, or the collection of toilet paper referred to at the beginning of this chapter. Many may still be in use, just as the traditional china cabinet contains items for display, and carefully conserved, but also brought out for use on occasion. There are many problems of definition. Objects now displayed as works of art may have had quite different purposes and contexts in the culture from which they are drawn. This can lead to problems that, at one extreme, border on the absurd – as when an entirely mundane object is displayed using exactly the techniques used to display a sculpture. This can be seen, without having to leave our own culture, in any design museum, and suddenly to come across the same kettle or toy car as you have at home, beautifully lit and rotating on a plinth, is quite an unnerving experience, though an important one. At the other extreme, the result can be blasphemous, as when a revered object with great religious significance is presented as if it were merely aesthetic. Indeed, the result of introducing an aesthetic way of seeing can have the opposite effect – it can act as an anaesthetic, removing emotion and meaning. Such problems continue to cause great offence, especially in those countries such as the United States or Australia, where an indigenous culture is displayed in museums organized by, and largely for the benefit of, the colonizing people, though both those countries have taken active steps to correct the position. Even in secular western societies, where most educated people may regard medieval church vestments, for example, as charming examples of lost embroidery arts, the same offence can be caused to residual religious groups. Heritage managers today need to be ever more vigilant to ensure that all the meanings and values ascribed to an object are known.

Museums also contain many objects that are not artefacts, such as specimens of gems and minerals, although whether stuffed animals can be classed as artefacts is clearly open to debate. Equally, not all museums have

roofs, and the discussion as to whether buildings moved to a site are more usefully classed as artefacts or buildings has already been raised. The answer is of less importance than ensuring that developing holistic ideas of Heritage Studies means that such things are not neglected by both parties. Just as gardens are in danger of slipping between the 'landscape' group and the 'monuments' group, so large artefacts can be ignored. This is the case with those artefacts which are mobile, e.g. ships and railway locomotives. Occupying the middle ground between the architectural heritage and the museum curator's heritage they have problems of their own. Most such artefacts were working machines or houses. Successful interpretation demands that they continue to work, or be visited, but that cannot happen without wear and tear and the need to replace parts. Successful curation and conservation presumably demands authenticity which, in turn, clashes with using the vehicle or the machine. The needs of this generation clash with those of future generations, but future generations have no vote.

Artefacts of this kind thus raise many problems of authenticity and restoration, discussed at more length in Chapter 8. Jeremiah takes the view that the problem of authenticity in the motor car collection, the problem of how much of a car has to be replaced before it ceases to be authentic, has resulted in motor cars often being ignored by museums, even though calls for their conservation date back to the nineteenth century.[26] The motor car also admirably exemplifies the variety of interpretations possible. In any collection, context is fundamental. Cars are usually seen as part of the technological revolution, but aesthetic and social interpretations are at least possible. There are gender issues also. It is difficult to disagree with the view that sees most aircraft museums as 'toys for the boys' with precious little emphasis on the provision of services within the aircraft, although that could, in itself, be a sexist position.

Gallery divisions

These issues, and the traditional division within a museum into different galleries, raise fundamental questions about the nature of management and collecting itself. Collecting, and other forms of heritage management, impose pattern on the things collected. The moment the collector places stamps in an album, by country, there is an acceptance that it is the classification by country rather than size, shape or value which is the important feature. The author

once found a remarkable book in a second-hand bookshop concerning the backs of the pictures at the National Gallery. We are so used to the idea that the fronts of the pictures are the interesting elements, that this re-classification came as a shock. In museums, the boundaries between subject areas are most obvious. Geological specimens are in one gallery, probably curated by a specialist geologist, while next door is an art historian looking after paintings or a zoologist with the natural history collection. This division of the field of knowledge into galleries, each belonging to a separate academic discipline, is often taken as quite natural and, indeed, it does represent the original purpose of many museums, to display the physical world for the benefit largely of scholars. However, this is by no means necessarily the only way of dividing knowledge, and probably not the one favoured by local residents – who tend to think of place rather than discipline. New knowledge so often comes about through the re-classification of past knowledge, and there is frequently much to be gained from breaking the boundaries.

Outside the museum there is a considerable extent to which the same principle applies, with the landscape being divided up into myriad heritage designations, each of which is run by people from a particular academic discipline. This issue is considered later, in Chapter 5, but any study of a museum collection should consider the division between galleries as well as the sum of the collection. A museum study should always investigate what is not there on display, and what is not even in the storeroom.

Museums and identity

Some museums take very seriously the business of helping to shape and record the local area and are concerned with showing the products and artefacts relevant to their region, whether that is a town, a country or a nation. This has been condemned by some commentators,[27] but museums inevitably reflect the purpose of their funding agency. The ecomuseum concept, at its most significant in France, is a particular type which concentrates on this element of identity, although Uzzell[28] has shown its importance also in a British civic museum. But the museum, perhaps unlike the national park or the nature reserve, is not ineluctably tied to place, and many museums show material from other regions and countries. Sometimes, especially in the National Museums of imperial countries such as the British Museum or the Louvre, there may well be elements of international hubris in these collections,

and the issues of 'Elginism' or the debate about the repatriation of works from other cultures is discussed further later.

But there are other issues also. Many museums would see an important element of their role as introducing local people to culture from other places. In doing so they consider that they are contributing not only to the townspeople's understanding of world culture – part of lifelong learning – but also to international understanding and peace. The cause of understanding may well not be best served by every museum concentrating exclusively on local artefacts and supporting local cultural diversity and difference. The art collection policy of the Royal Albert Memorial Museum at Exeter was once to collect works by local artists, and a major collection of some significant artists was acquired. More recently the policy has been to collect a work, perhaps not a major work, of every major artist. Both these policies can be defended. The former may be more use to art historians, the latter of more value to local schoolteachers.

Other collections

But artefacts are not collected exclusively by museums. Most humans seem to collect things of little practical value, and for every rich institution collecting pristine models of particular cars for public display in a magnificent hall there are thousands of people trying to maintain an old Citroën or similar vehicle for their own fascination. Each year the South Western Counties' Static Diesel Engine Society's members display 200 rescued engines from the 1920s and 30s in a field. All round the edge of the field little engines with gleaming brass and new paintwork make wonderful noises and smells, and pump water from tank to tank in perpetuity. Someone else displays a collection of implement seats (see Figure 4.16). Every kind of artefact in every country can tell a similar tale. In the heart of Pennsylvania old Cononstoga wagons are collected and displayed in a seventeenth-century farm. Some of these collections may become dignified by the title of museum, but most are for personal interest. They are as much a hobby as a collection. Similarly, most homes have a collection, more often than not maintained by the matriarch of the family.[29] Such collections may not come directly under the control of heritage managers; indeed, their charm is perhaps exactly that these collections are so amateur, but all curators are aware of the amount of material that lies in attics, and the specialist knowledge that lies with it.

Other vast collections of artefacts lie in libraries and archives housing the

Figure 4.16 This collection of seats from farm implements is typical of the ingenuity of so many collectors in finding and displaying artefacts that no-one else thought to collect.

books and documents that are clearly not only heritage themselves but are the foundation of our knowledge about all the other heritages. While being clearly within the artefact category, such material has traditionally been kept by different professions in different institutions. Indeed, in Britain there is a substantial difference between librarian and archivist, and the line between the reference library, the archive and the museum is a very imprecise one. A volume of Constable drawings in the Devon Record Office was eventually handed into the keeping of the Art Gallery, not least because that is where most people would look for it. This is the area where the distinction between the demands of public access and the needs of conservation reaches its sharpest. The whole point of archives is to be consulted, and consultation clearly implies handling of materials that are frequently fragile. But the archivist has to be most rigid in the division between various markets – those who must have access to original and fragile material, and those who can manage with photocopies, transcripts and microfilm. Happily in this case, access to originals can be heavily restricted provided facsimiles are available. This is rather an unusual situation where the casual visitor is determined to see the 'real thing', whereas the scholar is probably perfectly happy working with a facsimile.

Project: a study of collecting policies
Make a list of the collections in your district. Include all those which are 'open to the public'. These will include the local museums, of course, but also collections of old cars owned privately by people who may also show collections at the county show, etc. There are three elements to the investigation: (a) to discover the involvement of official organizations such as the Area Museums Council, local authority, Heritage Lottery Fund etc.; (b) to ascertain the degree of management expertise; and (c) to investigate the collecting policy. Look for cases where the collection could be organized/interpreted for completely different purposes.

Activities

At this point the reader could be forgiven for supposing that we have now examined all the elements of heritage that are commonly organized at official level, as well as the subject of management. This may well be the case, and the last two sections presented here are perhaps mainly a challenge for future heritage management. Four of the five categories so far discussed are concerned with the conservation and presentation of identifiable things, including animals. Even the other one – sites – can be conserved. But there are many other phenomena that people try to conserve, to pass on to the next generation or even simply for their own future, which are about the things we do. Indeed, the deepest cultural identity seems often to be inherent not in objects which can be preserved but in more personal features and cultural traits. Many Welsh people, for example, would place the retention of the Welsh language as by far the most significant heritage campaign. By this they mean a language in daily use; the conservation of great libraries of Welsh texts, of artefacts, is all very well, but clearly secondary to the main aim. Language may be intangible, but some of the features in this category of activities are tangible enough if not subject to simple conservation. In France, food is considered to be an integral part both of the national and of the local heritage, the *terroir*, with *appellation contrôlée* now applied to food as well as wine. Nor are the French the only people to be concerned about drink – perhaps the most successful attempt in Britain to conserve a heritage which was seen to be under threat has been by the Campaign for Real Ale (CAMRA). The success of that organization is now copied in Turkey in an attempt to protect their distinctive coffee from the inroads made by the Italian varieties.

So activities that may become heritage include languages and diet, but there are many others. Sport can be heritage. Indeed, the House of Commons has debated which sporting events should appear on terrestrial television because they are perceived to be part of the national patrimony and more than merely a game. Certainly cricket is perceived by its supporters to be a critical part of the cohesive heritage of the Commonwealth, whereas the success of Euro 96 suggests that football may perform the same role in European terms. Suggestions that the local football club may have to be liquidated because of bankruptcy produce a response that is clearly beyond economic considerations. In many of these cases there may be items of material culture that can be conserved. Manchester United has a museum of its past glories, for example. But it is the activity of playing or watching football that is the heritage, not last year's shirts.

Discussions of religious heritage tend to centre on church buildings, but the religious practice itself – the liturgy – is something the preservation of which concerns many adherents. The debates in the Church of England over the Book of Common Prayer, and in the Roman Catholic church over the Tridentine mass clearly have a considerable heritage element. The argument is rarely that the old is right or is more theologically correct than the new, but that the old has value because it is old. Many feel that performing the rite as it has always been performed gives them a link to the past which is genuinely valued.

Along with religious practice come national holidays and diurnal rhythms. Most countries have different ways of organizing the day or the year, whether school holidays, or the Spanish use of the afternoon break or siesta. Christmas can be regarded as living heritage, the appropriate celebration of which is passed on to succeeding generations. In many Catholic countries individuals celebrate their anniversaries – the saints' days of their named saints – and very large numbers of events are still carried on even though the original purpose, or the religious meaning, has been lost: Carnival and Mardi Gras, the Helston Furry Dance, the carnivals of the Somerset towns (see Figure 4.17), Halloween, Fiesta. Nothing seems so well-worth conserving as a holiday.

People in Britain and in Portugal, both of whom switch to Greenwich Mean Time in the winter months, have even managed to turn the time zone in which they operate into a heritage issue.

With sport and religion we must also link the performing arts. In some cases works of art such as paintings are eminently conservable artefacts, and paintings and sculptures are conserved in galleries and works of literature in

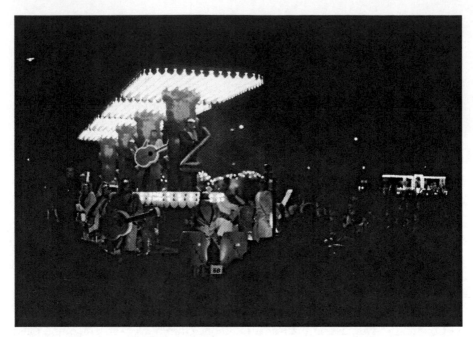

Figure 4.17 The beginning of November is carnival time in the Somerset towns, supported by Carnival Clubs who spend years building the floats. Such fiestas are determinedly maintained as local heritage.

libraries. But music, dance, film and television are also major parts of heritage identity. In some of these areas there is an important distinction, as with the Welsh language, between the physical conservation of the artefacts – the books, the musical scores, the films and video-tapes – and their use in the daily culture. The French government is concerned less for the physical wellbeing of reels of French film, than for the overwhelming of French-language culture by the English language. The question is: How many French films, shown how often and to which audiences?

Discussion of the arts is another reminder that there are several levels of culture between which snobbery is perhaps inevitable. In music, for example, we need to be clear whether the British musical heritage is composed of Vaughan Williams, Purcell, the Promenade concerts, Cecil Sharpe's collection of folk melodies, morris dancing or the Beatles and the industry surrounding their memorabilia – or all of these? And, then again, is the British musical heritage to be limited to British artists and composers? Is Mozart to be returned to Austria and jazz to America? Should concerts by foreigners be banned, or are Mozart and jazz the common heritage of all people? The heritage of folk dance and folk music may be threatened as much by

globalized high arts as by apathy. A recent study of the *sardanha* in Catalonia has shown that two factors have been responsible for the decline in this local dance.[30] Not so long ago it was a normal feature of Saturday evening in the village square. Then, visiting tourists would be invited to join in. This meant that no-one improved, because every week one had to start from scratch for the latest group of visitors. However, equally destructive was the enartment of the *sardanha*, which is now performed by professionals at concerts in Barcelona and abroad. This professionalization has been equally effective in removing the dance from its local adherents.

Many other activities would have to count as hobbies rather than as sports, but they are nearly all of enormous importance to someone. Gardens are conserved, though there are all sorts of difficulties along the way, but many people are much more concerned to conserve the activities, the hobbies, of gardening, pigeon-fancying, angling, a dialect or rambling. As has been shown in recent debates many people are prepared to become very involved in a campaign to preserve or enhance their right to walk in the countryside rather than the state of the countryside itself. There is much concern about the state of craft activities such as embroidery or carpentry. The concern is much less for the quality of such work, for artists and craftspeople ensure that the very highest standards of workmanship and aesthetics are continued and enhanced; rather, the concern is with the disappearance of such activities by the many and their restriction to a few crafts specialists. Wonderful knitwear is still produced, but the number of knitters is much reduced.

Conserving activities – a challenge

The great challenge, which began in the nineteenth century, of setting up systems to conserve and, later, interpret the things, landscapes and buildings that we care for has been partly achieved. Not that all such things are conserved, but we largely know how to do it. This is far from the case with activities. Despite occasional beacons, such as CAMRA, or the nurturing of Welsh or Breton, or the many displays and classes in patchwork and other old crafts available in many countries, the techniques are still highly debatable, often unsuccessful and, of course, divisive. The challenge for the twenty-first century may be to conserve those ways of life that we treasure, and to do so without killing them, pickling them and displaying them in a glass case. The

Figure 4.18 In the main square of Oslo the fishing boats nose up to the quay, and people can buy their fish and shellfish direct from the boat, in the middle of their capital city. Such activities are often more precious heritage than many more concrete elements.

developments of the folk museum and, more especially, the *ecomuseé* in France have been a determined attempt to preserve activities along with artefacts, and to do so at a local level. However, they have usually failed to overcome the problem of self-consciousness, and many find activities that become 're-enacted' to be quite unsatisfactory.

Some past activities we may have no wish to retain: hunger riots or pogroms, for example. But many regard handing on the ways of life to future generations as a way of improving their choices. The methods by which this can best be done will certainly include the specialist society, the use of the media and the internet, systems of quality control, evening classes and annual displays. It is quite a challenge for the heritage manager.

Figure 4.19 Visitors to the island of St Martin's in the Isles of Scilly were, in the mid-1980s, greeted by an array of signs in the hedge at the boat landing which were the result of lots of decisions by different residents attempting to promote their services, each in competition with the other. The result is not very controlled and some find it very poor design. Clearly, it could be done so much better and more economically. One can catch the boat to Tresco, an island under single ownership, and see a designer's hand. This is much tidier, more efficient and more comprehensible. It is also much more self-conscious, and one feels immediately that one has reached a commodified Tresco experience quite different from the casual chaos at St Martin's. This is not the fault of the designer, but of the nature of design.

Project

Examine the heritage of activities in your locality. What clubs are devoted to saving heritage of this kind? What events take place during the year? What evening classes teach 'lost' arts? Which choirs and bands are keeping alive the musical tradition? Which sporting teams are engaged in heritage events – the local derby match or the New Year race meeting? What percentage of the community is involved in organizing such things? What percentage spectates?

People

This final sector, the heritage of people, may be the root of all heritage values – the fight against mortality. The first things we rescue from the burning house are ourselves and other people. It can certainly be argued that the conservation of buildings, artefacts, activities and all the other elements is merely a surrogate for our inability to avoid death and, thereby, to conserve ourselves. This relation between people and mortality has been studied in depth by Lowenthal.[31] We want to save ourselves and our family and friends. The whole sex drive can be interpreted as the need for immortality, perpetuating ourselves through our genes. There is not likely to be any shortage of people prepared to be cloned. Through the laws of inheritance we attempt to achieve the vicarious immortality of our family. At all levels of heritage, from the familial to the international, and in all countries, people are cherished. The concept of founding a dynasty, the target of so many rich people, may be inherently a heritage concept, of controlling the inheritance, of passing on to the children not only the genes, not only the house and the garden, but also the title. We can look to the shelves of literature to see the significance of family roots and ancestry, certainly in European countries, over many centuries. The marriage between new money and ancient lineage is the stuff of many novels. However, an interest in one's ancestors is no longer restricted to the old world, nor to the aristocracy. Genealogy, the search for a personal heritage, is now a major concern in America as well as Britain, among the poor as much as among the rich.[32]

The Duke of Bedford, one of the first British aristocrats to open his house, Woburn Abbey, to the public, has written about the enterprise with great humour and a depth of experience only too obvious.[33] He soon discovered that he and his wife were essential parts of the heritage being conserved, and that

many visitors were much more impressed to see or meet a real duke and duchess than any of the buildings or their contents.

City councils make local dignitaries freemen. Twice a year, at New Year and the Queen's birthday, the British government announces those people who are to be considered heritage in varying degrees – those who are more worth preserving than others. Obviously, there is a mortal limit on the conservation of people, except perhaps for Lenin and Jeremy Bentham, but the honours system is in other ways a close parallel to the designation system for more permanent monuments. In Japan, people – especially great artists – can be designated as living national treasures. Decorations for gallantry, *légions d'honneur*, may also designate heritage people, even posthumously. Indeed the existence of the posthumous award clearly brings the whole area within the field of heritage, of things (in this case memories) conserved as lessons for the present. What the honours lists also demonstrate is the huge gap between the people whom governments think should be honoured and those favoured by the general public. The media, of course, have their own agenda, as television obituaries make clear.

Many of the most treasured heritage possessions have little significance or value in themselves, but they represent some lost relative or friend. The author treasures the breadboard from one grandmother and the water jug from the other. So many places are regarded as significant not because of what they are but of who owned them or lived there. In treating Hardy's cottage or Shakespeare's birthplace as shrines, this has little if anything to do with vernacular architecture. A black cowboy hat has recently fetched $8000 in an auction, bought not by a hat collector but by a fan of Yul Brynner, who wore this hat in the film *The Magnificent Seven*. So many items are significant not because of their intrinsic value (though that concept itself is far from simple) but because of their association with the famous.

These famous are a mixed bunch. There are saints, of course, the cult of relics being one of the origins of the heritage industry, some of whom were given special status as patron saints of countries or activities. Perhaps an earlier age had a system for the protection of heritage activities through the nomination of a saint. Music was safe so long as St Cecilia was there. In addition to saints, there were heroes, from William Tell to Nelson. Such heroes often had important national or regional roles, and their exploits were more important than their character. Indeed, the story of their exploits was more important than their actuality. Their private lives often did not bear close scrutiny (as in the case of Vlad the Impaler in Romania), neither did their

public lives. They were soon surrounded by myth, and the truth behind the myth soon ceased to have much importance. Whether Robin Hood existed or what he actually did become questions of little significance, but many Nottinghamshire people owe their income to him. Twentieth-century historians have taken great pleasure in debunking every hero; by so doing, they demonstrate only a hazy understanding of what heroes are for.

More recently, in times which are more secular and cynical and dominated by mass-communication, such saints and heroes have become replaced by victims and celebrities, and a few people manage near-canonization by falling into both categories, the most famous case being Princess Diana. Here is a world which considers returning the bones of some slaves who lost their lives in a shipwreck on the north Devon coast to St Lucia, from whence they may have come. The National Maritime Museum had an exhibition of relics from the *Titanic*, but the obvious fascination for huge numbers of visitors was not with the very ordinary array of objects salvaged from the wreck, but the fact that they had been the property of the victims.[34] Many artefacts, in effect, reflect their owner, much as do saints' bones. They are within the people sector just as much as the artefact.

Death and commemoration

People are the most obvious case of the heritage object having a limited life, but not the only one; animals and plants die, buildings rot away to ruins, languages change and sometimes disappear, as do religious practices and folk customs. The concept of heritage loss is discussed in Chapter 7, but here we should note the problems inherent in designating as heritage those features that are obviously mortal. In the UK there are Tree Preservation Orders, which are obviously of finally limited value, while zoos often have to face the public with the loss of their exhibits, as with the penguins at Winchester who all died in 1999.

Apart from delaying death, heritage commemorates its failure to do so. The dead are remembered in obituaries, in statues and in memorial services. War memorials name the dead, graveyards erect memorials, houses sport plaques to former inhabitants. Commemoration is often the alternative to conservation, and many heritage debates are between these two options. We can demolish the building but leave a memorial. We can develop this landscape for housing but we can leave photographs of it in the local museum. The fear of

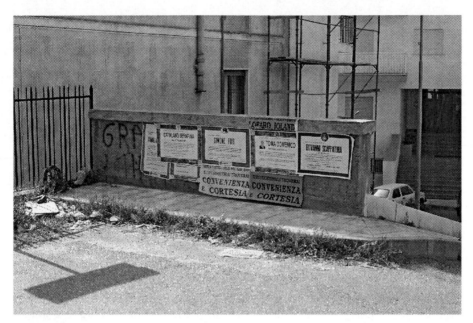

Figure 4.20 In Italy, here in Calabria, it is normal to commemorate and announce someone's death by posters in the street, as well as by photographs on the graves.

museumization represents the anxieties of those who would conserve a particular place or thing, who see it being commemorated instead. So Welsh folk tradition may be dead, but is remembered, rather than conserved, at the Museum of Welsh Life at St Fagans.

Conclusion

In this account of seven sectors of heritage, one major development has been left untouched. Heritage centres are now big business in many areas, especially those with a tourist industry, and those which would like to have one. At one extreme they merge into theme parks, from which they can be distinguished by their concentration on education rather than entertainment as their driving motivation in their publicity material.

At the other extreme, some of these places even call themselves museums, though they differ from regular museums in having few if any authentic artefacts. Of course, there are now many museums that have whole galleries that are more like heritage centres (e.g. the Exploratorium) and there are theme parks that include elements of a museum. Flambards in Cornwall, for

example, includes a Second World War display which is clearly the product of personal enthusiasm as much as of a wish to entertain or to educate. Such heritage centres are often place-specific, but include many of the aspects discussed in this chapter. It may be that academics and educators divide the world into 'nature' and 'culture', 'buildings' and 'artefacts', but outside the classroom this division is less obvious, and a holistic picture of 'this place' or even 'that time' is preferred.

The potential manager of an element of the heritage may well be shocked to discover the range and complexity of the job. The discussion of the sectors of heritage has two benefits. The first is the realization that there are so many problem areas, so many things which fit into more than one category and so many which do not fit comfortably into any, that however useful such a division may be in raising debate and examining the issues, it is of little value in organizational terms. Such a system must never be allowed to become a set of divisions for the purposes of conservation or interpretation. The worst thing would be to have separate ministries or departments, separate quangos responsible for each sector. That would be a recipe for confusion – for several important areas of heritage having no home, while authorities squabbled over responsibility for others – and would leave no chance of sensible priorities being adduced where a site possessed heritage elements in more than one category. Unfortunately, that situation is exactly one that exists in the United Kingdom and in most European countries. The United States can look with some pride at the common base of the National Park Service, but in their universities Cultural Resource Management is usually distinct from Natural Management, or even from Historic Preservation. There are non-governmental organizations, such as the UK's National Trust, that recognize no such divisions and operate quite happily across all of them.

The second major finding must be the way in which the same questions crop up in every area of heritage: Shall we allow public access even though that compromises preservation? Which story shall we tell? Whose heritage is to be conserved and whose ignored? At whose expense? Shall we stress international, national, regional or local identity? How do things become heritage? Should we display this in the context of its original place, even if that means repatriation? Can we adapt the heritage for new uses? How shall we route visitors around this site? Which kinds of visitors are welcome?

To divide heritage up into separate academic disciplines is a sure recipe for lots of reinventions of the wheel. Each discipline will debate the same issue within its own field, with precious little reading of the work from other

Figure 4.21 Some things seem to have an obvious heritage sector, but it can usually be questioned. Broadclyst village church is a monument, of course, but it also possesses some very fine artefacts, such as vestments and silver, and some fittings that might fall into either category, such as the organ. It is also home to liturgical practices, which some members may wish to retain, and to the ancient art of bellringing – the heritage of activities – while there are barn owls in the tower and lichens on the walls. Outside are the graves of some important people, including the Veitch family of gardeners, and all the dead are, of course, of great importance to their relatives. So the simplest piece of heritage is found to spread into five of our seven categories, without mentioning that this is also the site of the sacking of the village by the Danes a thousand years ago.

disciplines. Questions of public access, for example, are remarkably similar in nature reserves, archives, houses and museums, but the articles published within each area make little reference to work in the others.

The existence of theme parks, heritage centres and of Civil War re-enactments may also serve to remind us that the idea of heritage, the concept,

is abstract. Ashworth would go as far as to claim that the message is the heritage. The heritage is not the building, for example, but the plaque on it, the guidebook written about it and the entry in the register. Since everything that exists, and indeed everything that has ever existed, could be claimed by someone to be heritage, the only way to recognize it is by its interpretation. Something becomes heritage when it has a label. Indeed, at some sites it is quite obvious that even nothing can become heritage, provided it has a label.

Seeing heritage as a vast field, natural as well as cultural, at first seems to claim the entire world (and indeed beyond, in both a literal and metaphysical sense) as being within our scope – and so it is. The same is true of both geography and history. Unlike most disciplines which define themselves by their subject matter, geography studies all phenomena in their context of place, whereas history studies them all in their context of time. Heritage, equally, has, potentially, all phenomena within its purview, but it is concerned with how they are conserved and managed for the purposes of the present and the future.

Project

Visit a complex heritage site, such as a country house estate or a national park, an outdoor museum or a cathedral close, and list the heritages which are being conserved there. What organizations are involved? Does one sector dominate the others? For whom is it being conserved?

NOTES

1 G. Ashworth and P. Howard, *European Heritage Planning and Management* (Exeter: Intellect), 1999.

2 M. Afshar, 'The ecology of conservation: the medium, the message and the messenger', *International Journal of Heritage Studies*, 3(2), 1997, 109–15.

3 J. Sheail, 'Landscape and nature: the great divide', *Landscape Research*, 13(1), 1988, 2–5.

4 S. Grant-Branca, 'England's National Trust Holiday Cottages Scheme: a model for saving America's crumbling "parkitecture"', University of Plymouth, unpublished dissertation, 1996.

5 D. Worster, *Nature's Economy: A History of Ecological Ideas* (Cambridge: Cambridge University Press), 1994.

6 S. E. Larsen, 'Is nature really natural?', *Landscape Research*, 17(3), 1992, 116–23.

7 H. D. Thoreau, *Walden, or Life in the Woods* (Cambridge: Riverside).

8 K. Page *et al. Earth Heritage: Site Interpretation in England*, English Nature Research Paper No. 176 (Peterborough: English Nature).

9 For the text of the World Heritage Convention see < http://www/unesco/org/whc/nwhc/pages/doc/main.htm >

10 L. Rival (ed.), *The Social Life of Trees: Anthropological Perspectives on Tree Symbolism* (Oxford: Berg), 1998.

11 D. Lowenthal, *The Past Is a Foreign Country* (Cambridge: Cambridge University Press), 1985.

12 Worster, *Nature's Economy*.

13 P. Mason, 'Zoos as heritage tourism attractions: a neglected area of research?, *International Journal of Heritage Studies*, 5(3/4), 1999, 193–202.

14 J.-R. Pitte, 'The conservation of parks and gardens in France', *Landscape Research*, 12(2), 1987, 10–12.

15 R. Shipley, 'Heritage designation and property values: is there an effect?', *International Journal of Heritage Studies*, 6(1), 2000, 83–100.

16 Cambridgeshire County Council, *Cambridgeshire Landscape Guidelines: A Manual for Management and Change in the Rural Landscape* (Cambridge: Granta), 1991.

17 P. Fowler, 'Cultural landscapes of Britain', *International Journal of Heritage Studies*, 6(3), 2000, 201–13.

18 D. Meinig (ed.), *The Interpretation of Ordinary Landscapes: Geographical Essays* (Oxford: Oxford University Press), 1979.

19 Afshar, 'The ecology of conservation'.

20 A. Orbasli, *Tourists in Historic Towns* (London: Spon), 2000.

21 G. Ashworth, *Heritage Planning: Conservation as the Management of Change* (Groningen: Geopers), 1991.

22 E. Ennen, *Heritage in Fragments: The Meaning of Pasts for City Centre Residents*, Nederlandse Geografsche Studies, No. 260, 1999.

23 L. Young, 'Museums, heritage and things that fall in-between', *International Journal of Heritage Studies*, 2(1), 1997, 7–16.

24 A. Phelps, 'Locating memorial: the significance of place in remembering Diana', *International Journal of Heritage Studies*, 5(2), 1999, 111, 120.

25 A. Muresan and K. A. Smith, 'Dracula's Castle in Transylvania: conflicting heritage marketing strategies', *International Journal of Heritage Studies*, 4(2), 1998, 86–102.

26 D. Jeremiah, 'The motor car from road to museum', *International Journal of Heritage Studies*, 1(3), 1995, 171–9.

27 J. Bradburne, 'The poverty of nations: should museums create identity?' in J. M. Fladmark (ed.), *Heritage and Museums: Shaping National Identity* (Shaftesbury: Donhead), 2000.

28 D. Uzzell, 'Creating place identity through heritage interpretation, *International Journal of Heritage Studies*, 1(4), 1996, 219–28.

29 S. Pearce, 'The construction of heritage: the domestic context and its implications', *International Journal of Heritage Studies*, 4(2), 1998, 86–102.

30 A. de Mentaberry, 'Sardanha', unpublished BA dissertation, University of Plymouth, 1996.

31 Lowenthal, *The Past Is a Foreign Country*.

32 S. Taylor, 'The heritage of people'. Unpublished dissertation, University of Plymouth, 1996.

33 John, Duke of Bedford, *How to Run a Stately Home* (London: Deutsch), 1971.

34 S. Deuchar, 'Sense and sensitivity: appraising the *Titanic*', *International Journal of Heritage Studies*, 2(4), 1996, 212–21.

5

Selling Heritage

SUMMARY

Those who want heritage, who are the purchasers, either by the expenditure of financial capital on heritage, or by expending cultural capital, can be usefully divided into six groups. These are: the owners; the insiders; the outsiders or visitors – a group which includes tourists but many others also – government at many levels; academics in many disciplines; and the media. Many of us belong to various groups at different times, and motivations for acquiring heritage are very varied.

People who are prepared to devote time, money and effort to heritage want different things from it, including legitimation, cultural capital, identity and, sometimes, financial reward or just a living.

Many of the people, amateur and professional, who are lovers of heritage, however they choose to define it, and who may spend prodigious amounts of time and money in conserving it and even interpreting it to others, become defensive at the idea that heritage is a product or a service, and that like all such products and services it is called into being by the market-place and has a price. No doubt in Britain such defensiveness is partly a result of the disdain for trade that has long been a hallmark of the class system – and it still lingers. Also, many people are uncomfortable with the idea that their hobbies may be commercial products or services; they will deny any interest in the commercial value of their stamp collection, for example. Indeed, the hobby may be their means of relaxation or their way out of the rat race. Both culture and nature are frequently regarded as being beyond price – despite the apparently healthy state of the art market, and the high prices paid illegally for birds' eggs. Nevertheless, the notion of heritage as being for sale, with the consequent need to analyse its markets and its consumers, as well as its producers, is a remarkably useful concept, and a liberating one, in that

many of the apparently inexplicable debates of heritage conservation become lucid when seen as competitions between different markets with different uses for the product.

Heritage products and services may take many forms, from something as apparently uncommercial as a Site of Special Scientific Interest to a piece of furniture put into an auction house, or even 'collectables' specifically manufactured to be traded. The extent to which 'collectables' can be regarded as heritage clearly depends on their success, both as themselves and as surrogates for the real thing. Most postage stamps may, these days, be manufactured for collection, but there are still many serious collectors as well as a healthy market. As long as someone is having to invest their labour or their capital in the conservation and promotion of the heritage, then it can be seen as the result of a marketing process, and usually one that is multi-sold, that is the same product has a variety of markets.[1] The demand for the product by one market group may be quite different to others, and it is the inevitable clash between such different market groups that causes most heritage problems, and its fascination for others. Typically, of course, a market group with money, such as the tourist or the owner, is faced by a market group that, having little money, has to make its claim on the basis of moral rectitude, such as local people or academics. The ownership of land, for example, is countered by the moral assertion that 'This land is our land.'[2] Much of the material which follows could be couched in terms of 'stakeholders' rather than markets, but the latter phraseology, which puts exchange at the front of its thinking, is probably more useful for the manager. Certainly each group, or market segment, expects to pay for the heritage in which it is interested, in terms of time if not money. Governments can form an exception to this, by using legal powers to manage the heritage, rather than by financial involvement – though there is often plenty of that too. Export restrictions and building lists exemplify the use of authority rather than money.

Each of the broad categories of market in this chapter's classification has many sub-groups within it, which also often compete with each other. Heritage meanings and values are not only severely disputed between both the broad categories and the sub-groups, but also between individuals. The archaeologist who would seek to protect a stone circle from the hands of tourists, for purposes of research, is not necessarily beyond being a tourist elsewhere, or even being a druid at the weekend. The idea that there are specific groups who are heritage-conscious and others who are not is usually a result of defining heritage too narrowly.[3]

The benefits which each of these groups hopes to achieve from heritage have been broadly divided into three by Ashworth and Ennen. They can be socio-political, cultural or financial. A city council might begin a programme of heritage management because it wants to legitimate its own authority and boundaries, or to appear cultured in the eyes of other cities or central governments, or because it believes that extra revenues will accrue to the city by so doing. In most actual situations, of course, these motivations will be hopelessly intertwined.

Table 5.1 Heritage markets

Owners	Especially in built heritage and artefacts. Can include governments and organizations. Drives up market (gentrification). Concerns of privacy, security, finance.
Outsiders	Includes tourists, but also day trippers, educational visits, pilgrims, connoisseurs, all with different agendas, which don't mix well. Concerns for access and interpretation.
Insiders	Concerned particularly with activities, with sites and with people. Long-settled locals and club members. Concerned for access but also to exclude outsiders. Often oppose interpretation and pricing. Concerned with person- and event-related histories.
Governments	Primarily fund nature, landscape, built heritage and museum sectors. Levels of government often compete. Concerned for legitimacy and prestige, to show similarity within area and difference from others.
Academics	Often 'discover' heritage. Disciplines establish hegemony over types of heritage. Lack resources, so advise governments. Concerned for authenticity and conservation.
Media	Old agenda for 'newsworthiness' now joined by visual value for films etc.

Owners

Heritage is deeply concerned with ownership, and the root concept of inheritance is fundamentally a legal device for the transfer of ownership. A century ago 'heritage' only referred to property transfer, and the French word

heritage still has only this meaning. Despite this, the role of the owner in the heritage business is very often overlooked; certainly there are works concerned with building conservation where the owner of the property scarcely makes an appearance, presumably because they are written by and for public sector conservators whose interest is in buildings not properly maintained by private sector owners. A very large proportion of heritage is owned, much of it specifically for its heritage value. Artefacts are nearly all owned, even if the owner is a museum, and the same can be said for buildings. Land is virtually all owned, and this includes sites. The land on which nature is conserved inevitably belongs to someone, as does the land within national parks and other landscape designations. Where such ownership does not exist, as, for example, in the case of marine nature reserves, or wrecks, another raft of even more difficult questions arises as various heritage interests compete. Such complex questions of ownership are now frequently in the headlines concerning the most fundamental heritage of all – our genes, which, it may turn out, do not belong to us after all.

Some property is owned specifically for its heritage value, and such owners, whether private individuals or organizations such as the National Trust, or governments, might regard themselves as a separate category, but, in reality, all owners face the complex array of problems that arise from competing uses. The heritage manager is often dealing with owners who do not quite fit within business management criteria. Frequently, profit is not a primary concern, and many of the personnel are family members. So heritage owners can only occasionally be compared with business managers.[4]

The designation of land for nature conservation, e.g. an SSSI or a Biosphere Reserve, has not traditionally been likely to increase the market value of the land, so that the heritage value is an economic disbenefit. But this situation may well be changing quite drastically in many parts of Europe, at least, with agriculture becoming less profitable and leisure businesses more so. In the case of landscapes, national parks etc., there is more likely to be a heritage benefit, so that the land is worth more after designation, though often for different reasons. Occasionally the heritage value of the site may be vastly greater than any other value, as with Land's End, where its value merely as a piece of agricultural land on a clifftop is completely overshadowed by its positional value. There is no doubt at all that, in Britain at least, a plot for development within a designated area carries a premium compared to one outside – though this is much more questionable in other countries.[5] Designation may, therefore, result in considerable changes of ownership, as

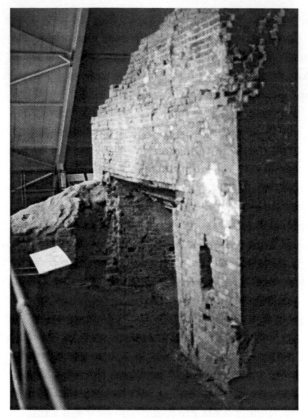

Figure 5.1 The value of this site at Coalbrookdale lies almost exclusively in its heritage significance, for this was where Abraham Darby first smelted iron with coal, and it is a World Heritage Site.

the property is used for different heritage purposes, so that land within an upland national park, without planning permission, may fetch more as land for 'hobby farmers', weekend cottage-dwellers etc. than for its agricultural value. Gentrification is often an inevitable consequence of heritage designation.

Motivations for ownership, as for visiting, are nearly always complex, and ownership brings its own trials. These are the people, above all, who pay for conservation. The amount of public, taxpayers' money going into building conservation is a tiny fraction of that paid by the owners of such places trying to keep the roof on and the place in good repair. On almost every occasion, it seems, the acceptable repair from a conservation perspective is not the cheapest functional option. There seems to be a presumption in much writing about heritage, often in the detail of the legislation, that all owners have but one purpose which is to maximize the financial benefit of the heritage to

themselves. While lawyers, in drafting legislation often intended to prevent owners doing whatever they want with their property, must reasonably make this assumption, for such owners undoubtedly exist, they seem generally few and far between. Most owners have a complex of motivations which have at least three quite different strands, financial benefit being one, heritage values being another, while a third is compounded of different cultural and familial values.

Financial benefit, or at least the minimizing of financial disbenefits, is obviously significant to those bearing the costs. There are certainly some occasions when heritage is held for these reasons alone, the most obvious being the works of art held in bank vaults, perhaps by pension funds. Whether such items can properly be called heritage at all, accessible only by the owner, would be a complex semantic point, although they are certainly latent heritage, and could become real heritage by being displayed or sold. Most owners of works of art, however, radiate a real fascination for the things they collect; they are not only collectors but connoisseurs and their collection is a hobby as well as a hedge against inflation. Of course, they may not be very enthusiastic about increasing access – of inviting visitors to see the heritage – and may well take the view that this heritage is 'theirs' and object quite strongly to the notion that other people who have not paid for its purchase or upkeep have some right to it. There is no doubt that increasing access brings significant costs, to minimize wear and tear, and for security, even if no interpretation is undertaken.

Private property owners, too, will keep an eye on the sale value of the property, though this may not apply to buildings in the public domain or in trust. Generally, a private owner will attempt carefully to protect or enhance the heritage appearance of the house, while retaining or installing modern conveniences and at minimum cost. So owners may well prefer to make new additions and alterations as a pastiche of the original style, rather than as an obviously modern intervention, believing that this is more saleable. Most non-experts seem to prefer an apparent authenticity of style rather than one of materials – a Viollet-inspired restoration rather than a Morris-inspired repair. Some new conveniences will be regarded as essential, such as a modern kitchen in a world where labour is expensive, and few owners would tolerate a refusal to install electricity or central heating, despite the fact that central heating may well be detrimental to many old building materials. Older properties had their own balances, and in granite areas the threat of radon is very much less in those old houses still full of draughts and ill-fitting windows

Figure 5.2 The roof of this listed property is being repaired using similar slates to the original, but the guttering is now plastic, painted to resemble the original cast iron.

than in those which are hermetically sealed – especially if the latter are opened only at weekends. The most common modernization dispute is about television aerials. Owners, too, will prefer lower-cost materials where possible. A typical argument concerns guttering, where the cost of plastic is about 10 per cent that of cast iron. The owner will probably opt for the former on the grounds that it can appear similar while saving money. The expert, usually wedded to concepts of authenticity of materials, will usually prefer the latter.

Not so long ago it might well be assumed that the owners of heritage, whether castles or mansions, or even churches, were themselves wealthy. As the definition of heritage has shifted to embrace the cottage and the prefab, so the heritage owner may be someone of very modest means, who may well be very tempted to sell property to those of greater means. In the case of the old-car collector, there is a whole range of incomes involved, from the collectors of veteran Rolls-Royces to those carefully maintaining a Ford Cortina. This process may have no end, with the rich constantly buying the property of the poor, but perhaps it owes its main significance to the growth of the middle classes. There are so many more 'comparatively rich' people these days, who can afford to spend money on property and who are very conscious of the prestige and fashion value of what they buy.

Some motivations for owning heritage are clearly heritage-related. The most obvious is prestige, the cultural capital discussed in Chapter 3. This can be demonstrated as much by a company buying a fine old building for its head office, as by an individual collector hanging works around the walls of his eighteenth-century house. The Duke of Bedford, in his outstanding guide to opening a country house,[6] admits that his least favourite visitors are the art connoisseurs who know vastly more about his art collection than he does. Needless to say, such snobbery fades easily into much more defensible attributes, such as self-respect, or healthy competition. Many of the flowers we now have were bred to laid-down standards of perfection at the competitive shows of florists' flowers in the nineteenth century,[7] and competition is surely one of the roots of improvement in much heritage, from rare breeds of pig to the Eurovision Song Contest to best-kept village. The very designation itself now becomes a prize in such competition, so that the listing of one's house becomes a goal in itself, perhaps equivalent to the person who works for charity primarily with a view to the acquisition of an OBE.

Owners, though, have other functions for their heritage. The wonderful painting might be hiding a damp patch. This is most obvious in the case of land and buildings. Only for very few parcels of land (perhaps a few gardens) and very few buildings (museums and some conserved public properties) is the heritage function the only or even the most important one. Most land is farmed, most houses are inhabited and most churches are used for worship. These provoke the most common disputes. The house needs a new kitchen; oil-seed rape may look unpleasant but is showing a good profit this year; sheep have traditionally kept the grass short, but they are no longer profitable; we have changed the style of Sunday service and we now need a stage and not a pulpit. Even strict heritage values may conflict with each other. The Stradivarius violin is at risk outside the bank vault, but only by being played can it give pleasure.

This is no place to enter into a long discussion of the art market, but clearly this is an area that baffles outsiders. The practice of the limited edition, which makes practical sense with an engraving, as the plate wears with use, has no meaning in photography other than to improve the price. Then there is the painting, where modern authority finds that the original attribution has changed and it is no longer to be regarded as by a great-name artist, and it becomes more or less worthless overnight. Similarly, 'art' attracts prices. Once an artisan or craftsman can be recognized as an artist or designer, the price of the product increases dramatically. No longer is he one

competitor producing, for example, wrought iron gates; he becomes a monopolist, with a monopoly over goods bearing his name, and therefore can charge monopolistic prices. Rarity rather than quality becomes the primary aim: artists are therefore worth more dead, unable to do more work; stamps are much more valuable with a rare printing flaw; the price of old records is enhanced if they were cut by a minor record company for the underground music scene. The buying and selling of heritage takes place just as much at the car boot sale as it does at Sotheby's, and in all this, of course, the heritage expert acts as authenticator and is deeply involved in the scholarship which has a direct bearing on prices.

The property market is probably a less confusing market for those not involved in the esoteric practices of the auction world (or indeed the world of the car boot sale), especially as far as domestic buildings are concerned. A study in Ontario has shown that although heritage status does generally add a premium, this is far from being the universal case. Large, derelict buildings, however well designated, cost a great deal more to restore than a new building of similar size, and hence can sometimes be purchased for nominal sums. The stricter the rules about restoration the greater the costs are likely to be. The

Figure 5.3 Poltimore House, Devon. A ruined listed building of virtually no value. Any future use for the building is bound to depend on a careful balancing of conservation requirements with changes needed for any practicable use. The more stringent the demands, the more difficult it is to find an end user.

problem of research here is very great, as it is impossible to find two identical buildings in the same place with different heritage designations.

Disputes

Ownership is often disputed; if it were not then lawyers would be less needed, and possibly less wealthy. First, there are the problems of security. Thieves have targeted heritage items for many years; most of the Egyptian tombs were robbed many years before they were opened by professional archaeologists, and their contents removed to 'safe-keeping'. There is a constant balance to be struck between the need for security and the need for access and safety. The bank vault has its attractions, and owners of houses open to the public may have some justification in presuming that some of the visitors coming to view may have other intentions and be planning a later visit, perhaps at night. Such activities *are* theft, of course, but there are many areas of endeavour where the legalities are much less clearly defined. The law of treasure trove in the United Kingdom attempts to deal with found objects, and there are many operators of metal detectors who are interested in converting such objects to their own profit. The ownership of such things lies with the landowner unless it is reasonably assumed that the goods were stored with the intention of returning to collect them. In that case, ownership is vested in the state. The underwater maritime heritage is even more disputatious, and not all finds eventually end up with legally constituted authorities. In 2001, the UK government announced an amnesty on items collected from wrecks by divers, a clear admission that it was a problem area.

More common still is the situation where the current *de facto* owner's claims are based on acquisition in ways that may be considered illegitimate or immoral, or where the trade is not fair. Such disputes are the very stuff of Elginism, so called due to the long-running claim by the Greek government to have the marbles from the Parthenon in Athens restored to Greece. This is dealt with at more length in Chapter 8.

Owning organizations

Ownership brings responsibility and the need for management and maintenance. The host of non-governmental organizations discussed in

Chapter 3 can be usefully divided into those that own heritage and those that do not, but who act as pressure groups or interest groups. Organizations which own substantial properties, such as the National Trust, find it difficult to campaign on single issues because they are obliged to make all the compromises that management of their estates necessitates. Properties have to be maintained, gardens tidied, drains kept clear and the roof water-tight. Such organizations can give the appearance of being resistant to new ideas. They tend to live in a constant state of crisis. But they demonstrate a practical understanding of real-world issues often lacking in pressure groups with a single interest. On the issue of access to the countryside and footpaths, for example, the NGOs which own land are bound to take a pragmatic position. They will incur the costs, and the risks, as well as reap the benefits.

Before we take leave of the owners of heritage, we should note that the heritage debate is persistently couched in terms of ownership, or a form of quasi-ownership. The possessive pronouns 'my' and 'our', 'theirs' and 'yours' are constantly deployed. Sometimes these relate to legal ownership, such as 'my stamp collection', but often the terms are employed to indicate a kind of stakeholding or wishful possession with little basis in law. We still expect to refer to an artist's work long after it has been purchased by others. 'My book' may mean a book that I wrote, not one that I own. This is equally the case with 'my place', which may occasionally refer to an area of ownership, but more often to a right asserted through residence, even if that residence ceased many years ago. 'This land is our land', asserted a book on England's countryside, an assertion of democratic ownership that would be disputed by the legal owners of the land. Such assertions also reinforce group identities with their consequent exclusion of others. If 'this land is our land', who are 'We'? If it is all members of this nation, it presumably excludes others, so I have a right to walk over farmland but a foreigner does not? The difficulties of family inheritance are made abundantly clear in the divorce and probate courts. Wider heritage is no less complex.

Owners, then, are not only major stakeholders but they also represent a massive market for heritage. The fact that they are often excluded from the debate to an extent reflects their importance; so many heritage issues reported in the press, which concern government agencies and private organizations, involve the championing of someone else's rights over and against those of the owners. Most heritage legislation is a diminution of owners' rights to do as they please with their property, and the fact that property rights are deeply embedded in western democracies has meant that such legislation was a long

time coming, and was constantly fought. We can now turn our attention to some of those groups that want to acquire heritage rights that are not legally theirs.

Exercise: interview
Research into heritage management necessitates quite sophisticated interview techniques, and other means to discover people's needs. This involves a particularly delicate interview of a private owner of substantial heritage (probably a house). They will not wish to discuss the financial implications of their ownership, but may be prepared to discuss what it means to them, their motivations, the benefits and burdens. Although a questionnaire can sometimes be a useful starting point, this is qualitative research of a more flexible kind. Very careful planning is required, as well as the preparedness to allow the conversation to develop in much less structured ways if you are to discover material of real interest.

Insiders

The group which can form the professional heritage manager's biggest problem is composed of 'insiders', not least because they tend to be vocal, amateur and with an unpredictable agenda. This is the group, usually quite small, that has a distinctive and possessive attitude to the heritage item, characterized by a set of personal historical meanings. They may be those who use the possessive adjective about it – 'my place' – and, indeed, an owner may be a highly specialized form of 'insider'. In the most simple cases these are local people for whom the heritage is simply the regular backdrop to their everyday existence. These are the parishioners whose church is splendid fourteenth-century, the people who live in the conservation area or the national park (especially if they lived there long before any form of designation), or the passengers who travel on an old steam railway merely to get to work. They may include those few native Welsh speakers for whom the language is simply their mode of speech and is not an 'issue' at all. Naturally, most family heritage is of this kind, with the inherent meanings being restricted to a small group. The most blatant case of the difference between insider and outsider views is the case of portraits, typically nineteenth-century photographs. These can, and are, discussed at some length in texts on the history of photography, and also change hands in the market-

place against a set of meanings of aesthetic quality.[8] Those meanings simply do not impinge on the family meaning – the person for whom this is a portrait of their great-grandmother or the great-uncle killed in the Boer War. Immediately, even the focus of attention is different, usually making for physiognomic comparisons with current family members. This raises the most significant point about insider heritage, and why members of this group differ from other kinds of visitors. Their interests are usually personal and associated with events or people of their acquaintance. They are working to a very different agenda. If this section explains insider heritage, at least in part, by personal family anecdote, then that is no accident.

In May 1995 an English village put on a display of memorabilia from the Second World War to celebrate the half-century after VE Day. Considerable numbers of visitors came from the nearby city as well as passers-by and tourists. All were interested in the photographs, uniforms and equipment on display, though the locals, of course, discovered the histories of their friends and were able to recognize their elderly neighbours in the faded photos of the dashing young matelots. Only the locals, however, spent hours poring over the map of the village in 1945, together with the details from the electoral roll of the inhabitants of every house. Memories were greatly stirred, not only by the old but also by many children who were able to place those of whom they had heard, and by many relative newcomers who could see who had inhabited their properties 50 years before.

Being inside that paradigm in the company of others who are not can be a profoundly disturbing experience. Some years ago I was involved with teaching photographic theory and history to design students. On one occasion the photographer Peter Fraser came to talk to the students about his work – photographs taken on a journey between Bristol and Glastonbury and later published in *Two Blue Buckets*.[9] As the title implies, these were certainly not traditional landscape photographs. At one point he decided to concentrate on a particular image, a picture taken on a slant of a white wall with a cupboard and a clock. To one side was a cloak on a peg; to the other the corner of a very old wooden notice board. He handed this around to the students who were invited to comment. They did so, of course, strictly within the paradigm intended, and discussed the colour fields, the arrangement of shapes and the meaning of time indicated by the clock. Finally, coming to me, he was shocked to find me in tears. I knew where it was; it was the vestry of my parents' village church, which I knew very well, and where, only a few days before, I had buried my mother.

Figure 5.4 A charming Somerset churchyard at Dinder, but it carries all sorts of special meanings to those whose relatives lie buried here.

No doubt most of us can quote similar experiences, where our own personal heritage crosses with the public perception. The personal meaning seems, at the time, to be the only proper or decent one. On the occasion mentioned, I felt not only that the set of values I put onto that photograph were the right ones, but also that all the other aesthetic values were wrong and completely trivial. I even felt some anger, or at least dismay, that such a shrine should be treated by others with such inconsequence. It seemed obscene. No wonder that insiders are not simply a different group of visitors, in the way that schoolchildren and family parties might be considered different; they are a completely different category who use the heritage with a different set of values, and are probably quite impervious to the meanings being peddled by the managers of the site and their interpretation advisers.

Of course, such insider values may be scattered geographically, and are not necessarily morbid. We all carry in our heads a portfolio of sites, perhaps in many counties and countries, that hold particular significance for us, usually connected with a particular event, or a person rather than an object. In one of his programmes, showing his home country, the comedian Billy Connolly took viewers to a range of garages in the back streets of a small Scottish town. The site had not always been garages; it had once been a park, and was indelibly

associated in his mind with a particular event and a particular girl from his past. Everywhere the heritage manager works there are other people's dreams.

The work on insideness comes largely from landscape specialists, and several kinds of insider and outsider were recognized by Ted Relph (see Table 5.2).[10] The existential insider he described, whose experience is so involved with the place that he cannot imagine anything else, is probably rare in the western world, but we all have empathetic insideness. Later, Tom Griffiths looked at Beechworth, Australia, a small town high in the Australian Alps of Victoria.[11] This historic town had been an important gold-mining town and, later, a mountain resort, as well as the place where the bandit Ned Kelly was shot. Much of the town was now in the hands of the National Trust for Australia, but the local people were somewhat bemused by the Trust's careful restoration of eighteenth-century pigsties. Not that they were without a sense of history; they were keen to erect a monument on the spot of Ned Kelly's shooting, a project regarded with great ambivalence by the Trust, and they were keen to point out

Table 5.2 Insideness

Vicarious	Second-hand experience	Acquired through art and literature, e.g. Hardy's Dorset. Can be deeply felt but fundamentally romantic. Also the attitude to the homeland of the diasporic community.
Behavioural	Direct aesthetic experience	Self-conscious, aesthetic, largely visual, involvement but without other emotional involvement. Typical for a visiting professional.
Empathetic	Direct emotional experience	Self-conscious and deliberate emotional involvement, typical of incomers. Tends to lead to active conservational involvement especially in activities.
Existential	Unselfconscious experience	The insideness of 'home' where we know everyone and are known, and the place is full of significances.
Deep existential	Unselfconscious and unreflecting experience	This is the unreflecting and even dismissive insideness of those people who know no other place. Having no comparison, the place is neither good nor bad.

Source: adapted and developed from E. Relph, *Place and Placelessness* (London: Pion), 1976, pp. 52–4.

the 1930s house where the family had lived who once 'ran this town'. Both the locals and the Trust had a deep sense of history, but the one concentrated on people and the other on things.

As we all have scattered meanings, so insiders may not necessarily all be locals in the geographical sense. Some locals may be outsiders, and some insiders may be distant. Some people living locally may be recent incomers who have not yet acquired the set of meanings that translates the place to a condition of insideness. Others will have had insideness knocked out of them by educational experience. Operating at both levels can be difficult. To the insider, a house is important for its occupants and for events that have occurred there, but a set of evening classes delivered to the local history society by an architectural historian can give some insiders the outsider's professional, academic view as well, and the acquisition of this cultural capital can, very frequently, lead to the insider paradigm being denigrated. The traditional British system whereby many children leave home to go to a distant university or college to learn their trade or profession is guaranteed to produce people who are outsiders even in their home. As they probably carry out their profession a long way from their childhood home, their attitude to the locality where they reside may be devoid of local knowledge and memory, and will therefore remain 'objective' and 'professional'. Many would wish that to be the case, and would regard acquiring the inevitably subjective view of the insider as 'going native'.

The question of acquired cultural capital is fundamental to Ennen's work on attitudes to built heritage by inhabitants of Dutch and Hungarian city centres.[12] She discovers that most of the concern for heritage, as defined by authorities and academics, shown locally, comes from a small band of 'historic connoisseurs', but that there are other middle-class inhabitants who have a different view. These 'consuming connoisseurs' are not necessarily less wealthy or less educated than the historic con-noisseurs, but their attitudes are shaped by different paradigms. While not anxious to demolish the city centre, the meanings that are important to them are not – or not necessarily – enshrined in bricks and mortar. Just as Connolly could awaken old memories on a site, though it was no longer a park, so it might be that the site and not the hardware is important for such inhabitants. There are many accounts by inhabitants of cities that had been destroyed by bombing of the numbing effect not so much of the destruction but of the disorientation, so that the sites of significance could not be found.

Figure 5.5 Even this scene of Newcastle in the 1960s, from a contemporary slide set, largely demolished and awaiting redevelopment, can be viewed nostalgically by people who spent their student days there.

Equally, there are real insiders who are not local. They may be those who have left, but who retain an interest from afar, and many parts of Europe are used to the fascinations of those from overseas seeking their roots, and pretending to be 'more Irish than the Irish'. A search on the internet for 'Czech heritage' revealed more than 100 sites, all but one in North America! Much heritage, too, which does not have a specific geographical location may well have its insiders. *HMS Belfast*, the museum warship on the Thames, has many visitors who served on the vessel, or who served in the Royal Navy, showing different degrees of insideness.

The insider group may be very large and the members may not know each other at all. The most obvious cases here are to do with religion and language. A few of the western admirers of the beauty of Japanese or Chinese calligraphy may actually be able to read what is said, and they are part, of course, of a linguistic inside group, which, in the case of Chinese or English speakers, might number many millions, and within which a vast amount of humour circulates, certainly in English. The play on words so favoured by British comedians and writers depends on a set of insider values that are totally obscure to those who do not speak the language at an advanced level. Even

more obvious is the example of a religious symbol. One of the most basic points made by native Americans or Australian indigenes about the need for them alone to curate their heritage is that only in that way can the 'true' meaning, the insider meaning, be properly interpreted. In the same way, the wearing of a crucifix may carry a large range of meanings from the merely decorative (outsider) to the personal reminder of redemption to the committed believer. Just as Relph described different kinds of insideness, degrees also exist, and for many wearers the crucifix may be both of those things and possibly a talisman as well.

Insiders, therefore, have a particular interest in people and past events, and in activities. They are certainly not opposed to the conservation of objects, buildings and nature, and are often involved in doing just that, but their motivations may be quite different. They are frequently able to raise very considerable sums of finance when they feel their corporate identity is threatened, and their opposition can be powerful and unexpected. It pays any developer, including those developing a heritage attraction, to pay careful attention to local opinion, however irrational it may seem. One organization that cultivates this area with care is Common Ground, which has been responsible for a number of projects to persuade local people to look after the things – often of little national consequence – which make the local scene.[13] They have taken an interest in parish maps, in old orchards and in beating the bounds. Often the keenest proponents are newcomers to an area trying to acquire some roots as quickly as possible. Learning the local geography is, of course, fundamental: who lives where, and which places to avoid. Certainly, Common Ground's insiders are not the existential insiders noted by Relph, but their heritage is still run on a basis of local significance which has little to do with national and international canons of aesthetics or quality.

Some attempts to formalize local heritage by recording house names, and even the campaign by Common Ground to remember the field names by having them inscribed on gateposts, may be resisted, as older inhabitants may consider that people should all know the names through oral tradition (see Figure 5.6). We can distinguish between 'us' and 'them' by the fact that 'we' know what this field/ lane/house is called, and what happened here in former times. It makes the village postman's task more than normally difficult, however, unless he is, of course, a native himself.

Figure 5.6 This lane in the author's home village is known as Scratcharse Lane, but this is not inscribed on any sign or map. Insiders acquire such names orally and use them as items of identity.

Managing personal values

Insiders' heritage is often not susceptible to management. The meanings invested may well clash with official views quite powerfully. In the city of Exeter is a building that remains the maternity hospital and which, until recently, was also the hospital's geriatric department (see Figure 5.7). The maternity hospital is shortly to move elsewhere. The building is undistinguished and is a ramshackle collection of various periods, and English Heritage is unlikely to demand its preservation. But many inhabitants of Exeter were born there, and many also have relatives who died there. There is possibly nowhere else in the city so full of personal meaning to local people. The architecture is irrelevant; it is the events that matter. Like family heritage, with all the deeply held meanings attaching to it, insiders' heritage is also concerned more with sentimental value than cash value. Emotions are concerned more with people and events than with objects. Commemoration is a more effective means of keeping such memories than is conservation, and a sensible management policy would be to treat it as a site rather than a monument.

Figure 5.7 The maternity hospital in Exeter, of little architectural significance but enormous public meaning.

There has been, in recent years, a distinct move to such commemoration becoming commonplace, even completely divorced from normal insideness. Bunches of flowers by the roadside memorialize the victims of road traffic accidents, and the most outstanding example of this must be the death and memorialization of Princess Diana. The huge sea of flowers given by those who wished to be connected in a personal, emotional and insiders' way was an extraordinary phenomenon. Very few of these knew the Princess in a personal way, so it seemed to be a taking over of the insiders' ways of memorialization by outsiders; an invasion of the private by the public. Television seems able to create communities that can display insider solidarity while not actually knowing each other.

Insider meanings, at least of a particular emotional kind, are given much more credence today. Family history and genealogy are now taken seriously by university departments, and this very section, of course, is part of such a movement to recognize insider values.[14] However overdue such recognition of insider values may be, there are obvious dangers inherent in it; for example, for the construction of a new road, rail or power station. If insider values are paramount, then a great many projects will be stymied. In addition, removing

insider values from insiders and giving them a constitutional position, debated by academics and managed by officials, may not strengthen them. Once catalogued and classified they may be killed. Insider values depend on close and deep understandings between people, whether members of a family, of a settlement or of a religious group. In a world of individuals with few ties, insider values may well not exist.

Exercise: 'chatting'
For an outsider to penetrate insider heritage values requires persistence and charm. Select a place where you are scarcely known, and discover the insider meanings attached to established heritage sites there, and insider values attached to other sites which they might consider heritage. To do this you need to be completely unthreatening. A formal method has been devised known as 'small group research',[15] but much good work has also been done by 'chatting', in the pub or elsewhere. You need a reason to chat – such as taking the dog for a walk or doing a painting. Waving a clipboard does not work!

Outsiders

Outsiders, who constitute by far the majority of visitors in a managed heritage site, have a completely different agenda. One important group of outsiders are the tourists, but to listen to many debates on heritage one would assume that the sole purpose of heritage is to feed the tourist market, though that market is so voracious it seems scarcely to need artificial feeding. Certainly access is one of the central issues in heritage, and most pieces of heritage are sold many times over for different purposes to different markets and to different kinds of visitors. But the idea that heritage is the creation of the tourist industry is actually less tenable than the opposite conception – that tourism is the result of the creation of heritage. Most heritage was not primarily or originally produced or designated for tourism but for a whole network of financial, social, cultural and even spiritual needs such as prestige, legitimacy, scholarship and nostalgia. Tourists may indeed be vitally important to the financial viability of many heritage sites today, but the concept that such sites should be financially viable is itself a comparatively recent idea, and a result of the vast increase in tourism.

Educational parties

Educational parties are one other significant visitor group who form the bulk of visitors in terms of numbers, if not of income, at many sites. Looked at in terms of visitor attraction management, the educational party is particularly difficult to cater for, and not very lucrative. One of the fundamental characteristics of visitors who are part of an educational group is that they are, or may be, unwilling visitors. Teachers and parents may consider the trip to be valuable, but the recipient may think differently, or may live within a peer culture where to despise the visit is the only allowable option. Also, many people, in Britain at least, are wedded to the notion of free education, and substantial charges for a school trip will not be welcomed, not least because it would mean that schools could only visit places that could be afforded by the poorer parents. This attitude to free education is often coupled with a resistance to the interpretation at the site being exciting. So education should be free but also boring, while we might pay quite a lot for entertainment.[16] This problem has led to the concept of 'edutainment', which then leads to all the problems of 'dumbing down'. However, there has been a considerable

Figure 5.8 Schoolchildren at Stokesay on a well-organized visit, with classroom preparation, and a working relationship between class teacher and heritage educational officer.

amount of support for this sector from the Heritage Education Trust, and the Sandford Award is given to sites that reach certain standards in interpretation for educational parties.

Not only is there a resistance to substantial payments by educational groups, but also the needs of the visit may vary dramatically. All teachers are very well aware of the spread of ability within one year group, but many heritage sites expect to deal with educational parties from preschool age to postgraduate and from a considerable range of subjects. All too often they attempt to do so with a common piece of information, or educational pack typically aimed at 8- to 10-year-olds. The existence in Britain and some other countries of a National Curriculum does help, so that heritage sites can be prepared for only a limited number of age groups with a limited number of topics. Even so, a group of undergraduates studying Heritage Interpretation will usually defeat all carefully laid plans! Very often heritage centres cope with such visitors best. They may be short of authentic artefacts but they are usually geared to the idea that everyone should be educated all of the time. Whatever the site, educational parties have little in common with tourists, not least in their motivation. Problems can certainly arise when two sets of behaviours clash, and when students used to visiting sites as tourists and behaving accordingly are expected to behave differently if the visit is part of their educational work. Much of the evidence concerning the efficacy of interpretation towards school parties suggests that direct learning is limited, though changed attitudes may be considerable.[17] Measuring the factual gain in knowledge produces rather disappointing results, and the gain in comprehension is so much more difficult to measure.

Tourists

Tourists are usually classed as those away from home for purposes of pleasure and staying at least one night. That omits a great many people, not only those out for the day, but also those with other primary functions or different motivations. Day-trippers may sometimes be real locals and insiders, but as it is now common for people to travel 300 km for a day trip, to the capital for example, this cannot be inferred, and such day-trippers are not easily distinguishable from tourists in terms of motivation or income. Day-trippers are, however, prime targets for many heritage managers as they may be persuaded to return on many occasions. The real locals may also be an

important part of the visitor profile, as they, too, may come frequently, all year round.

A great deal of literature is concerned specifically with heritage tourism,[18] but that literature often makes some presumptions that may be questioned. The first is the difference between heritage tourism and green tourism, which is the tourist industry's distinction between cultural and natural heritage, but which dissolves on closer inspection. In so far as there is a distinct group of such tourists, this is the same group in both the green and cultural areas. Snobbery is very rife in this field. Beaches are usually not regarded as heritage at all, almost never being designated, however important they might be to a place's history and geography. Equally, heritage tourism is often presumed to be a superior activity, whereas a good case can be made to the contrary. The visitor to an international theme park (which is presumably the very opposite of heritage tourism) or to clubland in Ibiza may be as responsible for as much air fuel as the visitor to America's national parks or to Greek temples, but he is not likely to abrade archaeological monuments nor tread on wildlife to the same extent.

With one significant exception tourist visitors to traditional heritage sites, museums, nature reserves, archaeological sites etc. have a higher terminal educational age than the average, and come in two age groups – the young adults, who are not big spenders, and those in their forties and fifties, usually couples without children. The latter group are wealthier than the average although their interests may be more in local colour than in the bland universalities of international hotels. Such tourists are, in fact, from the middle-to-upper income bracket, middle-class and middle-aged, except visitors to zoos and perhaps also caves. Zoos attract all ages and classes, especially children and family groups.

There is a real danger of circular argument if we accept the idea of heritage as being cultural capital. If we restrict our definition of heritage to certain 'cultural' phenomena, then, by definition, the visitors will be of a certain type. One could be quite cynical about this, and suggest that if art galleries fail to attract the poor and ill-educated then they are doing exactly what art is intended to do these days, i.e. to differentiate the culturally sophisticated from the rest of society.

The needs of tourists have been debated at length, and the tendency for the industry to produce commodified packages of experiences which attempt to be 'authentic' is well known. This problem is explored further in Chapter 7.

Foreign visitors

Tourists, and indeed other visitors, may not come from the same culture, and those from a different culture might well be seeking a completely different set of meanings. Most of Africa, Latin America and Asia are entirely used to the presumption that many tourist visitors will come from alien western cultures and will probably be considerably more affluent than the locals. The heritage such visitors wish to see is not necessarily that which the locals wish to see or to show. Tourists may well want it confirmed that their own culture is superior, so that European visitors to Africa may want to see primitives, just as southern English visitors to Ireland, Wales, the Highlands of Scotland or even Devon and Cornwall want to see primitive ways of life, not Scottish or Cornish triumphs of engineering.[19] British visitors to India may wish to see the sites of the British Raj. The Czechs have some difficulty accepting that the vast majority of their visitors come from Germany and Austria, and are clearly interested in the history of the Habsburg Empire and of the Sudetenland, neither of which subjects are completely without political problems in the past. At a Moorish castle and garden in Spain, a group of Saudis in flowing robes

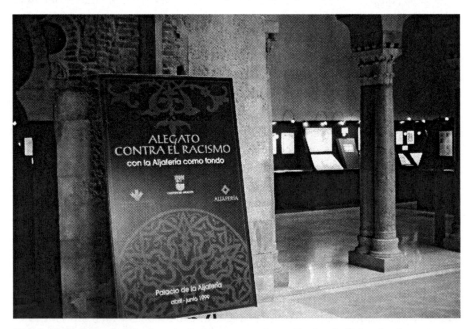

Figure 5.9 A Moorish palace in Zaragoza, northern Spain. A determined attempt to use divisive heritage to unite people.

had come to visit 'their' heritage, which clearly caused some embarrassment to the Spanish guide.

There are also differences in behaviour between national groups. One guide, whose task was to take groups of foreign tourists around a central European World Heritage town centre, confessed that she welcomed Americans, Japanese and Germans, who kept together in a group, listened to her exposition and asked sensible questions, but she feared British and French groups who wandered all over the place, determinedly followed their own interests and asked 'ridiculous' questions.

Pilgrims

Motivations are always difficult but there are visitors who profess quite different motivations from tourists, and these include pilgrims – travellers with a fixed purpose that may or may not be achieved. Pilgrims may find a spiritual goal at their destination, but they may also be denied it by the activities of tourists.[20] Equally, some tourists quite unexpectedly achieve an unsought

Figure 5.10 At Mont St Michel, France, the crush of modern visitors and the market atmosphere may not be that different from medieval times.

spiritual experience. Nevertheless, the degree to which tourists and pilgrims can reasonably mix is debatable. Not that all pilgrims have always been other-worldly. Chaucer's pilgrims certainly had mixed experiences and mixed degrees of piety, even though they had similar motivations. A visit to Mont St Michel is one such experience today. Entering the village from the causeway, the normal route up to the abbey is through a narrow alley, densely packed with people and lined with stalls, shops and cafés selling a variety of products from religious artefacts (CDs or rosaries) to classic tourist paraphernalia such as T-shirts and Mont St Michel paperweights with a snowstorm (see Figure 5.10). Numbers today may be greater than in medieval times, but it would be very dangerous to assume that the standard of taste has declined.

Presumably, modern pilgrims include not only those going to Lourdes or Santiago de Compostela or on the Hadj to Mecca, but also those on the well-trodden paths of Nepal or Peru, and perhaps those going to the Parc des Princes or to Bayern Munich. The specific goal will often be part of a visit with other by-products. The gulf in understanding between the dedicated fan and the visitor who is merely there to see a football match resembles the problem in the Church.

Connoisseurs

Another group of visitors who undoubtedly regard themselves as rather special are the connoisseurs, so much despised by the Duke of Bedford. Many of them are academics, who are treated in this text as a separate group from visitors, partly because they so rarely regard themselves as visitors and partly because they so rarely are prepared to pay, whereas most visitors are. At the most cynical, the manager of the heritage site may regard the connoisseur group as those who wish to take up more staff time than any other group, at a time specially reserved for them, to be shown things which other groups do not expect and, of course, to see them free of charge. The group intends to pay in cultural capital instead of hard currency. This text regards academics themselves as a completely separate market for heritage, and they are discussed below, but they, too, are visitors, and can provide both an opportunity and a problem to the heritage manager. Their needs are extremely varied, but are likely to be significantly different from other visitors.

Return visitors, of whichever group, are perhaps the Holy Grail of heritage management. Many people within day-tripping range may be persuaded to

return again and again, and to bring their visitors with them. Indeed, for many people a visit to the local cathedral or museum is a regular part of one's routine when family or friends come to visit, but not at any other time. Locals (even if real insiders) can also be persuaded to be regulars. Partly, of course, this can be done through pricing policies, such as season tickets, but it is also vital to have a variety of things to do, perhaps extensions of the regular tour, so that 'next time we will go up the tower'. Also, regular visitors will demand much more flexibility and the chance to follow their own interests.

Managing visitors

The problem for the management of a site with multiple visitors is to try to please as many as possible. This is done by separation in time and by place, market segment differentiation, supported or driven by pricing policies, and sometimes by interpretation policies. For example, a tour focusing on the religious role of the cathedral can be used for pilgrims, and special events, called services, may be provided for them. School parties may come in the morning, the general public in the afternoon, with special, expensive visits for connoisseurs in the evening. Quite often, significant differences can be made simply by advance warning, so that a tour of the roof space can be organized without extra cost, but the need for a week's warning is to ensure that the motivation is a strong one, not a casual response. Similarly the position of the car park, if there is one, is a vital element. Managers of countryside are well aware of the effectiveness of a lack of a car park in restricting visitors to those who wish only to walk. The Landmark Trust, which lets small, historic buildings as holiday accommodation, advertises that none of its properties is equipped with television. This, too, can be an effective means of market segregation.

Visitors come in many kinds and these are not fixed. The same person may be an academic connoisseur in this site, and a tourist in that one. Today he may be leading a school party, tomorrow visiting with the family. At some places his visit may be more that of pilgrim than tourist. On many occasions different visitors do not mix; that is, they do not feel comfortable with the other group there. This is a common experience in a church, but it happens elsewhere too. On one occasion the author and his family found themselves, during an afternoon stroll, shod in sandals and lacking any pack, on a part of the Appalachian Trail, winding for 1000 miles from Georgia to Maine. Our

Figure 5.11 View across the Appalachians of Pennsylvania from the Appalachian Trail. If one has hiked for several hundred miles, it is only too easy to be upset at people appearing in flip-flops and shorts!

presence, reminding the serious walkers that they were only a stone's throw from civilization, swimming lake and burger bar, was not widely welcomed!

Exercise: observation
Simply observing people has an important role in heritage management research. This exercise needs to be done in a civic museum or a cathedral – some place where there are many tourists and also many other types of visitor. Watch people, and note which groups, and which members of which groups, look at what and listen to whom. Also examine the degree of market segmentation practised by the management. Being a 'fly on the wall' of a school party visit is particularly rewarding. However, it is certainly not acceptable practice to publish the results of covert research, except with express permission. The knack is to be so much 'part of the furniture' that people act normally, knowing you are there.

Governments

At the end of the eighteenth century the revolutionary government of France decided not to destroy all the palaces and other built monuments of the Ancien

Régime, but to take them over and convert them to uses more appropriate to the new revolutionary nation. Many date 'heritage' from that time, a point at which the past was deliberately conserved by official government action for the purposes of the present. Whether one accepts that as a starting-point of the whole heritage enterprise or not, there is little doubt that a vast amount of heritage is recognized, designated and conserved by governments for a variety of purposes, though they are usually closely concerned with prestige and legitimation.

Of course, governments have always created things that have become heritage. Thousands of years after the pyramids, which themselves were perhaps the greatest attempt to conserve people, the Roman emperors built triumphal arches and columns to commemorate great victories and events. So this was the commemoration of the heritage of events. These become heritage monuments at the point where someone (usually officially) makes the decision that these should be conserved. Some buildings are designed to be heritage at the outset; designed to be conserved as symbols of power and wealth. Houses of parliaments are obvious examples, and opera-houses are also clearly in the same league. Perhaps revolutionary France was the most significant occasion

Figure 5.12 On the walls which enclose the Roman Fora are maps to illustrate the history of the Roman Empire, erected during fascist days to draw a parallel with the new Italian empire – a most blatant example of legitimation.

when one government decided to conserve and restore the monuments of another in order to give credence and legitimacy to their own existence, though the fate of the Kremlin buildings and palaces of St Petersburg after the revolution is a more recent similar example.

Governments come in many shapes and sizes, from the parish council to the United Nations, which not only makes use of identity devices such as a flag and a blue helmet, but, through UNESCO, also designates World Heritage. By far the most significant level in the manufacture of heritage has been the national, and the relationship between levels of government and heritage is discussed in Chapter 6. Suffice to say here that governments ignore heritage at their peril. The European Commission and Parliament have largely ignored the creation of a European heritage with all that entails for identity, and have left such matters to the much broader Council of Europe. Now that many in Europe are interested in producing a closer integration, the failure to produce an identity and pride shared by most of the citizens of the European Union can be seen as a major hindrance. Most Europeans seem to feel French, or Greek, or perhaps Catalan or Welsh, but rarely European. At last the EU has begun to recognize this lack of a conscious European identity and is beginning to address it, through Culture 2000 and similar programmes.

Government as market

Governments sometimes act as a market for heritage in the literal sense; that is they may bid at auction to purchase items 'for the nation', through their intermediaries such as the museums. All museums have a budget for the purchase of heritage, usually using public money, whether this is a civic museum or a major national collection. Monies from lottery sources can be regarded in the same light, as the museum may be, or may feel, obliged to justify purchases to the nation. In this case the government concerned becomes an owner as well. Some monuments are also purchased by governments, such as Stonehenge and all those properties belonging, in England, to English Heritage. County and city councils also purchase such properties, and sometimes they are themselves the owners of listed historic buildings. Indeed, the recent British history of governments disposing of their own properties which have become heritage has been a fascinating exercise of different motivations. The disposal of mental hospitals and defence

Figure 5.13 The disposal to the private sector of the Royal William Victualling Yard on the waterfront at Devonport has brought about a study of differing motivations and uses for these major historic buildings, not least between two levels of government, national and municipal. Courtesy of David Pinder.

installations have both been examples of the tension between government as owner and as designator of heritage.[21]

Government as legislator

More often governments and councils act as a market indirectly. To purchase all the buildings which the British government, with the advice of its organizations such as English Heritage or Historic Scotland, has decided are of sufficient importance to be designated, whether scheduled monument or listed building, would bankrupt the Exchequer, so laws are made, designations imposed and, to a considerable extent, the government makes sufficient constraints on the treatment and disposal of the property so as to impose its will with little cost. Such systems inevitably create considerable friction between owners and governments. In these cases governments do not act directly as a market force, but use their legal muscle to impose their wishes. Nevertheless, such decisions are not without cost, and the imposition of such

listings, their control and development, imply considerable expenditure on organizations such as the departments of Culture, Media and Sport; Environment; Food and Rural Affairs; English Heritage; the Royal Commission on Historic Monuments; and the conservation departments maintained in council buildings all over the country. There are also incomes forgone, as when owners of historic property, whether portable works of art or buildings, are given tax incentives to encourage access and conservation. Such tax breaks exist in Britain, but are the staple means of conservation in some countries, such as the United States. Needless to say, the listing process – imposing the national will onto private owners – is one which encourages governments to designate vastly more heritage than they could possibly afford to purchase. They ostentatiously do not 'put their money where their mouth is'. It is small wonder that the comparatively cheap way of having your cake without buying it is an attractive option to governments, and some (for example Spain), have extended it to cover the more portable areas of heritage.[22]

National and other governments are involved particularly in that side of heritage concerned with tangible things rather than activities. The UK government is clearly deeply involved in purchasing natural and landscape heritage for the nation – in national parks and nature reserves – and in funding English Nature, English Heritage, the Countryside Agency and similar bodies; and county councils often fund similar local bodies. Buildings are listed, monuments scheduled and historic gardens registered. Battlefields are designated – most particularly in the United States – and war memorials are maintained all over the world. There are national, county and civic museums and art galleries that are maintained at public expense, housing collections that are not only local but also international. While the collection policies of many local museums give special emphasis to the collection of art works by local artists, archaeological artefacts from the region and exhibitions of the local area's nature and culture, they usually also include space for works of national or international importance, not uncommonly those collected by a local worthy. Councils and government organizations get involved less often in the conservation of activities, sports, diets and religious practices, but there are significant cases here too. Certainly the performing arts usually receive government funds, and not just for performing new works.

Why should governments be so deeply involved? The reasons are largely summarized with the three elements – legitimation, prestige and economics – that were introduced in Chapter 3. The third is straightforward. A great many

heritage ventures these days have a significant role in generating income. Cities create heritage centres, such as the Plymouth Dome, with at least half an eye on tourist revenue, either direct to the council or to businesses in the council area. However, comparatively few heritage sites were specifically designed for tourists or for profit. Even for those that are major money-spinners this was a late consideration. The Tower of London may make a profit, and considerable efforts may be made to increase that profit, but to assume that it was originally conserved for that reason is absurd. Neither is it likely that the Tower of London, or Stonehenge, would be razed to the ground if the tourists stopped coming. Governments might moan, but eventually they would pick up the bill, or insist that tax-payers do.

Prestige is more important. Cities and nations do not fund even heritage centres for profit alone, let alone museums, arts festivals or nature parks. Such funding provides enhanced status for the city or the country, which status reflects on the members of council or parliament, and which may have an economic side-effect. At a lower level, such as the smaller cities and the counties, these often demonstrate the city's or county's importance in the

Figure 5.14 The famous abbey ruins at Glastonbury were once open freely to all, but they have recently been enclosed and interpreted. The needs of protecting the monument have often been found to coincide with the wish to generate income. Visitors under control can be more easily charged.

region. Dorset's County Museum tells us of the history, geology, archaeology and culture of Dorset. We are certainly reminded of Dorset's importance on the national stage, in geology and literature, for example, and now the World Heritage status for the Dorset coast is clearly regarded as a major prestige boost, as well as bringing more tourism. Location marketing is in the process of becoming a major area of expertise, dedicated to the 'selling' of entire cities or regions.[23] In location or destination marketing, the inextricable connections between prestige and revenue are constantly stressed.

Glasgow is the outstanding case. The transformation of Glasgow into a City of Culture was not only predicated on local, regional or even Scottish significance; stress was laid also on the international significance of the Art Gallery. Australia's investment in the Sydney Opera House is not primarily intended to promote Australian opera-composers, but to put Australia and Sydney on a world stage of significance in this field. The recent development of the Guggenheim Gallery in Bilbao is an attempt to do the same. It may succeed, but Bilbao is not Sydney, the major city of a continent, and an attempt at Groningen, in the north Netherlands, to produce a European-scale

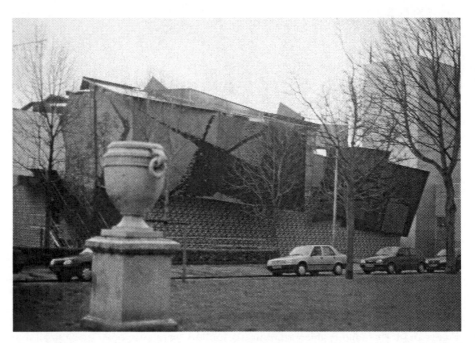

Figure 5.15 The modernistic museum at Groningen, north Netherlands, was intended to acquire cultural capital for this rather remote city. It has been only partially successful.

art gallery has not been so successful.[24] It is now well understood that a single visitor attraction, except perhaps on the enormous scale of the Eden Project in Cornwall, is unlikely to succeed unless supported by other attractions, including the free ones of coast, town and countryside.

Governments thus buy heritage, dabble in the market place directly and make major alterations to it indirectly. The parish or district councillor, the MP and the MEP all serve different geographical areas, and within those areas, and within their competence and pocket, they will buy heritage, setting up museums and special conserved areas and supporting activities that tend to demonstrate its historical legitimacy and geographical significance. The current boundaries will be regarded as either inevitable and fixed or as, possibly, too small – movements such as that for Greater Serbia. The area will also be given an identity, however unlikely, which will form part of the mythical package, so that villages may resist anything that is perceived as threatening to their rurality, while countries may promote only certain types of industry.

Exercise
Examine the 'heritage making' of your District or County Authority. By reading their publications, including websites, it is possible to develop a clear picture of those elements which the authority considers to be distinctive and important. Take particular care to examine the published accounts, to see where the authority channels money for the support of heritage. What grants are made, and what arguments are made to obtain them?

Academics

Academics are deeply implicated in heritage. They have not usually been separated as a specific stakeholding constituency, but the argument to do so is a strong one. Of course, the amount of money disbursed by the academic community in purchasing heritage is not very substantial, although universities do have considerable collections of artefacts, especially books and archives; works of art are commonly held and many university buildings are listed. That merely makes universities a specialized form of heritage owner, as is the National Trust. Nevertheless, academics devote a considerable amount of their time to the study of heritage, so their contribution is in kind;

in cultural capital rather than in cash. At the least, they expect to acquire a stake in the future of the heritage they study; at most, they expect the heritage to be conserved and interpreted in the ways they dictate and to be available freely, and possibly uniquely, to them.

Any study of heritage formation, of how objects and activities acquire that peculiar patina of heritage-ness, must inevitably look in some detail at the role of academic research. This is done in Chapter 7. Very often one of the early indications that there was something worth conserving was in a piece of research, sometimes even at undergraduate level. The Open University course on modern architecture expected all its final-year students to undertake a piece of serious research into a building of significance. This produced a huge corpus of material on twentieth-century buildings, much of which becomes quoted as these buildings become listed. One of the most obvious features of those historic gardens that have been registered is that they are among the few that have received careful study. A scholarly article on the significance of a particular feature may appear in the journals, such as the *International Journal of Heritage Studies* or the *Journal of Cultural Heritage*, with recent articles on English suburban gardens of the 1930s and on Scottish walled gardens. More often the journal will be a specialist publication in archaeology, architectural history or, for the natural heritage, in the ecological field.

Academics rarely perceive themselves as a market, preferring the self-perception of the disinterested observer, merely studying heritage objects for the sake of scholarship. But such scholarship is an aim in itself, and a perfectly worthy one. Many great museums saw one of their fundamental aims as the conservation or preservation of the material objects of human culture (and indeed of nature also) for the purposes of study. Taxonomy was studied in museums, and in Kew Gardens. Without museums and conserved sites archaeology would scarcely exist. Even if archaeologists were able to discover completely new sites, they would have nothing to compare them with. Inside a general museum, national or civic, one expects to find various rooms or galleries where objects are displayed, where knowledge is organized, in the ways dictated by academic disciplines. Indeed, there is a very great probability that the curator in charge of each gallery has at least a first degree in the appropriate discipline. One expects to find an art historian in the art gallery and a geologist in the rocks collection. This sounds so normal as to be not worth saying. But that is probably not how most people organize knowledge, and there are always other specialist viewpoints. The fact that most accounts of the nineteenth century do not mention the history of art, literature, music or

science is a problem for academic authors steeped in particular disciplines, not the common view which sees place as a whole, not as a series of different, but inter-connecting subject areas.[25]

There are turf wars, of course. Most objects have become the cultural property of a single discipline, but there are disputes. Paintings are within the purview of art historians, even landscape paintings that might also interest geographers. But portraits sometimes provide a dissonance, as the discourse of art history may not say much about the sitter. So the great portrait of Henry VIII by Holbein is as much the cultural property of historians of the Tudor period as it is of art historians.

One of the most obvious examples of this academic hegemony over objects is in the church. There are many ways of looking at churches and their surroundings. Interest could be in the history of the parish, the fixtures, the music, including the organ, the architecture, the liturgy, the bats in the belfry or the lichens on the wall. There is even a geological guide to a cemetery in existence. But the winners here are the architectural historians, and in the vast majority of churches the interpretational material will be written by, and perhaps largely for, architectural historians. The categories will be theirs, so that this church will be classed as Perpendicular Gothic rather than High Church Anglican, or Heavitree Stone or even Victorian (which might apply to most of the fittings). In museums, as was discussed in Chapter 4, each discipline tends to 'own' one of the galleries or departments. But this is largely true out of doors also. Ecologists are deeply involved with the designation and management of SSSIs, as are geographers of national parks. In the UK there is a subtle distinction between the scheduled monument and the listed building, the former being essentially uninhabitable.[26] But many places are both, and the easiest way of understanding the difference is that scheduled monuments are suggested by archaeologists and listed buildings by architectural historians.

The academic fraternity's enormous success in controlling heritage does not rely on the deployment of their own funds, but on exerting power in other ways. In the United Kingdom there are a number of organizations that have significant legal powers and advisory functions. These are known as the Amenity Societies, and include the Ancient Monuments Society, the Victorian Society and the Open Spaces Society. These organizations have the legal right to comment on all planning applications that are within their area of interest. These are consequently powerful organizations that advise national and local government on an appropriate response in many cases, especially in the built

heritage area. Local authorities have often set up their own advisory bodies, such as the County Historic Buildings Trusts, County Gardens Trusts, County Wildlife Groups and Civic Archaeological Advisory Groups. Such organizations tend to be dominated by academic members, and they are often self-perpetuating oligarchies, who invite members to join the active committee rather than being elected by the membership. In any case it is not always easy to join, and a substantial part of the large membership fee is to cover the publication of a very worthy scholarly journal. However worthy such publications are, they are likely to be of little interest outside the field of scholarship, so such organizations deftly succeed in always putting forward a highly knowledgeable, but frequently very narrow, opinion on many topics.

Scholars, therefore, play a major role in identifying what constituted the heritage and have been foremost in attempts to conserve it, whether this resulted in museum collections, nature reserves, listed buildings and even, more recently, folklore and customs. Their success has been remarkable and has resulted also in the high standards of conservation practice that are such a notable feature of so much heritage. However, there has been a tendency for each bit of the heritage to fall into the scholarly concern of only one discipline, and therefore for its presentation and interpretation to be single-faceted.

The second area of success has been in teaching. Students learn about the conserved heritage at university, and pass that knowledge on to their children or, as teachers, to their pupils. So the enormous increase in interest in the heritage, which has characterized the second part of the twentieth century, is the result of this vastly increased education. It bears important fruit in ensuring that the raw materials of the disciplines are maintained. Unfortunately, it has rather bitten back, and some academic disciplines are now not so keen to provide unlimited access to the heritage for which they have fought so hard. The academic market is, in general, rather opposed to general access or any activity that might compromise the longevity, or the condition, of the conserved object. Locking the door on the cave paintings of Lascaux, or covering over the Roman baths at Exeter are entirely rational acts, taking the academic perspective. After all, special access will be accorded to 'bona fide scholars'. Professional archaeologists will usually know how to obtain access to the stones at Stonehenge. The opposite view may be that heritage locked away by scholars for conservation reasons has no more justification than the Stradivarius in the bank vault, locked away for financial reasons. Both deny the very purpose of heritage.

Figure 5.16 A specially arranged visit to the famous sculptures at Réggio di Calábria, for a group of academics including the author. Scholars are often able to negotiate privileged access.

One group of visitors to heritage sites has every reason to be grateful for the success of academics in controlling access to heritage, and that is the future generation. Academic disciplines are very concerned about conserving the things in which they are interested for future scholars, for the future of the discipline, and they can sometimes be the only voice speaking for the future as opposed to the satisfaction of current wants. Burying an archaeological monument in controlled conditions, so that future generations can use it, may be an entirely proper archaeological response, and it may not only be future archaeologists who get the benefit.

The problem of controlling access, though, is a perfectly genuine one, faced most commonly by those parts of the heritage not easily hidden – national parks, geological coasts, eagles' nests, Stonehenge. The academic support for conservation clashes with the public need for access. The answers are difficult, but are not helped by the note of derision so often easily detectable in commentaries upon tourism by academic writers. This has its roots as much in the problems of cultural capital as in the needs of academic disciplines.

Exercise: management of access
At a large and complicated heritage site, how is access managed? How are different groups kept apart? In what ways are there: different time slots for different groups; differential charging; use of special events, different tours and access to different things; use of physical barriers, including car parking?

The media

There are signs of a new and important force in the market for heritage, represented by the media. The media have, of course, always had an interest in heritage issues and have reported them widely, though whether this has been done well or badly is debatable. To that extent the press, whether in print or electronic form, cannot be said to represent a different market, merely being representative of other stakeholders, though frequently committed to raising issues and making evident the latent disagreements between various stakeholders.

However, there are also other developments that suggest that the media is developing a position of their own, making use of the heritage for their own purposes. One of the most obvious and oldest cases has to be the BBC television series *The Antiques Roadshow*, where the public is invited to bring in items for discussion and valuation. Quite clearly, the aim is to make exciting television rather than to report on the antiques market, and in this aim they are markedly successful, to judge by the show's longevity and popularity. There will, inevitably, be an effect on the antiques trade, however, with a mass-audience being introduced to the value of items and to the tricks of the trade.

A more recent use of heritage for televisual purposes is *Time Team*, which is far from being a passive report on archaeological events. Instead it makes active interventions into the landscape. Welcome, no doubt, as the extra funding to archaeological work may be, as are the increased numbers of applicants for archaeology courses, the emphasis is inevitably on techniques which look good on the screen rather than those which may produce more specialist knowledge. Such televisual archaeology is unlikely to take seriously the very proper claim that much archaeology is best left under the ground and invisible.

Films have sought appropriate locations for the setting of dramas for a long time, but recent years have witnessed a great increase in this activity not only

for films but also for television. The locations used are only occasionally the original locations intended by the author (presuming we are dealing with a film/TV adaptation of a literary work, which is by no means always the case) and there may be different locations for interior, exterior, garden etc. The filming, then, itself becomes part of the heritage, so that there are many visits to Saltram House in Devon because part of *Sense and Sensibility* was filmed there. Exeter city guides recall the time, over 30 years ago, when *The Onedin Line* was filmed at the quayside. Stills are, even today, being used in civic publicity. There is now a very real marketing effort made by cities and counties, and by organizations such as the National Trust, in attracting such location work. In this case the need of the media is significantly different from academics, for example. The main requirement, certainly in all the visual media, is for places that look correct for the period. Authenticity of appearance is all; materials are of no account.

The popularity of nature programmes is well known, and television series on the wildlife of many parts of the world are a regular occurrence. In the main, this is reportage, and must be seen as an important part of education in natural history, landscape heritage and environmental consciousness, rather

Figure 5.17 Gold Hill in Shaftesbury, Dorset is much used by the media, and is well known to location finders, figuring in advertisements and films. Its heritage agenda is thus largely media-driven.

than as a separate market force in its own right. The same cannot be said of Keiko, the orca whale that played the part of Willy in the film *Free Willy*. Here we have the media playing an active role in conservation, both in making the film and in the demand for the whale's later release. Many ecologists would argue that the agenda for conservation priority is now being driven by the media's need of good stories and pictures rather than hard scientific fact.

Public relations, or communications management, is consequently a major aspect of successful heritage management, including clear policies for potential media disasters.[27] This has rapidly become the criterion on which the entire success or failure of major projects is likely to depend. The communications strategy should therefore be at the heart, and indeed at the board, of a developing heritage project, and will need to take account of newsworthiness. For example, television and radio programmes usually prefer controversy to compromise and agreement, and will always look for the outstanding feature – largest, longest, tallest, smallest, oldest. Linkages with people, preferably well-known or local, are also newsworthy.

Exercise
Write a press release for a heritage event. This could be an archaeological discovery or a new purchase for a museum or a new building open to the public. Your press release has to grab the attention of the local media, press, radio and television, in preference to the other 100 they received on the same day.

Conclusion

Heritage is a product in the market-place, and that market-place is a crowded one (see Table 5.1). There are at least five major players in that market, including owners, governments and academics as well as the more obvious visitors and insiders, with the media becoming a sixth. These groups have certain common characteristics but the groups compete with each other and there is friction between the different sub-constituencies. Visitors are inevitably keen on access, but academics, often, are not. The latter are keen on authenticity, which may not trouble insiders very much, who will care deeply about very ordinary things that may not appeal to governments' needs for prestige. Academics, governments and visitors want to conserve material objects, while insiders accredit deeper meanings to people and to sites.

NOTES

1 G. Ashworth and P. Howard, *European Heritage Planning and Management* (Exeter: Intellect), 1999.
2 M. Shoard, *This Land Is Our Land* (London: Paladin), 1987.
3 B. Bender, *Stonehenge: Making Space* (Oxford: Berg), 1998.
4 B. C. Williams and C. S. C. Bradlaw, 'An economy of country houses', *International Journal of Heritage Studies*, 7(3), 2001, 273–94.
5 R. Shipley, 'Heritage designation and property values: is there an effect? *International Journal of Heritage Studies*, 6(1), 2000, 83–100.
6 John, Duke of Bedford, *How to Run a Stately Home* (London: Deutsch), 1971.
7 Described in R. H. Biffen, *Auricula: The Story of a Florist's Flower* (Cambridge: Cambridge University Press), 1951.
8 M. Weaver, *The Photographic Art: Pictorial Traditions in Britain and America* (London: Herbert), 1986.
9 P. Fraser, *Two Blue Buckets* (text by R. Martin) (Manchester: Cornerhouse), 1988.
10 E. Relph, *Place and Placelessness* (London: Pion), 1976.
11 T. Griffiths, *Beechworth: An Australian Country Town and Its Past* (Melbourne: Greenhouse), 1987.
12 E. Ennen, *Heritage in Fragments: The Meaning of Pasts for City Centre Residents* (Nederlandse Geografsche Studies, No. 260), 1999.
13 S. Clifford and A. King (eds), *Local Distinctiveness: Place, Particularity and Identity* (London: Common Ground), 1993.
14 H. Kean, 'East End Stories: the chairs and the photographs', *International Journal of Heritage Studies,* 6(2), 2000, 111–28.
15 C. Harrison, M. Limb and J. Burgess, 'Recreation 2000: views of the country from the city', *Landscape Research*, 11(2), 1986, 19–24.
16 R. C. Prentice, 'Heritage as formal education', in D. T. Herbert (ed.), *Heritage, Tourism and Society* (London: Mansell), 1995, pp. 146–69.
17 D. T. Herbert (ed.), *Heritage, Tourism and Society* (London: Mansell), 1995.
18 A. Orbasli, *Tourists in Historic Towns* (London: Spon), 2000.
19 See R. McKenzie, 'The "photographic tour" in nineteenth century Scotland', *Landscape Research*, 17(1), 1992, 20–7.
20 M. Winter and R. Gasson, 'Pilgrimage and tourism: cathedral visiting in contemporary England', *International Journal of Heritage Studies*, 2(3), 1996, 172–82.
21 NHS Estates and English Heritage, *Historic Buildings and the Health Service* (London: HMSO), 1995.
22 A. Martinez, University of Zaragoza, personal communication.
23 *Locum Destination Review* is a journal on destination marketing. See < http://www.locum-destination.com/ldr.htm >
24 E. Ennen, 'The Groningen Museum: urban heritage in fragments', *International Journal of Heritage Studies*, 3(3), 1997, 144–56.
25 P. Howard, 'Academics as a heritage market', First International Conference of the Association for Heritage Interpretation, Bournemouth, July 1999.

26 Department of Environment, *Planning Policy Guidance Note 15: Planning and the Historic Environment* (London: HMSO), 1994.
27 D. Hayes and M. Patton, 'Proactive crisis-management strategies and the archaeological heritage', *International Journal of Heritage Studies*, 7(1), 2001, 37–58.

6

Heritage as Identity

SUMMARY

The third major dimension within which heritage management operates is that of the levels of geographic identity. Apart from the clash of national or regional identities, these may be dissonant with different levels of identity, perhaps municipal or continental. Heritage strengthens the identities at the level of our home, our neighbourhood, our town, our region (which may have several layers), our nation and at the continental and universal levels. We also have significant identities which are not geographical in their operation and these may be growing. Good management demands an understanding of the identities that can be reinforced or challenged by interpretation.

Heritage of all the different kinds discussed in Chapter 4 carries a variety of meanings to all the various groups discussed in Chapter 5. Whether we are discussing the family photograph album or the national park, a major outcome of conserving and interpreting heritage, whether intended or not, is to provide identity to that family or that nation. There may be other purposes as well, such as legitimation, cultural capital and sheer monetary value, but the common purpose is to make some people feel better, more rooted and more secure. Even the acquisition of cultural capital can be seen as a means of providing identity to a particular group. Unfortunately, the designation, conservation and interpretation of much heritage simultaneously makes another group feel less important, less welcome and less secure. Just as a family can have no more effective way of ensuring that someone feels like an outsider - lacking identification with the main body - than by disinheriting them, so a state or other organization can determine identity by the acquisition of heritage or its destruction.

Not all things that provide identity can be regarded as heritage. As we have

defined heritage as that which people want to save, collect or conserve, heritage is recognized, designated and self-conscious by definition. The semi-detached housing, so typical of Britain and dating largely from the 1930s, has been virtually unique to Britain and, presumably therefore, an integral part of our identity since it was built. However, only recently has it become recognized as such, with John Betjeman among those who have helped us do so.[1] Only once we have recognized it can it enter the heritage process. In a recent radio programme, a French visitor to Britain hoped that the distinctive three-pin electrical plug would remain a national identifier, thereby starting the process to convert it into self-conscious heritage. This heritage creation is a tool deployed in many attempts to create an identity. A recent example was the Conservative campaign, in the 2001 UK General Election, to 'save the pound', converting what had been a largely unrecognized part of British identity into a recognized element of heritage.

Table 6.1 Heritage identity levels

Level	Typical heritage interests
International	UNESCO: World Heritage Sites – natural, cultural and cultural landscapes; Ramsar sites etc. Controlled by nation-states.
Continental	European Union, Council of Europe: mainly environmental and built heritage. Conventions; Cities of Culture; routes and networks; fauna reserves. Largely controlled by nation-states.
Nation-state	National museums, monument protection systems, regalia, honours. Also control levels above and below, with agenda of legitimation.
Regional	Some confusion between regional and national (e.g. Wales, Catalonia). Environmental, landscape and built heritage often administered at this level, e.g. English Heritage, CCW, Historic Scotland, *parcs regionaux* in France. Also sub-national sports and museums, especially folk museums.
County/civic	Monuments often administered at this level within national objectives. Also museums, archives, civic events and celebrations, commemorations, sports. Also coasts, and public parks.
Locality	Parish/ward is often responsible for footpaths, fêtes, local events, sports clubs, church. The level at which people largely know each other and the heritage is dominated by activities, sites and people.
Neighbourhood	The street, hamlet or block, which often share festivals, commemorations of events and people.
Home	Family routines, graves, photo album, pets. Largely matriarchal agenda. May be geographically dispersed.

Figure 6.1 Identities are important when under threat. Just as Scots and Welsh are more likely to be conscious of heritage than English, so folk dancing is more common in Moravia than Bohemia, and more common under socialism than since. (Photo: courtesy of Alena Salasová)

There are, no doubt, many things that distinguish identities which remain unspecified and unrecognized and which may never be called forth as heritage.

As seen earlier, the fact that there are things that we do not wish to be conserved raises difficult questions about the nature of heritage. Is Auschwitz part of German heritage whether Germans want it or not? Is slavery a part of British heritage? The answer has to be 'Yes', because there are people who want these events commemorated, whatever their nationality. Indeed the national adjectives here are irrelevant, and only a result of the national obsession of so much heritage work. Many people - German, Israeli, Polish and others - wish to see Auschwitz commemorated, and many people resident in many countries wish to see, for example, the relationship between slavery and the cities of Bristol or Liverpool commemorated.[2] So heritage may be foisted on the descendants of the perpetrators against their will.

So our identity is composed of more than our heritage, but there is a large proportion of identity – inevitably, the portion that dominates the agenda – which we have identified as part of our make-up and which we want to save. Most elements of identity can become heritage. So a uniform, a flag or a corporate logo, deliberately designed as an identifier, is also likely to become heritage when campaigns are mounted to conserve it. The Union Jack is certainly heritage, while last year's corporate logo may not be. There may be other parts of identity that are accepted as transient and which there is no campaign to save. The outfits worn by our athletes at the Olympic Games are clearly part of British identity, as is the song representing Britain at the Eurovision Song Contest, as may be the *haute couture* by British designers, but they may also be, of their very nature, transient.

The fascination in recent academic work with national identity has obscured the fact that we all have many identities, some of which have a geographical component and many others which do not. To suppose that the author's identity is summed up simply by being British is absurd; there is a gender identity, a professional identity, a religious and social one, even perhaps a sporting one, as well as a whole collection of geographical ones. Those other identities and their impact on the way we perceive the world and ourselves are discussed at some length in Chapter 8.

The geographical identities discussed in this chapter nest together like Russian dolls. Most of us manage to belong to a home, a neighbourhood, a town and a country all at once, and most of the time we manage all these identities without obvious conflict. They are not different hats which we wear at different times, but more like an outfit of clothes. They are more like clothes than skins because we have choice over our clothes as we do over our heritage. Within very broad limits, and ever-increasing ones, we choose who we wish to be. The only helpful way of deciding who is Cornish is to include those who wish to be. Classification by birthplace or parentage soon gets into very difficult territory, and moves towards racist policies. We might start to claim that some people who have lived in Cornwall all their lives are somehow not Cornish, while others, perhaps living in Australia and who have never visited the county, *are*. While this might make for a pleasing conceit at sporting contests, it is obviously very dangerous; the world of pass-laws, with jobs being reserved for particular ethnic groups, and other racist policies, is not far away.[3] So people choose their heritage, within limits. We may have difficulty manufacturing an identity with a far-distant place with which we have no connection, but we each have eight great-grandparents and we can choose

to be descended from any of them. Beyond the family, many people leave their home district and 'take a different identity', including a name, and perhaps even manufacture some grandparents to go with it. One of the understandings soon acquired by family historians and genealogists – amateur or professional – is that received oral tradition about ancestors contains immense quantities of mythical wishful thinking. One genealogist relates the story of discovering that a client was descended from an important immigrant Huguenot family, only to have the contract terminated by a determinedly Catholic client.[4]

How many layers of geographical identity we have will depend partly on these choices and partly on the complexities of the society we inhabit. They relate to levels of government, but only indirectly. These are personal identities and are emotional in character. In any family there will be members who are very conscious of the family unit and its membership, and there will be those who have little interest in it, and who indeed prefer to live completely outside it. So it is at each level. There are some of the nesting-boxes of governmental administrative boundaries, within which we live, with which we identify quite closely – perhaps parish, county, England – and there are others for which we may have little feeling – district, region, Europe. The types of things that create these levels of identity may differ as may their importance. The reason why debate has centred so much on the national is because the national level has, over the last two or three centuries, been so much more powerful and able to impose its identity than other levels. That was not always the case (the Church having been at least as powerful as the state for many centuries), and it may change again. There are certainly many who perceive the nation-state and its heritage being displaced by more local regional identities (Catalan, Welsh, Kosovan) and by international, continent-wide identities (European, African). This pincer movement attacking national identity, if it exists at all, is certainly being resisted, for example by the French in protecting its film industry, or the Danish in voting to keep the krone, and the two parts of it are by no means necessarily compatible. There is no automatic reason why the regions should be any more continental in their thinking than the nation-states, except that it provides the region with a powerful ally against the nation.

These people, at different geographical levels, who hold various meanings in heritage, are also the visitors to heritage sites. The interpretation of such sites needs to take account of the visitors' baggage of meanings, and may want to change them. The museum or gallery will often use temporary exhibitions to tell different stories to different kinds of visitor. There is a neighbourhood or civic story to tell to local, hopefully repeat, visitors, and a national or

international story for tourists. The resonance of such exhibitions with the aspirations of people at different geographical levels will be vital.

Home

The first, and often most deeply felt, geographical level is the home. This equates to a certain extent with the concept of the family, but the family may not be neatly encapsulated within a single place; so although 'home' usually has a geographical identity, the family often has not. There have always been varieties of family and many substitutes, but most people seem to live within a small community which can equate with home. The home is the insiders' sphere *par excellence*. There may well be people with a geographical identity at a lesser level than the home; there are doubtless many young people for whom their bedroom, especially if it is a single room, has real personal meaning at a much deeper level than the home as a whole. However, identity and attachment does not equate with liking. Attachment to places may well be a complex mixture of love and dislike, though it probably excludes indifference. The members of close-knit families do not necessarily like each

Figure 6.2 The American suburban home, perhaps through the influence of film, has become the archetypal architectural expression of home.

other all the time, and places with which we identify closely are as often infuriating as they are likeable.

Home, of course, is where the heart is. The old saw tends to overlook the fact that the concept of home is by no means universal, and only the Germanic languages have a word that expresses the difference between house and home as it is understood in English. The French *maison* does not have the same ring, although *chez nous* expresses a very significant feature of 'home'. Modern developers claim to be building homes, not houses, because they understand that a home is a house invested with all the meanings and emotions that residence brings to it. It will have a large array of objects which are redolent with memory and meaning. Good advertising suggests that it is better to build 'homes in communities' rather than 'houses on estates'. Some work has been done on heritage within the home, and has shown interesting variations between the things in which men invest meaning and those in which women invest, with the discovery that usually, the woman makes the heritage choices in the main centre of heritage collecting, the living-room.[5] However, asking people to nominate their favourite possession ignores some important points. Sometimes we do not recognize the significance of objects until they are lost. Many things relate to people and events, and their material worth is quite unimportant. The photograph album is a treasure in many households, and many heirlooms have little monetary value.

Equally, defining only material objects understates the significance of the non-material. Many of the things that identify the home relate to how things are done. When family members leave and establish their own homes they discover that there are other ways of celebrating Christmas, that some people have breakfast in the dining-room or that they put the milk into the cup before the tea. There are annual celebrations that mean nothing to outsiders. There are special places, too, invested with meaning from previous events. Where the home has been inhabited by the same family for some years or generations, the place will be alive with the ghosts of those things and places that stand as permanent memorials to events, incidents and accidents of the past. Such meanings, however immaterial, are immensely powerful, and do not relate to outsiders' official heritage in any way.

Many properties had previous occupants; they were different homes. The relationship with previous occupiers of the house is another ambivalent and problematic one, both parties having much in common but being very cautious of the changes made. Some people, including the writer, inhabit houses that had a notable previous occupant, who is a peculiarly powerful ghost. On the

one hand this may produce a pride in the property, but there is also the disturbing feeling that visitors to the house somehow disapprove of recent changes. Managers of heritage buildings that are or were also homes have a major task to accommodate the meanings of the residents.

Dispersed homes

The identity of home may not have a simple geographical location. There may be other houses from one's childhood, as well as the homes of close relatives. All of these carry powerful meanings and memories; so the heritage of home, to an extent, transcends geographical boundaries. There are several people living for whom an old house carries special meaning.

There are those, too, whose home does not have a stable geographical location. Nomadism is a very old lifestyle, and transhumance (shifting between two homes) has a long history also. Modern transhumance may occur weekly between town flat and weekend cottage, or annually between work home in England and holiday home in France. Then there are groups of a travelling nature, especially Roma, for whom the concept of home is not geographical, but whose heritage can clash very crudely with settled people. Indeed, the conflict between settled arable farmers and nomadic pastoral farmers has been a universal cause of conflict, whether Hutu and Tutsi or cowboy and farmer.

Management

The heritage of home resists management, except by those entitled to manage. Members of the home group may dispute among themselves the right to manage and control the home heritage ('Where shall we keep the trophy you won at football?') or of what it consists ('How long do we intend to keep that moth-eaten chair your mother left us?'), but they will soon combine to assert their joint right to make such decisions and will resist attempts to take such control away from them. So the natural reaction to an attempt to designate one's property, as is commonly done in Spain, and to restrict the things one can do with it, is to resist. Such resistance has to be overcome by large amounts of prestige (cultural capital), and some financial advantage also helps.

Exercise

Locate the heritage items within a home, probably your own. These could be the china cabinet, the photo album and things in the attic or in the garden, but they will be elements of material culture that are invested with 'sentimental value'. Who looks after them? In which room are they conserved? What events are also part of the home identity? These could be holidays, anniversaries, celebrations or memorials.

Neighbourhood

The neighbourhood is the geographical area within which we are insiders, where we know more or less everybody, and where they know us. There may be different sizes of neighbourhood in urban or rural environments and the techniques of mental mapping are useful in determining them.[6] There will be places in the United States where an entire county may be the neighbourhood, or in Australia an even larger area. In many cities it may be merely a street or two, or even a single building. In Spanish cities the term 'neighbour' is applied to other inhabitants of the same block of flats, few of whom one may know well. It may have a multiple or tiered element, with small groups of homes within a wider grouping, as so many Cornish villages actually comprise several hamlets. The author lives in a hamlet that lies near the edge of a village. The latter is a wider locality where one would expect to recognize and be recognized by, everyone and where there are important elements of physical heritage to be jointly conserved. In towns, a single housing estate can equate with this sub-level.[7] The village green may be stoutly defended against any encroachment – except by the erection of a communal building, e.g. a village hall. The school, the shop and the pub will be defended as much for their social functions as for their architecture. The church is in a slightly different category – a symbol rather than a social function, except for a few. Most localities will show a similar range of heritages, and they may well include natural as well as man-made phenomena. Trees may be important, but this may be as much for position and function as for rarity or age. One tree may be the village conker tree while another may be the support for the annual fete. Thus the neighbourhood will certainly save certain physical things, natural or cultural, but its interests still tend to lie towards the less material, and will be concerned with events. Even the significance of the physical heritage tends to be negative rather than positive – no-one takes too much notice until there is a

Figure 6.3 The stocks in Broadclyst, Devon, represent an official conservation of village heritage, but the corrugated plastic attempt to protect them reminds local people of the man who made it, now deceased.

threat. This has been the history of heritage protection over centuries. Before 1800, conservation was almost always a response to threat, rather than the outcome of positive designation by survey and inventory. This remains the case in the community. Only when the local open space or the footpath or the chapel are threatened do they assume a dominant position.

Much of the local heritage, too, is not physical. A game of 'The Knowledge' is played in most communities. Many places have unrecorded names or special pronunciations to distinguish outsider from insider. The small port of Topsham is pronounced Tops'm by residents and, usually, 'Top-sham' by others. 'Our place' is clearly not 'yours' or 'theirs', and this has always been the case. Indeed, the very name is imposed from outside. To insiders the place is simply 'here', or 'the village', or 'going into town'. Only outsiders need a name for it. So Walton is an English name for the 'village of the Welsh', whereas Inglesby is a Danish name for 'the village of the English'. Small communities manage perfectly well without house names or numbers, which are only needed for outsiders. There are sites of importance and regular events – such as the Guy Fawkes Night bonfire in the field, the annual street market,

the visit of the fish-and-chip van on Friday evenings or even the regular monthly visit of the rubbish skip – that turn into a meeting-point and an opportunity for a beer. The locality knows the niceties of distinction in social class of each bar in each pub. Residents will feel free to criticize any aspect of the place and its life, but they are united in their opposition to any outside attempt to identify or to cure the problems. Such close-knit communities might even be distinguished by their mutual animosities. If there are no points of distrust, dislike and suspicion it may be because new inhabitants have not been there long enough to develop some grudges, or that they do not spend a sufficient part of their lives in the place for them to have any interest in their neighbours. Such places, filled with newcomers who 'keep themselves to themselves', are perhaps now almost the norm, and may develop their own heritage identity, as the suburbs certainly have done. A heritage code of behaviour can be negative as well as positive. The traditional joke of no talking on the commuter train may be one such heritage non-activity.

Otherness

This introduces the concept of 'the other'. At most levels of identity, certainly including the neighbourhood, though much more common at national level, is the fundamentally divisive nature of heritage.[8] Many neighbourhoods are defined as much by social, religious or ethnic group as by location. Identities are so much easier to define if they are negatively drawn against another locality, nation or group. A significant element in Irish nationhood has been, quite simply, not being English or even British. Many nations have a significant 'other', a place against which they define themselves.[9] Considering that Britain and Germany have fought two world wars within the last century, it is perhaps surprising that the British significant other is France and not Germany. With a degree of monotonous regularity the articles in the more xenophobic British press referring to the awful doings of 'foreigners' or 'continentals' are actually about the French. The Spanish too have the French as their 'other', while the smaller nations inevitably have their large neighbour – Spain for the Portuguese, Germany for the Czechs. 'We' are not like 'them'. The same is true between villages and localities, between cities, between counties and even between regions. The annual 'derby' match is, of course, a significant element in this rivalry. Just as beating England at rugby is, for the Welsh, rather more important than beating Scotland or Ireland, so it is

important for Newcastle United to beat Sunderland, or for Lancashire to beat Yorkshire in the annual Roses Match in cricket.

Humour will often illuminate these divisions. In Germany the regional distinctions are marked by the division into Länder, and much German humour is based on the supposed characteristics of the Prussian or the Bavarian, the Saxon or the Rhinelander. The richest vein is perhaps connected with the 'There was an Englishman, an Irishman and a Scotsman' breed of joke. Of course, in order to understand it, it is essential to understand the mythical characteristics of each – English snobbery, Scottish meanness and Irish stupidity. So those who do not have this knowledge – the real outsiders – cannot understand. If each country has an 'other' to match itself against, most also have a butt of their humour. So jokes told against the Irish by the English are often repeated by Irish about people from Kerry, and similar tales are told by Germans about East Frieslanders, by French about Belgians, by Americans about Poles and by Canadians about Newfoundlanders.

At a regional level there is the constant attempt in the north of England (as well as of Italy, Wales, Spain and many other countries) to underline the

Figure 6.4 Cornish identity revolves much more strongly around mining and fishing, which can be seen as distinctive, than around agriculture or tourism which they share with other parts of the country. Tolgus tin streaming works north of Redruth is one of the Trevithick Trust's properties.

distinction between them and the southerners, whereas in the south-west of England there are many attempts to distinguish the line between the south-west and the south-east. North–south distinctions are probably inherent and derive directly from latitude – those nearer the pole usually perceiving themselves as colder and therefore harder-working than their warmer, more idle neighbours. Appleton has suggested that the east–west distinction also has a fundamental element: the sun rises in the east, hence we tend to face 'eastward' and perceive a threat coming from that quarter.[10]

Such distinctions underpin heritage at every level. The heritage of the level of the home and family is densely influenced by the differences perceived between the identity of this household and that one – heritage and identity are powerful elements in 'keeping up with the Joneses'. The Joneses, who really perform the service of being the 'other', may be next-door neighbours, but they may also possibly be one's brother's household. Only at the United Nations level are we free from such an 'other'. In studying the heritage of any area or any group (for the 'other' of most minority groups will usually be the majority group) it is well to identify the 'other'.

City/district

For those living in towns and cities of considerable size, the neighbourhood, the area where we are known, will only be a constituent part. Most inhabitants accept an identity to a city, or a city-region, though the alignment with the rural district is often much less strong. Ennen's work makes clear that the proportion of the inhabitants actively concerned with the built heritage is quite small, even in well-defined and historic towns.[11] The district to which some identity is felt may not reflect the administrative boundary, designed much more for convenience than identity. One of the important markers of this identity is the local newspaper and its region of distribution which, being ephemeral, is one of those that does not have an obvious heritage element.

The identities of rural districts may vary from those that are highly defined, and regarded by their inhabitants as very distinctive, to those that are much more amorphous. Islands, such as the Isles of Scilly, clearly come in the first category, but so do places such as the Peak District, Penwith or even the Vale of the White Horse. A strong geomorphological personality does seem to be related to a strong local identity, which is obvious in many places but is

sometimes adopted to underline locality. The Cévennes National Park in southern France, for example, uses the distinction between the granite of Mont Lozère, the limestone Causses and the schist of the south-east valleys to emphasize landscapes, products, activities and an entire heritage identity. Indeed, there is a long French tradition of stressing the uniqueness of these *pays*.[12] However, there are many places where even the official district name hints at a lack of strong identity, either because it is merely directional, such as mid-Devon, or because it is a name produced from obscure sources the boundaries of which are simply not recognized by anyone, insider or outsider: for example, Wansdyke, where a significant prehistoric feature is used to give the prestige of antiquity to the area surrounding it, but without any justification for the boundaries or traditional use of such an appellation. In such instances the search for a name that will not offend any group often

Figure 6.5 The civic identity of the former steel town of Le Creusot is firmly reinforced by the display, on a roundabout on the main access road, of what was once the largest steam hammer in the world.

results in a new name with historical precedence; the use of heritage in an attempt to promote unity.

Most cities have not only a much more powerful identity, but also one that has been cultivated by authority over many years. In the UK, most city authorities of any size rank as either district councils or single-tier local authorities, and will therefore have planning control over the listed buildings, scheduled monuments and conservation areas within their boundaries. The council will probably own several conserved major buildings and probably a civic museum and/or art gallery. This is the first level at which the local, insiders' view of heritage is at least balanced by both an official view (that of local government), expressed by the council and its officers, and by a tourist view (that of the visitor), also cultivated by those responsible for the town's welfare. The very title 'city' will be guarded jealously, together with the ceremonial and paraphernalia that go with the title, even by those small places, such as Wells or St David's, whose claim is historic and ecclesiastical rather than relevant today. Towns without such status actively seek it, and three new cities were created for the millennium – Brighton, Wolverhampton and Inverness – all vying to demonstrate their heritage credentials. Such a title becomes another of those heritage titles that have no real power attached to them, but which remain, nevertheless, greatly sought and having considerable cultural capital. Other examples are Lord of the Manor, Order of the British Empire and even Peer of the Realm. There is an uneasy feeling that many spatial designations are similar; indeed, long ago it was suggested that the designation of the Tamar Valley as an Area of Outstanding Natural Beauty 'solves nothing but makes everyone feel better'.[13]

There have been spectacular successes in the rebranding of cities, with Glasgow as perhaps the most outstanding example, and Newcastle now seeks to emulate Glasgow's success. The significance of major events such as the Glasgow Garden Festival and its designation as a European City of Culture can be critical. Overseas there have been very successful cases in Baltimore, Bilbao and Weimar. In the most successful cases there has been a deliberate campaign to stress genuine achievements and to return pride to local people. The heritage has been restored, re-enacted and conserved primarily for the sake of the city's prestige and its inhabitants' pride, though no doubt with an eye on tourist revenue. Glasgow really does have a long history, an ancient university and a cultural tradition that might have become largely obscured by the industrial developments of the nineteenth century. Newcastle is also an ancient foundation and historic city. There have been less successful attempts

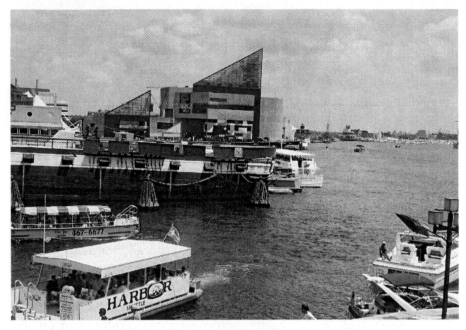

Figure 6.6 The waterfront at Baltimore is one of the first waterfront developments with a close eye on local heritage. There has since been a tendency for every riverside city to develop very similar heritage districts.

to puff up a rather undistinguished history and graft on tourist visitor attractions that might have been placed anywhere. There is emerging some experience which suggests that few people will travel very far to a place perceived as unattractive merely to visit a museum or a visitor attraction, however good it is.[14] The Earth Centre, near Doncaster, and the Royal Armouries, in Leeds, for example, are struggling for visitors. The Millennium Dome may come to be seen as the classic example of this phenomenon.

City heritage extends much further, of course, than buildings and artefacts. There are many events and organizations of considerable significance, from the football team to the annual festival. Cities, too, tend to have a 'Golden Age', a feature strongly marked at national level. This may be imposed on the city inevitably by history, but certain times are clearly preferred. So often in Britain the age is either Good Queen Bess or Queen Victoria. The exception is Bath, which is firmly stuck as a representation of Georgian England. Most gem cities have such an obvious period, when they were built and since when they have been in decline. There is celebration of local worthies also by street names and by monuments. Occasionally, these can provide controversy, perhaps because, as at Bristol, the city's most prominent philanthropist, Colston, earned the

Figure 6.7 Telč, in Moravia, is a classic 'gem city', largely built all of a piece in the late sixteenth century, which has since decayed. It is now rapidly being restored for visitors.

money he somewhat niggardly disbursed from the slave trade.[15] In Exeter stands the neglected statue of General Sir Redvers Buller, VC, a genuine Victorian hero in his younger days, whose later reputation was rather tarnished in the Boer War, which is one of many wars the British have decided quietly to forget, until very recently.

Exercise
Examine the heritage elements of the marketing campaign of a town or city and the techniques by which rebranding is attempted. Which departments of the council are involved? Are the museum, the built heritage, civic events, parks and gardens all being driven by a common agenda? And to whom is that agenda aimed – tourists or locals? Is a heritage district emerging, largely ignored by local people?

County

Inhabitants of all but the very largest cities often have another identification with a regional unit such as a county, in England, although such identities seem much weaker in Scotland and in Wales, or indeed in France. The persistence of such identities is impressive given the number of changes to county boundaries over the last century. Although the detailed boundaries may have changed, entities such as Yorkshire, Kent or Warwickshire have existed since before there was a recognizable country called England, and long before the union with Scotland. Such long histories are not easily erased. In France, Napoleon made a determined effort to efface the old provinces by creating a network of new *départements*, in order to strengthen the power of the central government. Despite two centuries of promotion and the power of the central state, the provinces still emerge and have, to an extent, been resurrected in the French regions. Burgundy seems to have more resonance than Saône-et-Loire. The British government operates in a very similar way. Yorkshire has been split into several constituent parts, while boundaries have been greatly changed elsewhere, usually to the benefit of cities. The old allegiances largely remain, however, and Somerset Cricket Club still expects to draw on support from outside the current boundaries, from those parts of the old Somerset now under other administrations, while Middlesex exists in speech, in postal addresses and in Wisden, if not in administration. These loyalties invade the tourist literature and the guidebooks, which treat Yorkshire as being between the Tees and the Humber, whatever the government says.

Region

Regional government is not strong in Britain, unlike in Germany, and the regions of England have even less power than the regions of France, although if Scotland and Wales are considered to be regions, then some power is now devolving. The English regional offices of central government have little democratic authority and no policy-making role, although the new Regional Development Authorities are attempting to produce an official regional heritage. There may, nevertheless, be significant identities and loyalties obscured by this lack of official recognition. But our identities do not necessarily follow government directives. The north-east of England, with

a quasi-official capital at Newcastle, probably has a closer identity than elsewhere, even for a time meriting its own minister. The official region also includes Cumbria, a fact not recognized by the population either east or west of the Pennines. This identity is clearly based on remoteness, an industrial history that has similarities and a geomorphological likeness. The common understanding does not prevent Tynesiders, Wearsiders and Teessiders having local competitions. A regional 'appellation' is less often heard in other parts of the country, for example the east Midlands. Americans and Canadians, though, have very powerful identities at this level, which clearly relate to the state and the province. Many would regard themselves as Texans first and Americans second. Even the car number-plates reflect this identity, with New York being the Empire State, and New Jersey the Garden State. Spain, as well as Germany, has devised a form of government that attempts to give the various regions the amount of delegated powers they would each like. Catalonia (with a specific linguistic heritage, like Quebec) would like more than Aragon, but, of course, not everyone believes they have enough power, as the continuing terrorist action in the Basque country demonstrates.

In most countries there are, therefore, a number of layers of identity between the neighbourhood (where everyone is known) and the nation, a large group or imagined community,[16] held together by various bonds, but comprising considerable numbers of people. These intermediate heritage identities are usually unable to compete with the nation, as the legal authority to make heritage, to provide public funds for conservation, lies usually with the nation, and those national governments have no more intention of allowing the constituent parts to develop a quasi-national identity than autocratic kings approved of over-mighty subjects. So, with the exception of the federal states such as Spain or the USA, the nation remains the most important repository of heritage.

Exercise
Map the various regional identity markers. Is there a common understanding of the 'region' between the newspaper's sales area, the television region, the official government region, the sports leagues and all the other regional organizations, public and private? What common elements are identified by the Regional Development Association?

Nation

Nations, we have come to accept, are 'imagined communities'. This acceptance is comparatively new, and in days of less travel, nationality was often perceived as a natural feature. Talk of English, or British, blood was quite common, and few people would accept that nationality was entirely learned.[17] This new acceptance of the constructed nature of nationhood seems, uneasily, to sit alongside a great upsurge of national sentiment in many parts of the world, but especially in Europe, from Spanish Galicia and Scotland in the west to Dagestan and Kosovo in the east. Exactly what constitutes a nation is still deeply mysterious and varied, but it is, or can be, different to a nation-state.[18] The United Kingdom is a nation-state comprising at least three peoples – English, Welsh and Scots – plus some who consider themselves Irish, and many others. Only a few European nation-states comprise more or less exclusively one nation – Portugal, perhaps, or the Netherlands. The glue that holds nations together also varies dramatically, but it is the nation and the nation-state that have held the central field in heritage and identity for very many years. A book concerned with identity exclusively would focus on the nation, if only because nations have been so adept at manipulating it. In heritage management, this would be even more true, as heritage policy is mainly made at national level. Even those nations that are less than nation-states, such as Catalonia or Wales, frequently have control over their heritage.

Territory

Nations use heritage largely to legitimate their authority, demonstrating both that the boundary possesses some ordained significance, and that within the boundary there is considerable cohesion. Britain's national boundary, the sea, has at least the advantage of being clear, though the assumption that the sea was a divisive rather than cohesive influence was probably unreasonable until the invention of the railway and fast terrestrial transport. The 'English' Channel, like the river Rhine, is, by nature, suited to be as much a pathway as a boundary. Other administrations have much more difficulty over historic boundaries. The Welsh boundary with England has been a shifting phenomenon over the centuries including quite recently when Monmouth-shire, in England, became Gwent in Wales. France remains the best example of

a nation-state attempting to impose cohesion on its territory by the construction of equal-sized departments, and the concept of l'Hexagone. Many African states today are busy producing a heritage to inscribe a national identity onto lands where the boundaries were defined by colonial powers in the nineteenth century with little reference to any physical or social distinctions. Even in Europe few boundaries have the historic tenacity of the Pyrenees or the western boundaries of Bohemia.

Where administrations perceive their boundaries to be inappropriate, this is because some further area 'naturally' falls within it. So administrations are forever justifying either their existing boundaries or an enlargement of them. The Poles have a minister for Polish Cultural Heritage Abroad. Within the boundary, the wish is to legitimate the similarity of all the territories. Very shortly after the creation of a Scottish parliament, in 1999, a prominent Scottish composer reminded his nation that the Scots were very far from being a wholly united nation, and that the Scottish attitude to its Roman Catholic minority was a difficult area. Similarly, some Asian inhabitants have complained that while they do feel British they do not feel Scottish. The myth of Scottish unity could not be exploded until a sufficient degree of autonomy had been achieved. The United Kingdom government, of course, for ever emphasizes the things and activities that hold together the different parts of that territory, and among such things, including the Crown and military pageantry, has also been the history taught in schools, now clearly contested in Scotland and Wales.[19]

Common identity

National identity has been the subject of so much work over the past decade that there seems little point in repetition. Nation-states have wielded heritage to create themselves and to distinguish themselves from foreigners. Such manipulation of identity is immensely successful. England, for example, and, later, Britain, especially in the eighteenth century, invented itself as a Protestant nation opposed to Catholics on the continent and in Ireland.[20] This bore little resemblance to the liturgical practices of the Church of England, which remained hard to classify but which are certainly not Calvinist. Indeed, the Church of England has retained the Catholic creeds, and regards itself as Catholic but reformed. Such a sleight of hand was most successful. The bulk of the English population could be contained within one Church, while the state

was provided with a powerful identity to use as it wished. Threats to the security of the state could be ascribed to papists. Scotland, with a much more Calvinist tradition, could be contained within a nation that regarded the defence of Protestantism as critical to its identity. The result, for people visiting England from a Catholic country, is complete confusion. They had come to understand that this was a Protestant nation, but they cannot distinguish Catholic from Anglican practices.

Such clever manipulation is commonplace in heritage, and legitimation has been a major reason for conservation. The palace of the Louvre ended as a museum, and Versailles itself was not demolished. Later, in Russia, the Hermitage palace also became a museum – national heritage contained within a national heritage building. When the Soviet Union subjected eastern European states, the national museum in Prague, for example, was not closed, but the exhibits and the national history were rewritten. All the national museums of eastern Europe were very busy in the 1990s rewriting that history

Figure 6.8 The Tsar's Bell stands in the Kremlin, in Moscow. Russian visitors have themselves photographed against it to unite their personal heritage with that of the state.

once again. Any feeling of British superiority, that we have no need to rewrite our national history, needs to be tempered by looking at the changes in the History curriculum now in force in Wales and in Scotland.

The features that stand for that national identity can be quite surprising. In Washington one is photographed in front of the White House, and in London in front of Buckingham Palace. But in the Kremlin stands the Tsar's Bell, a huge artefact which was too large to be hung successfully in the bell-tower, and which has stood, broken, on the square for many years (see Figure 6.8). It has now become iconic of the nation, and visitors to Moscow, from the furthest-flung reaches of Russia, have their photographs taken beside it. Their family heritage, contained within the photo album, is united with the national heritage, represented by an oddly broken symbol of the continuity of Russia.

Totalitarian governments produce identity as a deliberate policy, and the maintenance of selected parts of the cultural and natural heritage is integral to such a policy. Sometimes, too, they deliberately destroy heritage, as has been so obvious in the Balkans and in Afghanistan with the Taliban destruction of Buddhist monuments. The cult of personality is a part of heritage creation. But it has not only been dictatorships that have manipulated heritage for centuries. The capital city acts as a repository of the best in the nation (and in the empire, too, in the case of London, Paris and Lisbon).[21] In many countries the classification of heritage artefacts and buildings uses terms such as 'of "local"', "regional" or "national" importance' as levels of increasing significance. Items deemed of 'national importance' should naturally be housed in national museums – and that means in the capital city. The recent restoration of the Stone of Scone, Scotland's national heritage, from Westminster to Edinburgh was of profound symbolic significance – devolution was visibly occurring, and power was moving along the road and across the border.

National museums presume dominance over regional or civic museums. Items of real quality discovered in the provinces are assumed to be 'too good for them' so that the Lindisfarne Gospel is in London not Newcastle, let alone Berwick-upon-Tweed. There have been reversals to this policy in two ways. First, national museums now exist in Edinburgh and Barcelona, as well as London and Madrid, and they make strong claims to house Scottish or Catalan heritage (see Figure 6.9).[22] Second, some national heritage is deliberately moved out into the provinces, for example the National Armouries to Leeds. Often this has been to act as a development catalyst in an area with economic problems, just as with government departments, as with DVLC in Swansea. So

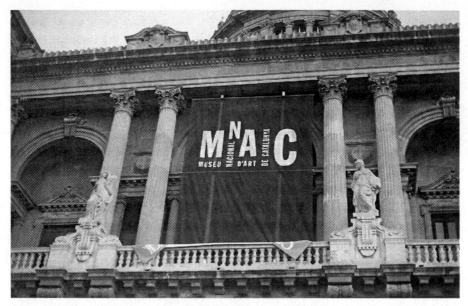

Figure 6.9 The disputed nature of Catalonian national aspirations can be seen clearly in their museum façade in Barcelona.

far the policy has not been an unmitigated success, at least as far as visitor numbers are concerned.

Golden ages and places

The concept of the Golden Age is well known, and many countries, towns and regions look back to a particular period of special importance; the best known is perhaps the Dutch Golden Century, the seventeenth. In Britain the age of Queen Elizabeth I has the same significance, and perhaps in France it is the reign of Louis XIV. Perhaps one should not be surprised to find that the Golden Age is usually the period when a country's power and influence was most widespread. In Norway it is inevitably the Viking period, not the period when Norway was the territorial possession of Denmark or Sweden. In some countries it can be quite modern, and the Czechs look back to the First Republic between the two world wars.

Many of the landscapes designated as being of special importance are similar to the Golden Age in that they are places that summarize the nation's (or group's) self-image more than other places. The Norwegian Vestland, around the Hardanger and Sogn fjords, is one obvious example, while

neighbouring Sweden has Dalarna,[23] where almost every village has its folk museum. Irish nationality is focused on the Gaeltacht in the west rather than the Pale of Dublin, which has led to considerable difficulty in taking the national capital into the bosom of the national identity.[24] In England the 'golden places' are probably the Vale of Sussex and the Cotswolds,[25] which are the epitome of the English landscape, recurring over and over again in novels, poetry and painting, at least in the twentieth century. There are other highly favoured places also, such as the Lake District or the Cornish coast, but these represent the 'otherness', and are often praised for their un-English qualities.

Apart from named geographical areas, there are also landscape features that have regional or national resonance. The 'lake in the woods' has a particular significance in the United States, not unconnected with Thoreau's writings at Walden Pond,[26] and reinforced by films such as *On Golden Pond*. The coniferous forests of the Schwarzwald have a similar place in many German hearts, as their suburban gardens, so often reproducing a fir forest in the town, witness. Such landscapes and features represent the mythological heart of the country or region. But these 'national landscapes', which have arisen more or less naturally through art and literature, are by no means the

Figure 6.10 In Germany many people follow rivers to their sources, hence their source springs have particular significance. In this case there is no fresh spring but a rather boggy area caused by water welling up, so a new spring is being dug out and constructed.

same as the national parks, which are, of course, government definitions, and are influenced by practicality as well as romance. There may also be 'golden people', whole groups regarded as being somehow more representative of the nation than others. In France these are probably small farmers, in Britain seafarers, and in America cowboys

The peoples

Nations, however, are more than governments, and the people's need for heritage is perhaps less concerned with legitimation than that of their rulers. These nations, of peoples, consist of self-selected groups. The English are those who consider themselves as such, and buy into a particular set of identities. Many of them will be British subjects resident in England, but there will be many living abroad – ex-pats etc. – while many British residents will not consider themselves British. The distinguishing features of these nations are various. Some regard the language as the most significant identifier, a jealously guarded heritage. The Czechs and the French do so, but English is too widespread for it to be a defining feature here. These heritages – of the nations as distinct from the states – not surprisingly tend to come from the activities sector, rather than from physical features. Language and religion are definers in some countries, and sports are probably the most regularly shouted identity, whether it be the English cricket team or national efforts in the Olympics. To regard a sprinter as 'running for Britain' makes no more sense than to say she is running for her own pride, or her family, her church or her village. But national pride is too deeply ingrained to be eradicated easily, despite the occasional sport where it has been avoided, such as the European golf team. Diet and drink are also significant national markers – ones we are happy to share with others, but which remain our own. The full English breakfast and afternoon tea are important heritages, as is top-brewed beer, as distinct from foreign lager. The day is divided into sections that are very national. Many tourists have been caught out by the completeness of the French lunch period or the Spanish siesta, while English streets are sometimes frequented at say 6 pm by hungry visitors who are quite unable to grasp that everyone has gone home. National heritage can also, on occasion, override decisions of the state. The United Kingdom has 'gone metric' on many occasions since the Napoleonic Wars, and only people over 45 will have been schooled in any other system than the metric one, with the possible exception of temperature. This has made precious little

difference, and people still happily buy beer in pints, meat in pounds and timber in inches. Other activities are ceremonial, whether harvest festival or Remembrance Day, the opening of Parliament or the Queen's birthday honours.

National heritage is not restricted to activities however. Some buildings undoubtedly become iconic, and these may be approved by the government. The Eiffel Tower can be used as a shorthand visual image not only for Paris but also for the whole of France, as can the Houses of Parliament in London. Building types are used in the same way, with the thatched cottage being a particularly English preference, though it is also a Breton icon.

National usually takes precedence over regional or local. County cricket teams or civic football teams are expected to allow players to play for the nation, and this 'national interest' is critical in most heritage areas. The national parks are there for the benefit of the nation, and parochial, local and regional interests must take second place, unless, of course, the locals can persuade the nation that their local-ness is somehow symbolic of the nation also. The National Trust, too, has a brief for all the people, and has come, in its second century, to appreciate that the heritage it conserves should be not only that of the rich and powerful holders of cultural capital, but also of the many who have felt dispossessed.[27] The nation, in this case, is a strange one, consisting of England, Wales and Northern Ireland, but in any case it is not local. While the Trust attempts to treat sympathetically its thousands of tenants, they do not hold votes in council, which are reserved for members representing the national interests.

Exercise
Select a foreign country of convenient size and investigate the heritage protection systems in force and the country's self-promotion. How are nature, landscape, monuments, museums and sites managed? To what extent does the nation invest its identity in those official things? What other elements are of vital national importance to the people? Is there a 'significant other'? Are there golden ages and places? Which arts do they regard as especially their own? Do they have nostalgia for 'lost lands'?

Europe

If nations and their heritages dominate regional and local heritages, so that the latter can only operate within the determined rules, there is now another

competitor, which is the continental level, with attempts to provide some degree of overarching identity in Africa (at least south of the Sahara), Latin America, the Arab world and, of course, Europe. There is much discussion about whether the European Union is a collection of sovereign independent states who co-operate for various purposes, or whether they are moving towards 'ever closer union'. Nowhere is this debate more evidenced than in the EU's attitude towards heritage and identity, which is highly ambivalent. One problem is that responsibility for heritage is divided between different commissioners and directorates, a division much more complicated than the usual one that exists between nature and culture. The problem, however, is much deeper and concerns whether Europe should promote an identity or not. Supporters of the first proposal, the group of independent states, will clearly not be prepared to spend money on giving Europe an identity, defining and designating a heritage at a European, supranational level, an identity which would be viewed as competing with national identities. Political parties who support that view have no wish at all for people to 'feel European' and they consistently stress the differences between 'us' and 'them'. This is far from restricted to the British, although Britain may be one of the few countries where people consistently refer to 'Europe' as though it was some other place, like America, across the sea. Providing European designations, such as Special Protection Areas, for environmental or immovable heritage, may be supported in order to provide a degree of common understanding. But clearly, even those national governments that are most federalist in their policy are often still not prepared to support, for example, the very best exemplars of heritage being removed from national capitals and deposited in a massive European museum in, say, Brussels or Strasbourg.

Perhaps it is no surprise then that the major player at European level is not the European Union but the Council of Europe, a much wider organization and one without aspirations to political union. So CoE actions, being almost entirely within the control of the member states, have been much more widely welcomed. There have been many major campaigns, conventions and designations, but they still fail to address adequately two major problems.

The first problem is to define Europe, as clearly neither the membership of the EU nor even the CoE is adequate. Presumably the ideal is to find an identity to which all those living within the bounds can assent, while at the same time excluding, but not dismissing, those outside. If Russia is included, then that includes Vladivostok, and if Vladivostok is part of Europe, then to exclude Washington or Rio de Janeiro would seem absurd. If we try self-

definition then we simply start the circular argument, as the whole point of creating a European heritage is that not many people feel a European sense of identity. Whichever area of heritage is taken there are real problems of definition.

The second problem is migration. European people and culture have spread all over the world, and others have spread here as well. The history of Europe is littered with major migrations from Asia and, more recently, and less willingly, from Africa and the West Indies. It is very difficult to imagine any aspect of any European heritage that would not exclude, and positively denigrate, many people resident on the continent.

There was a time when this was not a problem. The term Europe was once uncommon – it was usually called Christendom.[28] Even then there were, of course, major groups of outsiders, notably Jews and Roma. Christendom had once included much of the Middle East, but one part of the history of a 1500-year span was the struggle between Christianity and Islam played out in Spain and later in the Balkans. Such a concept of Christendom even managed to survive the Reformation, which added a third part to Christendom – Protestant, as well as Catholic and Orthodox. Despite the wars between these groups, there remained some sort of acceptance of a common bond. But Christendom could not survive nationalism, and the decline in organized religion has made it impossible to revive it, even if it were considered sensible to revive a concept that would alienate all the Muslims, not only in Kosovo and Bosnia but also in Britain, France and Germany, as well as other groups. Nevertheless, echoes still remain. Turkey has applied for membership of the EU, but this seems to meet with a resistance which is not entirely explained by Greek enmity or by human rights abuses.

So if European heritage is not religion, of what might that heritage be forged? All experience at national and sub-national levels suggests that to create a heritage of buildings, of designated landscapes, of nature reserves and Red Books of endangered species, would be comparatively straightforward, and a feasible result of official national governmental organizations working together. Indeed, to a considerable extent that has been achieved in the various conventions. But it will not touch many hearts. The real heritage bonds are more abstract, and more difficult to forge. If religion will not do, then sport is at least a possibility. In golf, Europe now plays as a team, though golf is scarcely the obvious team sport. Certainly, there are European athletics meetings and European leagues in football, though whether football matches between national teams create a sense of unity must be strongly in doubt.

Indeed, if war was once famously described as 'politics continued by other means', then sport, all too often, is war continued by other means.

There are several other candidates. The sea is one distinguishing feature of the continent, the relationship with its history and economy being very deep-seated. In the cultural field, music is the most obvious example, not being based on language. But, despite the Eurovision Song Contest, there may be now no music that is distinctively European. This continent has been so successful in the cultural field that European music and art have become world culture, and we have been left with little to call our own. Indeed culture tends to be either European (or western) or 'ethnic'.

One of the major problems may be a lack of an obvious 'other', which would need to be not only sufficiently different but also sufficiently known. China, for example, may be different, but it is so unvisited by Europeans that the differences are of little concern. The only real candidate has to be America; and France is by no means the only nation, though it is the most prominent, to stress European culture as distinct from American – to protect its own film industry, language and culture against American (or Anglo-Saxon) infiltration. A Hungarian author recently pointed out that globalization was actually Americanization,[29] and this puts the UK in an ambivalent position. Continental anglophiles might argue that Britain can act as a buffer against American interests, but anglophobes may regard it as being an American cultural aircraft-carrier, raining down fast food, jeans, Hollywood films and the English language onto the Continent.

The other great difficulty lies with the very history of Europe. This continent does not have a monopoly on war, genocide and ethnic cleansing, but it has had more than its share. Any heritage of Europe that fails to take account of the dark side is doomed to be undermined. As the European Union strives for closer co-operation, one cannot ignore the fact that other attempts to provide unity throughout as much of Europe as possible included the efforts of Caesar, Napoleon, Hitler and Stalin. So perhaps the monument on the hill south of Slavkov nad Brna in Moravia, at Austerlitz, the battle of the three emperors, is critical to European heritage. If so, then so too must be Verdun and Auschwitz, Dresden and Sarajevo. Perhaps the single most cohesive element in the history of Europe is the constant tramp of everybody's armies and the constant flow of refugees from each of the tribal territories. Even in commemorating such events there seems to be no end to the ability of national interests to turn the interpretation into a celebration of national prowess and military glory, as at Waterloo, although

Figure 6.11 A British cemetery from the First World War, though with some German graves also, at Ration Farm near Armentières. Any heritage of Europe which ignores such sites is surely doomed to fail.

displays of tactics and strategy can also be remarkably free from nationalist rancour.

Some attempts have been made with European paths, the first being the Camino to Santiago de Compostela, and many more are now planned. But perhaps a common European culture is being forged more on the crowded beaches of the Costa del Sol, the campsites of France, in the festival at Salzburg and on the tourist trail at Rome. The latter has been a European City of Culture, another successful CoE initiative, although this has carefully refrained from defining European culture. A common European identity may well be emerging unnoticed by many, and it may be much more vernacular than people imagine. Modern houses and even clothes look very similar throughout the Continent, and the arrival of a common currency over much of the continent must inevitably have an impact on culture. Already, Italian coffee, German cars and British underwear are commonplace throughout the Continent, and in many cases the world. As so often, the concept of Europe immediately spills over into globalization.

Figure 6.12 This house is actually near Žďár nad Sázavou in western Moravia, but it could be almost anywhere in Europe. Perhaps the European identity is not historical but mundane and all around us.

Exercise

Investigate and compare the various European conventions in the heritage field. Who are the signatories? How do they work? The Council of Europe website will be a valuable source, but you may need to discover how well understood they are at local and national level. Look at Valetta, Granada and Florence.

World

In many ways our most obvious identity is that of *homo sapiens*, and it would be easy to claim that, biologically, that is our most important heritage, made quite specific in our genes. As with the European level of heritage there is a problem in feeling this identity because there is no obvious alternative, no 'other'. Our difference from other primate apes is too obvious and our power over the rest of the natural world too blatant to strengthen our common humanity. So people invent aliens, and perhaps even gods, in order to have a less one-sided contest. The Ancient Greek pantheon of gods very clearly provides such a role.

UNESCO has produced a World Heritage List divided into cultural and natural heritage sites, the first being screened by ICOMOS and the latter by IUCN. As is the trouble with European and all other official heritage at the supranational level, this list is submitted by the various national governments, called states-parties, so that UNESCO has no power to list places against the wishes of the nation-state. Consequently, when the Afghan government deliberately destroyed the famous Buddhas, UNESCO could complain, but they had never been inscribed on the list as world heritage. The list is heavily biased in favour of those parts of individual national heritages which the individual national governments consider to be in their top class, and which they have every intention of conserving anyway. Inevitably, politics and national prestige are involved. An examination of the World Heritage List should always consider those places that are not inscribed, as well as those that are.

In any case, such heritage is, yet again, largely confined to buildings and natural sites, though there are also attempts to list endangered species, through the Red Books, so that, in one sense, whales can be world heritage. However, there is no system to decide that Mozart, for example, is world heritage and Bach is European, whereas Wagner, say, is merely national heritage. And, in any case, should this be simply a question of quality, which is itself virtually impossible to define? Similar terms are used in the judgement of research qualities – 'of international importance', or merely 'of local importance', but, of course, the strictly local may well be of enormous importance to every other locality.

So world heritage remains a matter of national states and their need for prestige, selecting some of their preferred heritage (but not heritage which they may not be prepared to fund or where they cannot guarantee complete conservation) and asking for a World Heritage certificate for it. As far as the local press is concerned, the major reason for attempting such status is not a desperate desire to guarantee its conservation, but rather to attract more tourists. The submission is examined by committees of specialist academics, the International Council on Monuments and Sites (ICOMOS), for cultural sites, and the International Union for the Conservation of Nature (IUCN), for natural ones, obviously with their own disciplinary agenda. All of this proves difficult and contentious enough with archaeological remains and landscapes, without trying to put such values on our customs.

The system that does do this, of course, is the market. In a host of heritage areas, the market decides what is to become part of the world identity and

what is not. In part, this is simply a result of the globalization of powerful international concerns, so that the burger is clearly now world identity, as is Coca-Cola. The market is now fast extending into the cultural field, with Guggenheim, the cultural equivalent of McDonald's, opening branches around the world. Such globalization is not always American. For example, to see a Russian café devoted to Irn-Bru is a little unexpected, but the cultural market has many sides. Certain local, regional or national traits get into the tourist brochures: Masai dancing, Dogon villages, Portuguese fado. Others become art, so that flamenco is now only marginally connected with Spain – let alone Flanders, its eponymous origin – and is on the international art circuit, like opera. Some areas of the world – perhaps, in recent years, most notably South America – become fashionable, and before long every clothes shop is showing ethnic fashion allegedly relating to that place and usually to the accompaniment of Andean pipes played in every high street. Of course, such world culture is largely played out in the metropolitan cities and the tourist places (most of the former are the latter also), so the 'folk' arts and crafts played in the Ramblas in Barcelona are indistinguishable from those of the Pompidou area of Paris or Covent Garden in London (except that the Catalans play guitars better). Just up the road there may be another large city, such as Zaragoza, which remains more distinctive but determined to join the ranks of the metropolitan and lose its distinctiveness. Heritage may be consciously manipulated to demonstrate difference but, especially when allied to tourism, so many heritage districts closely resemble each other.

Dolan writes of Kalgoorlie in Australia[30] and reminds us that very many places and people are very keen indeed to become part of the globalized world market. As the Iron Curtain was dismantled, the people of former eastern Europe were very anxious to demonstrate to visitors their newly opened pizzerias or Chinese restaurants, as symbols of their status as a part of world culture. Just as those who promote local identity are often the newly arrived residents, so perhaps only world travellers are very interested in national identity.

'Glocalization'

Recently there has been some attention given to the concept of the 'glocal'. This relates to the realization that the most universally understood identities are not those of global industry, let alone those of world heritage

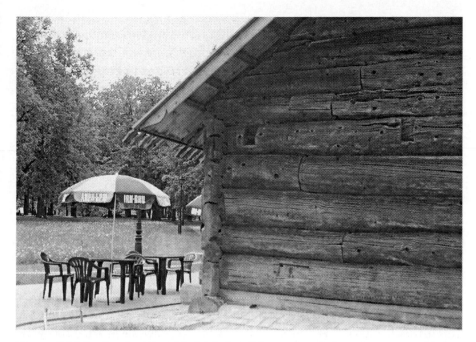

Figure 6.13 Irn Bru is a Scottish drink, but this wooden chalet-style restaurant is in a park in Moscow. Globalization is not necessarily an American phenomenon.

monuments, but those of home, family and neighbourhood. A movement has begun in Italy, called Slow Cities, with a charter to support local produce, local industry and local environment, and this has now spread to France, Germany and Scotland. This concept of demonstrating all over the world the particular local heritage and identity of quite small places certainly seems to be one that could produce an enormous vista of exhibition possibilities.

Multiculturalism

Another major, and related, issue which has changed in the recent past is the question of multiculturalism. This has been most dramatic in the USA, where the central plank of cultural and identity management was once to create one nation from many. This certainly produced a singular view of history, not least in the national parks, which was worryingly one-sided and almost demanded to be undermined by black, native American, Hispanic or other white European American perspectives. The converse situation, now rapidly becoming the accepted tradition in America, as in Europe or Australia, is that every group

should guard its own identity, look after its own museums and make its own traditions. Even at the Alamo there is now more than one interpretation.[31] The inevitable decrease in national sentiment may be no great loss, but the equally inevitable increase in the consciousness of local, regional and group difference may not make for peaceful coexistence. Much may depend on how widely these identities are shown. The idea that each group should keep its own identity can be used in a 'glocalized' way by exhibiting these identities to each other. If, however, they are kept secret, the results on inter-group perceptions can be easily foretold.

Groups without places

This chapter has based its premise on the significance of geography and geographical territories to our sense of identity. But modern life may be making geography out of date. Certainly the assumption that our identities, at various levels, have a territorial reality may well have been true 200 years ago, but it is much less true today. Fast personal transport has meant that we may belong to a golf club 50 miles away. Extraordinary developments in communications mean that we can be part of a tutorial group consisting of people residing in twenty different countries being taught by someone in yet another. We noted earlier that most families, in this country at least, are quite widespread, and that many people have moved around considerably. So there are many places that are, or have been, home, or that have very considerable local meanings. The same is true of many groups. Some Churches, such as the Church of England, are highly territorial, but other religious sects almost ignore distance, and brethren may be widely separated. Football clubs not only have supporters all over the country and abroad, but few of the players will have local roots. Fans of a television soap, or of a pop star, may be situated in many different countries. For many recent immigrant groups, their ties are more likely to be stronger with similar groups in other towns or even countries than with their neighbours. Two differing cultural groups can share the same territory and scarcely impinge on each other, as do the Amish with the American (known as English to the Amish) in parts of Pennsylvania or New York State (see Figure 6.14). Certainly the lack of an exclusive space has not prevented the Amish, like the Gypsies, having a very distinct culture, and they take considerable care over its protection. The Amish, however, are a rooted farming minority, whereas travelling or nomadic groups traditionally

Figure 6.14 This Amish buggy is in town selling produce, one of the points of contact between Amish and the 'English'. Ellington, New York State.

undermine a basic geographical preference. Governments keep trying to corral people into territories, whether on a reservation or a ghetto, or by preventing illegal immigration. Success has not been total.

Communities that lack a territory are not debarred from developing a heritage. Sports clubs certainly have done this, not only through static museums that have a place, but also through the network of collectors of memorabilia negotiating with each other through telecommunications, the post and the occasional fair. Such a method of conserving and re-enacting a heritage is now commonplace in many fields. Those who spend their time re-enacting past battles gather in one place from a very dispersed base, as do the car ralliers, the stamp-collectors, and even the members of political parties, who have their conferences at different venues each year. Indeed, the fair, rally or conference may well be the fundamental method of conservation for so many artefacts and activities, the beginning of an annual event being the equivalent of designation for the static heritage. So while there are certainly geographical identities with heritages attached to them, there are others, too, and most of us have elements of each. Perhaps the concern with heritage and identity displayed at the change of the millennium is largely a response to the new transport and communication techniques and the consequent failure to be able to delimit simple cultural-geographical boundaries. The heritage manager's role may well be to allow a largely displaced people to acquire a local identity without having to be resident in one place for many years.

Exercise

Investigate and describe attempts in your area to increase access to heritage to groups other than the hegemonic group. This may include museums, exhibitions, the conservation of buildings important to other groups and events (perhaps such as the Notting Hill Carnival), and they may be staged from either within or outside that group.

NOTES

1 See M. Drabble, *A Writer's Britain* (London: Thames and Hudson), 1979, p. 236.
2 S. Morgan, 'Memory and the merchants: commemoration and civic identity', *International Journal of Heritage Studies*, 4(2), 1998, 103–13.
3 N. Kennedy and N. Kingcome, 'Disneyfication of Cornwall – developing a Poldark heritage complex', *International Journal of Heritage Studies*, 4(1), 1998, 45–59.
4 S. Taylor, 'The heritage of people', unpublished dissertation, University of Plymouth, 2000.
5 S. M. Pearce, *On Collecting: An Investigation into Collecting in the European Tradition* (London: Routledge), 1995.
6 K. Lynch, *The Image of the City* (Cambridge, MA: MIT Press), 1972.
7 R. D. Sack, *Human Territoriality: Its Theory and History* (Cambridge: Cambridge University Press), 1986.
8 J. E. Tunbridge and G. J. Ashworth, *Dissonant Heritage: The Management of the Past as a Resource in Conflict* (Chichester: Wiley), 1996.
9 M. Ignatieff, *Blood and Belonging: Journeys into the New Nationalism* (London: BBC), 1993.
10 J. Appleton, *How I Made the World: Shaping a View of Landscape* (Hull: University of Hull Press), 1994.
11 E. Ennen, 'The meaning of heritage according to connoisseurs, rejecters and take-it-or-leavers in historic city centres: two Dutch cities experienced', *International Journal of Heritage Studies*, 6(4), 2000, 331–50.
12 P. Vidal de la Blache, *Principles of Human Geography* (ed. E. de Martonne) (London: Constable), 1926.
13 S. H. Burton, *The West Country* (London: Robert Hale), 1972, p. 289.
14 For Locum Destination Review, see < http://www.locum-destination.com/ldr.htm >
15 Morgan, 'Memory and the merchants'.
16 B. R. O'G. Anderson, *Imagined Communities: Reflections on the Origin and Spread of Nationalism* (London: Verso) (2nd edn) 1991.
17 M. H. Gayer, *The Heritage of Anglo Saxon Race* (London: privately pub.), 1928.
18 E. Hobsbawm and T. Ranger (eds), *The Invention of Tradition* (Cambridge, Cambridge University Press), 1983.
19 P. Gruffudd, D. T. Herbert and A. Piccini, 'Learning to think the past: heritage, identity and state education in Wales', *International Journal of Heritage Studies*, 4(3/4), 1998, 154–67.
20 L. Colley, *Britons: Forging the Nation, 1707–1837* (New Haven: Yale University Press),

1992. See also D. McCrone *et al.*, *Scotland – the Brand: The Making of Scottish Heritage* (Edinburgh: Edinburgh University Press), 1995; J. Bradburne, 'The poverty of nations: should museums create identity?', in J. M. Fladmark (ed.), *Heritage and Museums: Shaping National Identity* (Shaftesbury: Donhead), 2000, pp. 379–93.

21 F. Driver and D. Gilbert (eds), *Imperial Cities: Landscape, Display and Identity* (Manchester: Manchester University Press), 1999.

22 Fladmark, *Heritage and Museums*.

23 M. Crang, 'Nation, region and homeland: history and tradition in Dalarna, Sweden', *Ecumene*, 6(4), 1999, 446–70.

24 B. Graham, 'Heritage conservation and revisionist nationalism in Ireland', in G. J. Ashworth and P. J. Larkham (eds), *Building a New Heritage: Tourism Culture and Ideology in the New Europe* (London: Routledge), 1994, pp. 133–58.

25 C. Brace, 'Looking back: the Cotswolds and English national identity, *c.* 1890–1950', *Journal of Historical Geography*, 25(4), 1999, 502.

26 H. D. Thoreau, *Walden, or Life in the Woods* (Cambridge: Riverside), 1854.

27 The National Trust, *Linking People and Place* (Cirencester: National Trust), 1995.

28 N. Davies, *Europe: A History* (Oxford: Oxford University Press), 1996.

29 M. Bezzeg, 'The influence of globalisation on museology', *International Journal of Heritage Studies*, 5(1), 1999, 16–20.

30 D. Dolan, 'Cultural franchising, imperialism and globalisation: what's new?', *International Journal of Heritage Studies*, 5(1), 1999, 58–64.

31 H. B. Brear, 'The Alamo's selected past', *CRM (Cultural Resource Management)*, 22(8), 1999, 9–11.

7

Heritage as Process

SUMMARY

Heritage is not a static phenomenon; all aspects of it – things which are considered heritage, the markets for it, and identities – all change quite fast. In particular, one can trace a process followed by items entering the heritage chain. This moves through discovery or formation, inventory, designation, protection, renovation, commodification and, sometimes, destruction. Heritage managers are responsible largely for controlling this movement.

We have recognized heritage as being like a cube that can be cut three ways, according to the type of heritage involved, by the stakeholder, the market and by the level of identity. Most of the heritage issues that reach the press involve one or more of these dimensions. There may be a dispute about the type of heritage that takes priority (Should we retain the heritage of the activity of stag-hunting or the heritage of stags?) or a debate between stakeholders (academics wanting to restrict access to an archaeological site opposed to a tourist company who want to use it) or a dispute between levels of identity (Is the Lindisfarne Gospel local, regional or national heritage?). But the problem with a cube is that it is very static and resistant to movement, so here its usefulness as a metaphor breaks down. All sides of our cube are subject to rapid change; the fields of heritage are often re-classified so that items come into different categories, the balances and tensions between levels of identity are in flux as new nations and regions emerge and new markets, or subdivisions of old ones, frequently emerge. In particular, new things become heritage all the time, and go through a process of becoming more self-conscious, and at least some of those things revert eventually to being 'not heritage' any more. This process of heritage, the change that comes upon things by coming into the heritage market, is the subject of this chapter.

Like any other service entering the market-place, the most obvious feature is packaging or commodification. Just as a travel company cannot really deal with the individual traveller, and needs to provide ready-made packages, however exclusive, to a few, which are therefore more expensive, so the heritage industry has to select and package heritage in order to comprehend it. Even private heritage may go through several of these processes. Designation is a move in this direction, of course. We may be at a loss to deal with the astonishing variety of precious buildings in a small town, but actually the British designation system assures us that there are only three kinds: Listed Grade 1, Listed Grade 2* and Listed Grade 2. This simplifies everything, and we can make rules for each of these. Add some advertising to that standardization, and we have a commodity. This commodification is sometimes seen as a modern and unwelcome development, but it is perhaps only the commercial end of the human need to make sense of the world by making patterns and classifications.

Formation

The process starts with heritage formation. How are some things selected, from the vast range of possibilities, to become heritage, to be given that patina of preciousness and self-consciousness, and sometimes the extra commercial value that goes with being heritage?

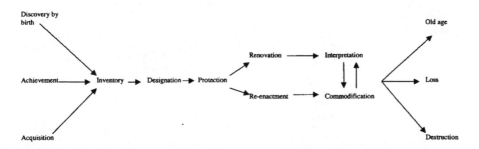

Figure 7.1 The heritage process

In *Twelfth Night*, Malvolio says that some men are born great, some achieve greatness and some have greatness thrust upon them. It is always fun to misuse a famous quotation, but it really is possible to suggest that some things

are born heritage, some achieve heritage status and some have heritage status thrust upon them.

Born heritage

The things that are born heritage, which are designed from their very inception to be conserved, we usually call 'art'. This is not the place to get into a detailed debate about the meaning of art, but one of the distinctive features of much art is that it is intended as a self-conscious work for purchase and collection. Thus some buildings are designed as 'architecture', whereas others are merely intended to do a job. Most paintings or musical works are 'born heritage', or at least are intended to be so, whereas photography is much more difficult, and we slowly learn to distinguish between those photographs intended to be 'art', and thus collectable heritage, and those which are not.[1] This, of course, does not prevent some of the discards becoming heritage in another age, or to a different group of people. This is the difficult distinction

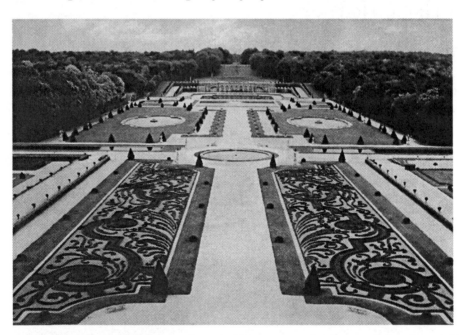

Figure 7.2 The great garden at Vaux le Vicomte was clearly intended to be a self-conscious, designed artefact right from its inception – heritage 'from birth'. Equally self-conscious rules, forbidding additions, for example, can be applied to buildings and even gardens of this kind without any feeling of absurdity.

that librarians have to make between what should be filed as 'literature' and what is merely 'fiction', which is largely a heritage distinction. By recognizing the artistic status one is also hinting that this needs to be conserved and that the owner may not have the unfettered right to demolish it or tear it up. When Lady Churchill destroyed the portrait by Graham Sutherland of Sir Winston, many people felt that she had no such right, even though it was her property and was, after all, a portrait of her husband.

Achieving heritage

Things that become heritage by achievement do so usually by survival, and this is the group depending largely on obsolescence and rarity for its significance.

Obsolescence

If time is the great healer, then it is the great maker of cultural heritage also.[2] This is one area where some distinction can be made between cultural and natural heritage, because fauna and flora do not become obsolete, though they may become extinct, of which more later. Things, though apparently not people, get more interesting with age – a process studied by David Lowenthal. At the moment, the typewriter gathering dust under the author's desk is merely an obsolete piece of equipment that should have been discarded ten years ago. Any hope that it might be of some use some day must now surely be dashed. It is certainly possible that my grandchildren may discover it with some interest in 25 years' time, and might decide to conserve it. At that moment, when such a decision is consciously taken, the typewriter becomes heritage. Outmoded technological advances are often 'rubbish' for about a generation before becoming heritage, though much will depend on the percentage that is scrapped.[3] In fact, in some specialist circles heritage is much quicker than that. Apparently, some ten-year-old computers already fetch a good price as historic items, and there is a considerable industry that makes its profits by buying things cheaply in the hope that they will become heritage and fetch a return later.

The importance of time is very much part of the ideas referring to the Circuit of Culture, and there is plenty of evidence to suggest that nothing is automatically excluded from becoming heritage, though that is far from suggesting that everything does.

Figure 7.3 A house in the Šumava mountains of south Bohemia, actually the field station of the Institute of Landscape Ecology at České Budějovice. On its wall is a ladder made of two spruce poles joined by wooden struts. I had never seen a ladder simply made from two trees, and I regarded it as heritage immediately. The residents, however, regarded it merely as a ladder. Inside there were two threshing flails, carefully oiled and hanging on the wall behind perspex. All agreed these were heritage. The residents then made bread, in a bread oven, with a long wooden paddle, self-consciously just as their parents had done; as much a re-enactment as a food-getting activity. This was heritage 'just on the turn'.

Rarity

Not all items become heritage merely by being old, of course. Something else is usually required, and rarity is often a critical element. The more of the originals that have been discarded, the more certain will be the heritage fate of those that remain. In the case of the cultural heritage, rarity is likely to relate directly to price, so that a market begins to operate. In the case of music or books, for example, the work that reaches heritage status the most quickly is usually the work that was very difficult to acquire originally.[4] Pop music published by minor labels, as part of the underground scene, is likely to achieve a much higher price than contemporaneous discs cut by the million. Even with the natural heritage, rarity can relate to price, which is one of the biggest problems. As the numbers of birds of prey declined, so their eggs

Figure 7.4 The little village of Holašovice, in south Bohemia, has been designated a World Heritage Site, mainly because it has survived. This type of village with baroque farmhouses around a green with a fire-pond was normal in the region, but only this one has survived more or less without change.

fetched a higher price, and the numbers declined still further. The highest prices of all, of course, will be paid for the eggs of an extinct bird, such as a dodo, just as artists' pictures get more expensive after their death. Rarity is fundamental in the field of natural heritage; animals and plants that are endangered are placed on special lists, such as the Red List, and special measures are taken for their protection.[5] Scientists may be anxious to preserve every species, but the wider population is also keen to support action to maintain the existence of large vertebrates, especially if cuddly, as well as cetaceans. Exactly the same is true of most artefacts. Being the only surviving architectural feature or artefact makes for certain heritage.

Heritage acquisition

The third way of a place achieving heritage status is to have that status thrust upon it. Many objects, and especially houses, have celebrity status thrust upon them. As we have seen, an outstanding case is the purchase of a council house

Figure 7.5 Oradour-sur-Glane, west of Limoges, was the site of a particularly vicious Nazi atrocity in June 1944. The village has been carefully conserved as it was left – a particularly poignant way of having 'heritage thrust upon one'.

in Forthlin Road, Liverpool, by the National Trust on the basis that it was once the home of Paul McCartney.

The fame of a person rubs off onto their possessions, their places and even their friends. Things which would not be heritage for any other reason become so by having belonged to a writer, artist, admiral, pop star or merely a celebrity. In certain circumstances the former owner of a property does not even need to be famous, but merely needs to possess the vicarious thrill of celebrity. So the *Titanic* exhibition at the National Maritime Museum showed very ordinary everyday objects that became heritage simply by having belonged to victims of the tragedy.[6] Such celebrity may extend well beyond a building. Stratford-upon-Avon owes not only its tourist industry but also its keenness to conserve its buildings to William Shakespeare. Events, too, can confer heritage status, and battlefields lend distinction to some otherwise very ordinary landscapes – at Culloden, for example.

Exercise
What things are just beginning to be recognized as heritage? Identify things from your childhood that are now 'collectable' and examine the process by which this happened. These may well be items of clothing or pop music. Clearly, the idea of 'retro' is very closely related to heritage formation. You will need to examine the markets in which these things change hands, and the people who buy and sell them. Try and date the time it took for the objects to stop going 'downmarket' and to begin to increase in value, such as when cars stop being 'bangers' and become 'classics'. Collectors' magazines and websites can often put prices to such changes.

Academics from many disciplines produce heritage through their normal efforts; dissertations are produced about this battle, theses written about that type of butterfly, monographs about an artist's work or essays about a folk tradition. The purpose may be merely the excitement of research, but the result, inevitably, is to emphasize the importance not only of the particular example under scrutiny but also of all similar types. The more widely the paper is published the more important, the more collectable and conservable will become the phenomenon under scrutiny. Indeed, in many cases that was the academic purpose, and the scholars will themselves be directly involved in the conservation of the object. There are numerous cases where major heritage sites are closely associated with the archaeologist who excavated there, or the historian who researched it. Anyone who has ever had to make a case for the listing of a property, or otherwise designating heritage, will know that quoting the research material is an essential element. This place is heritage because we know a great deal about it; that place is not because we have no research information. The increase in higher education numbers, and the emphasis on research skills, rather than simply the imparting of information, have both resulted in a vastly increased research base and, consequently, more heritage, but there is no sign of there being a shortage. This point cannot be over-emphasized. Heritage is not rare. There may be very few examples of a particular kind of heritage (caves with prehistoric paintings, for example) but there is no shortage of heritage overall. We will simply invent more.

One very specific kind of academic creation of heritage is akin to collecting, but is concerned with the collecting of tradition, especially of folk tales, songs and dances. At the start of the twentieth century, in particular, composers and musicians roamed Britain and other countries seeking and collecting folksongs and melodies, and similar activities took place in other arts.

Sometimes these songs were collected and transcribed by people such as Cecil Sharp, and became very widely disseminated. School music lessons in the 1950s were marked by the learning and singing of English folksongs and sea shanties. Others listened to the melodies and transformed them and their harmonies into their own compositions, famous examples being Béla Bartók and Ralph Vaughan Williams, whose song 'Linden Lea' has become almost an archetypal folksong, despite the fact that neither words nor music have a folk origin. In either case the final performance – by a school choir at an annual concert or in the concert halls of Prague, Budapest or Vienna – bore little relationship to the context of the discovery of the song in the fields of Somerset or the inns of Hungary. The words were probably bowdlerized, and the music given an element of self-consciousness which is the very essence of heritage. The relationship between the carefully conserved thatched *cottage ornée* (see Figure 7.6) in Dawlish, built by gentry, and a real rural thatched cottage is similar to the difference between a symphony based on folk melody and the folk melody itself. Even where the folk singer is taken out of his pub or field and put on a stage, something very significant happens. Context makes

Figure 7.6 In Dawlish and Sidmouth, Devon, lie many such 'cottages' built by gentry for seaside holidays and providing a pleasant conceit, quite distant from the hardship of life for most who lived in thatched cottages.

Figure 7.7 Such a picture could be taken in many towns with a significant tourist trade, obscuring the fact that a folk gallery is an oxymoron. Once inside a gallery, or on stage, it can scarcely be regarded as 'folk'.

it 'art' and different sets of rules apply. The flamenco danced on stage by professionals, and probably televised, bears only a passing resemblance to the flamenco danced in the streets by amateurs. Whether the 'enartment' of a traditional musical or dance form actually promotes the conservation of the form in its original context is a difficult question.

Exercise
Research a piece of 'Folk Art' which could be music, dance, visual art, embroidery etc. What are its origins? How is it transformed into art? By whom? What are the contextual shifts that take place? Take note of the research and publishing activity that surrounds it.

This formation, or recognition, is the first stage of the heritage process, and may well be a great deal less of a conscious public, or academic, affair than suggested so far. The recognition may have a commercial origin, so that the critical heritage-making recognition may not be in anything as august as an article in the *Burlington Magazine*, but on the *Holiday* programme or when a Sunday supplement suggests a visit to a particular folk event.

Inventory

A very common stage after something has been recognized as heritage is the compilation of an inventory, which may be the *Good Pub Guide* or the *Buildings of England* series by Nikolaus Pevsner. In the case of many collections the inventory is an essential tool. Gibbons' Stamp Catalogues or auction-house price guides for furniture not only quote appropriate prices but enable a 'complete', or at least a rational, collection to be made. Not that all catalogues necessarily create heritage status. *Glass's Guide*, for example, is merely a price guide for second-hand cars, but they also publish another guide to classic cars. What is routine in the case of hobby collections is also commonplace in place heritage. The Pevsner series[7] enables the keen architectural student to 'spot' all the buildings and perform virtually the same routine as do train spotters or, most commonly in the natural heritage, bird spotters. This activity is encouraged by many organizations. The National Trust produces its handbook, and the National Parks Service, in the USA, produces a 'passport' which does not give any discount but encourages purchasers to visit all the sites and to buy a picture-stamp while there to fit in the space on the page. Neither authority may think of these products as primarily inventories, and indeed both will have much more detailed catalogues of all their possessions, whether portable property, buildings or land. Even if the main purpose is advertising and attracting visitors, the compilers would not be human if they failed to be proud of the numbers of properties increasing year on year. Counting the numbers of each type and classifying them is a human instinct, which is a regular motivation in heritage. Even when the things collected are not regarded as heritage, the fact of collection tends to make them so. We have already mentioned folksong, but at a much more mundane level publishers have made good profits from selling spotters' guides to animals or birds, *I-Spy* books for children about a hundred subjects and numerous volumes for spotters of trains, ships, cars and planes. A series such as the *Observers'* books is dominated by the natural heritage, whereas the more recent Shire Publications are essential for many collectors.

Classification is also a fundamental element in much of the academic world, and great gains in knowledge – in archaeology, for example – have derived from precisely such classification. Some would argue that such is the very purpose of the museum collection, and that this reference collection should always take priority over collections laid out purely for education or

entertainment. Indeed, there is an extent to which the very neutrality of the reference collection allows different classifications to be made.

Designation

Once listed and inventoried, the desire to designate may not be far behind. Indeed, some form of designation is synonymous with the making of the inventory – the decision to include this example but not that one is a form of designation. But the form of designation implied here is often official, bringing the new heritage item within the field of management, and has some form of selection and authentication about it. It is one thing for Pevsner to write his guide, and another for government agencies to devise and designate listed buildings or scheduled monuments. Although the government agencies may well take note of the unofficial work, they will have their own criteria, probably as part of the enabling legislation. Designation may imply some action to be taken, and some official status, and perhaps rights, but quite frequently it may not imply any active requirement to conserve or protect. Indeed, many designations required nothing more than notice to be given in case of demolition or destruction.

This designation is the point at which advisory bodies of experts are usually consulted, such as English Heritage, Scottish Natural Heritage and CADW, but also such non-governmental organizations as the Victorian Society or local ones such as the Hampshire Gardens Trust. Simply creating a society locates expertise. For example, the Milestone Society was formed in 2001 and intends to protect the heritage of waymarks.[8] The members of such an advisory body will usually be a mixture of academic specialists, owners of the heritage and government (or local government) appointees. It is at this point, for example, that it is taken for granted that churches are listed because of their architectural historical importance, not because of the liturgical tradition practised in them, or that designated gardens tend to be seventeenth- to nineteenth-century landed estates, rather than 1930s suburban gardens. This does not imply any particular collusion or conspiracy, merely that a group of experts, probably educated in the days when the history of art or architecture was viewed as a grand narrative, will simply take for granted that Salisbury Cathedral is greater than a nineteenth-century Methodist chapel, or that the gardens at Stourhead are more significant than those at 27 Acacia Avenue.

Designations are also often multiple, with each advisory sector having its own criteria, which can also cause problems by applying different criteria to the same site. In the UK, for example, it would be possible to have a monument that was both a scheduled monument and a listed building within a registered garden, in a conservation area, within a Site of Special Scientific Interest or in a national park. It might also have a European designation, such as a Special Area of Conservation, and could also be a World Heritage Site. Multiple designation may lead to better protection, but there is a danger that it merely leads to a situation where everyone assumes that someone else is taking responsibility.

Exercise
This is an exercise in the variety of designations. Draw a map of the local area and insert all the official and semi-official heritage designations that affect it. These will include nature and landscape designations, buildings and monuments, but there may also be museums registered as such by the Area Museums Council, or national collections of plants (organized by the National Council for the Conservation of Plants and Gardens). You will often find that the local advisory body has a supplementary list of sites not officially designated, but which they hope to designate in the future.

Protection

Part of the formal legislation that results in the designation of a piece of heritage may also involve measures for its active protection or conservation, but this is by no means always the case. There may be a long time lag between making a schedule of ancient monuments and bringing forward any effective means of conserving them. There are many reasons for this, the most significant being the double standards of most governments. The governmental need for legitimation of its authority, leading to government support for heritage designation, is bound to clash, in a property-owning democracy, with a deep-seated dislike of limiting the freedoms of owners to do as they will with their property, whether the property is portable or in land or buildings. Even the most passive requirement to conserve a building, for example, is certain to lead owners into substantial expenditure, whereas regulations preventing the export of portable heritage are a clear interference with the working of an established market in antiques. As the property-owning classes have tended to dominate the legislatures of such countries, including Britain,

of course, where for most of its history an element of property-owning was essential even to vote, let alone to sit in Parliament, this tendency to protect property-owners' rights has inevitably been powerful.

A second motivation counteracting the tendency to conserve things relates to all states, not just democracies, and is especially the case with the state's own property. Just like any other owner they are reluctant to abandon or reduce their options for the future by protection today. Frequently, governments exempt themselves from their own laws, as UK defence establishments are not subject to the planning acts. So defence land and buildings have been very slow to be released for heritage purposes or put under access agreements. Similarly, local authorities have been surprisingly lenient when they have applied to themselves for permission to demolish or alter a listed building that they happen to own, sitting on land needed for development, with the intention of generating income for themselves.

At this point we need to distinguish between some frequently used terms such as protection, conservation, preservation, restoration, repair and renovation. *Protection* is an all-encompassing and largely passive term. All sorts of actions and interventions in the area, building or object might take place within the broad term 'protection'. A protected area may exclude people, or protect from building development without any active management or intervention.

Preservation is a much stronger term but one that, in British usage at least, implies actions and perhaps even interventions to maintain the object as it was found. Indeed, 'preserve as found' is a key phrase in many areas of cultural heritage.

Conservation is an even more active management policy, where development and change are not impossible within a broad framework of protecting certain aspects of the heritage. Most typically, the distinction is made within the built heritage, where 'conservation' may accept a change of use, e.g. the addition of new elements (a new kitchen, lift or garage, to be part of the modern age), but within a general framework of allowing the heritage to be seen and examined. But such terms do not translate well, and in France apparently similar words are used with opposite meanings, so that *préservation* means 'conservation', and the French *conservation* means 'preservation'. Add to that complexity the fact that in American usage 'preservation' is used about the built and cultural heritage, while 'conservation' is restricted to use in the natural environment, and the student will wish to treat all such phrases with caution.

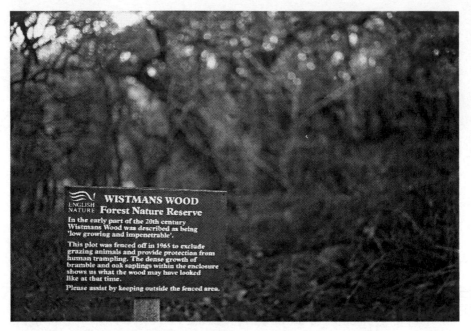

WISTMANS WOOD
ENGLISH
NATURE **Forest Nature Reserve**
In the early part of the 20th century
Wistmans Wood was described as being
'low growing and impenetrable'.

This plot was fenced off in 1965 to exclude
grazing animals and provide protection from
human trampling. The dense growth of
bramble and oak saplings within the enclosure
shows us what the wood may have looked
like at that time.

Please assist by keeping outside the fenced area.

Figure 7.8 Wistmans Wood is an ancient wood on Dartmoor, designated as a Site of Special Scientific Interest. At this fence, 'protection', enabled by the designation of the site, gives way to managed 'conservation' with the exclusion of people and grazing animals from the inner parts of the wood.

Restoration

The other terms take us into the next heritage stage, where active measures are taken. Buildings may be *repaired, restored* or even *renovated*; natural sites may become positively managed, and this may include deliberately taking action to preserve vegetation or even reintroducing species of plant or animal. The equivalent in the field of activity-heritage is surely *re-enactment.* This is the point at which the music specialist ceases to be content merely with preserving the manuscript of the Baroque composer, and with conserving old instruments in museums, and starts to play the old music with the old instruments (or modern copies of them), so that a re-enactment of the previous event can take place. It is the same moment at which the enthusiast for the Civil War ceases merely to read books, visit battle sites and collect memorabilia, and gets dressed up in appropriate costume to fight the battle again.

Academic disciplines are nearly always extremely cautious about this stage of the process. Most architects, since about 1900, and following the advice of

Ruskin and Morris, prefer to maintain buildings only to the extent of repair, attempting to 'preserve as found', and regard restoration which goes beyond repair as unfortunate (though often a necessity if a building is to continue with an economic use) and renovation as simply unacceptable. Renovation, where new matter is introduced into the building, would often be quite unacceptable. The Society for the Protection of Ancient Buildings would go so far as to accept that when repair cannot any longer maintain the fabric, then slow ruination is acceptable. Few architects would be prepared to allow Chartres Cathedral or the Taj Mahal to fall into disrepair, preferring minimum intervention in order to maintain as much of the authentic fabric as possible. Similarly, the music specialist is likely to be cautious about recreated music, because we cannot experience it as it was originally intended. A twenty-first-century person cannot hear 'Greensleeves' with the same mindset as a sixteenth-century one. Much the same is true in the field of historical re-enactment, with many historians regarding the search for authenticity in this way as deeply flawed.

This preference for authenticity and minimum intervention is not the common position of the general public, who seem to be delighted with battle re-enactments, whether as participants or spectators. The kind of authenticity beloved of academics does not bother them too much; they would like their old buildings to look romantic, but how that is achieved is of lesser concern. There are cases in every historic town of the popularity of the old-looking; though the case in Hildesheim, where a house was erected by public demand in the 1980s, is perhaps an extreme one (see Figure 7.9).

While this preference for a hands-off approach by the academics, coupled with an interest in appearance by the public, seems to be true for most areas of cultural heritage, there are exceptions, and the natural heritage is different in this respect. When it was revealed (New Year 2001) that Stonehenge had been considerably altered during the course of various twentieth-century repair and restoration programmes, including the use of concrete underpinning, the reaction of the press (which may or may not represent public opinion fairly) was one of alarm. In this case, probably because of the magical and mythical meanings of Stonehenge, modern tampering was presumably seen as interfering with its magic. This issue of varying kinds of authenticity is addressed in Chapter 8.

Natural heritage managers have a different attitude, and have long come to realize that almost all ecosystems can only be maintained by intervention and management. This is helped, of course, by the irrelevance of authenticity in

Figure 7.9 This property replicates one that once existed on the site, but Hildesheim was largely destroyed in World War 2, and the rebuild did not include this building. When the site became vacant in the 1980s local people were consulted and this replica was executed. One problem is that finding timber of sufficient quality is now very difficult, and the beams are badly cracked.

this field. It is possible to create an authentic heath – though it takes time. At Braunton Burrows, in north Devon, nature reserve status was removed from one site because the owner refused to graze the area as required to maintain it, insisting that nature should take its course. The rarity of the site, with its distinct assemblage of species, was thus lost.

Commodification

Most of the stages we have so far discussed are deliberate acts, usually by academics, governments and owners. A great deal of heritage is retained at this stage and does not proceed towards commodification and beyond. Indeed, such was once the norm. Museum collections were carefully conserved – some buildings were also, and some nature reserves – but little attempt was made to encourage people to visit, and commodification is essentially a commercial activity, though by no means always carried out by commercial organizations. In some cases commodification takes the obvious form of the object (and this would usually only apply to objects) becoming tradeable as heritage, most obviously in the antiques and art markets.

In the world of collections the point of commodification is where specific attempts are made to attract visitors, rather than simply allowing access. In the case of zoos this has nearly always been the case – scientific zoology and tourism going hand-in-hand – but most museums have become commodified much more recently. The temporary exhibition is one clear sign of the process, as is the rearrangement of a permanent collection as an exhibition, bringing out certain features and, of course, obscuring others. The deliberate attraction of visitors inevitably shifts the agenda of the scholars working on the collection, introducing ideas of newsworthiness and popularity. The more the museum depends on income from visitors the more this is likely to be the case. Places such as the British Museum, admission to which is free, have much less need to package their collections, but they usually find it valuable to do so, partly for the benefit of scholarship and partly to gain public acceptability.

Landscape regions are very similar here. Nature parks and national parks could be closed or open to the public, but the process only gets commodified when the brochure is produced – which explains to the visitors all the things they can do in the park – or the heritage centre opens. From that moment the area is in competition with other places for the visitors' favour, if not for their money. In the natural heritage field it is astonishing how many places are carefully conserved and then commodified and offered to the visitor quite freely, presumably from the passionate desire of the conservors to convert the public visitors to their own love of the place, its landscapes and its wildlife. This is frequently the result of pure altruism, but it can also be slightly misplaced. It does sometimes seem bizarre that a National Park Authority can take enormous trouble to persuade people, many of them

quite happy to remain within a five-minute stroll of their motor cars, to take to the open countryside, which can then become badly eroded and even crowded.

Commodification is itself a process, and probably one that is very difficult to stop. Once the income of the preserving organization is largely determined by the numbers or spend of the visiting public, it is extraordinarily difficult to move back. Most businessmen believe that one has to grow or die – there is no middle way – and this applies as much in the heritage sector as anywhere else. Most management theory is based on this presumption, although this has been recently questioned.[9] Public authorities are just as much involved as private companies. Just as the BBC, funded by licence revenue, nevertheless takes great interest in its audience share, so a national park is not likely to seek or publicize any drop in visitor numbers, if only because in a democracy they would perceive themselves to be less worthy of financial support.

Authenticity, however honestly attempted, tends to dissolve with numbers, and with spectating as distinct from taking part. The danger of the destruction of real local identity in favour of a simulacrum has been much studied. A local church choir were used to singing Evensong most Sundays, including during the summer months, at the chapel of the local National Trust house. This was re-timed to coincide with the closing of the house at 5 pm, and many visitors attended the service. On one occasion a small group wandered in and started taking flash photographs. This changed the ambience completely, and thereafter the choir could never muster enough numbers for the service. A few cameras had changed an unself-conscious and routine part of our heritage into a commodified re-enactment. The cassocks and surplices that were always worn suddenly seemed to be a rather ridiculous fancy dress. They experienced some commonality of feeling with the Masai tribespeople whose images so often illustrate world travel brochures.

The end of the process

Academics, and perhaps particularly geographers, do enjoy suggesting that processes are cyclical, and it is very tempting to do so here, and to attempt to demonstrate that the heritage process leads inevitably to the loss of heritage and the beginning of another cycle. However, while there are clearly cases where the loss of the heritage has occurred, equally it may not be the norm except in the very long term.

Sometimes the very popularity of places has literally caused their destruction. This can be so in the case of the erosion of landscapes and of built heritage. The geological heritage is particularly susceptible to being literally removed by its lovers. Exposures of fossil-rich strata or of unusual minerals are very likely to be excavated. Other ways in which the heritage can be effectively lost to the vast majority of people is by closure. The famous caves at Lascaux are now closed to visitors because their breath was damaging the famous prehistoric cave paintings. A simulacrum is now available to visitors. Many nature reserves have to be closed to protect the fauna and, through trampling, the flora also. Indeed, some animals have been so popular as to be harried to extinction, especially in the search for birds' eggs. Some portable elements of heritage – musical instruments or paintings perhaps – are carefully locked up in bank vaults, which is another effective loss, and others are stolen, often, we are told, to enhance the private collections of rich connoisseurs. The bank-vault collector, the thief and the invading army (for example the squads specially detailed to steal art works during World War 2) all represent a similar loss, whatever their legal rights. The built heritage has been the subject of deliberate attack because it is heritage. The case of the Serb attack on Dubrovnik, and the destruction of the Mostar Bridge during the recent Balkan campaign can be quoted, but the Baedeker raids of 1942, aimed at Exeter, Bath and Norwich, were also a deliberate destruction of historic places. The destruction of representational sculptures by the Taliban government of Afghanistan, which has destroyed many Buddhas, is quite incomprehensible to those whose religion is art.

Where there are rapid political changes heritage is particularly likely to be destroyed. The flag, the national anthem and the palace are obvious heritage symbols and hence targets (and so might be the ruling family, most obviously in the killing at Ekaterinburg), but this process can be much more benign. Throughout east-central Europe, much of the built heritage of the socialist years has been destroyed, either because the population cannot conceive now that they will soon feel nostalgia for ordinary things, such as *panellaki* houses, or because of their known associations with the old regime. Sometimes this is very obvious, as with the park containing old Stalinist statues in Budapest or with the physical dismantling of the Iron Curtain throughout the Šumava and Erzgebirge. Sometimes it is an association that strikes the outside observer as distinctly odd. In Moravia there is a campaign to get rid of the giant cultivation terraces put in under socialist agriculture, less because of their inefficiency than because of their perceived ugliness. Similarly, several village squares are

Figure 7.10 The west front of Exeter Cathedral: the deliberate destruction of sculptures for religious reasons is not limited to Afghanistan.

being cleared of the juniper planting that was such a feature of 1960s landscape architecture (see Figure 7.11).

Exercise: Two short essays
First, write a report on the destruction of some designated heritage, either locally, or perhaps using UNESCO's World Heritage in Danger site. Second, make a case for the destruction or closure or deliberate effacement of something that might be regarded by some as heritage. What do you think ought to be consigned to oblivion?

Except in philosophical terms, and in the very long run, it would be absurd to suggest that heritage is always lost. Some heritage settles down to a very long life indeed. It may become unfashionable and consigned to the deeper

Figure 7.11 In the village green of Pavlov, Moravia, the junipers planted during the 1960s are shortly to be removed. This kind of planting is associated with the Socialist period, and is now politically unacceptable.

storerooms of the museum, or the original reasons for the designation may become forgotten. There is evidence from landscape studies that although there may well be rapid changes of fashion, with different types of landscape or building becoming appreciated, it is relatively uncommon for the outdated fashion to be ditched once it has been replaced.[10] The Cornish fishing village may be regarded as a rather outworn cliché, but it isn't destroyed, unlike the unwanted architecture of the previous period. The tendency of the modernists to disregard and destroy almost any Victorian building has been superseded by the prevailing assumption that very little modernist architecture is worth saving. Tastes may change considerably, however, and the parish church is a good example. Not so long ago, inventories of English rural heritage, such as those by Pevsner and by Arthur Mee,[11] devoted considerably more than half their pages to the description of the parish churches, especially the medieval ones. The collapse of religious practice in the last quarter-century has led to a

very considerable revaluation of their importance but not their wanton destruction. Indeed, however small the congregation may be, the local population are likely to be outraged at the suggestion of bulldozing a church.

Finally, there is serene old age, and though Venice, La Serenissima, is not an example of this, Rome certainly is. There are places that have been heritage-rich for so long that they have learned to live with it. In Rome there are certainly hordes of tourists, but Rome is a very big city and has been catering for tourists for a very long time. There is not there, as in some places that have become popular more recently, the feeling that the visitor is an alien invader of a place whose real business lies elsewhere (see Figure 7.12). This can be true also of smaller places, especially resorts. Bath can be overwhelmed at a few times of the year, but generally lives with its visitors very well – after all, that is what it was built for. The author's favourite is Sidmouth, largely built in the early nineteenth century as a resort for the reasonably wealthy, which it still is. This ability to live at ease with one's heritage is difficult to define, but is a precious gift. For much of the year many parts of the Lake District can aspire to this, as can the Swiss with their efficient management of their alpine villages. The considerable work on the carrying capacity of various landscapes is most important here. Some beaches feel crowded at ten people per kilometre; others feel a bit empty with less than a thousand. Forests, in particular, are good at absorbing very large numbers without people feeling uncomfortable, whereas so many of Britain's national parks are based on open moorland, where the sight of another group on the horizon makes them feel crowded.

Conclusion

Heritage, therefore, is a process as well as a product. For a variety of reasons some things, activities or people become imbued with that special kind of self-consciousness that turns them into heritage. Someone wants to save them, and that someone, in effect, puts them on a moving pavement. The image of the pavement is perhaps better than that of an escalator, because the latter suggests upward or downward movement, whereas the pavement suggests inexorable movement into the unknown. There may be various ends to this process. In some cases an action might be taken which takes the heritage onto a circular conveyor that keeps going round and round, but another action might have put it into the one ending in destruction, whereas one of the paths might lead to the storeroom. Somewhere there is a path leading to a plinth for

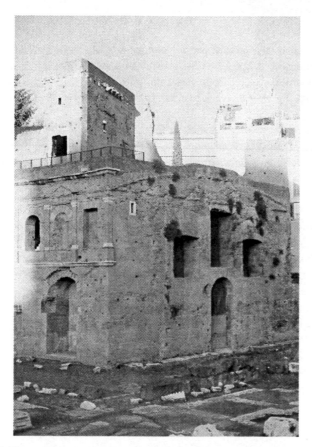

Figure 7.12 The existence of the ancient Roman fora, seemingly casually retained in the middle of the bustling modern city, enables an enviable relationship with heritage and with visitors.

an icon, such as at Venice, or in the Louvre for the *Mona Lisa*, but not all old heritage is quite so obscenely overused. There is still much room, whether in museums, in the landscape or in those towns that are well-adapted to their visitors and to their non-visitors. For there are equally huge numbers of heritage items such as grandad's photograph, quietly sitting on the mantelpiece at home, or the parish church or city square, folk dance society or embroidery group, equally peacefully doing their heritage job by enhancing the lives of their owners, members or neighbours.

NOTES

1 P. Howard, 'Landscape and the art referent system', *Landscape Research*, 17(1), 1992, 28–33. P. Howard, 'Asset formation and heritage policy', in J. M. Fladmark, *Cultural Tourism* (Shaftesbury: Donhead), 1994, pp. 66–73.

2 D. Lowenthal, *The Past Is a Foreign Country* (Cambridge: Cambridge University Press), 1985.

3 M. Thompson, 'The filth in the way', in S. M. Pearce, (ed.) (1996) *Interpreting Objects and Collections* (London: Routledge), pp. 269–78.

4 T. Holehouse, 'The interaction between the independent underground and the mainstream of Britain's popular music heritage'. Unpublished BA dissertation, University of Plymouth, 1999.

5 For the Red List of endangered species, see the website of the International Union for the Conservation of Nature at < http://www.iucn.org/redlist/2000/index.html >

6 S. Deuchar, 'Sense and sensitivity: appraising the *Titanic*', *International Journal of Heritage Studies*, 2(4), 1996, 212–21.

7 For example, N. Pevsner, *The Buildings of England: County Durham* (Harmondsworth: Penguin), 1953.

8 The Milestone Society is a new organization devoted to their conservation.

9 B. C. Williams and C. S. C. Bradlaw, 'An economy of country houses', *International Journal of Heritage Studies*, 7(3), 2001, 273–94.

10 P. Howard, *Landscapes: The Artists' Vision* (London: Routledge), 1991.

11 A. Mee, *The King's England. Devon: Cradle of Our Seamen* (London: Hodder & Stoughton), 1938.

8

Values and Issues

SUMMARY

Heritage is clearly a problem, and becomes so as soon as different people attach different values to it. The values which we hold can be envisaged as a series of lenses placed in front of our eyes, which correspond to our various attributes, each of which alters our perception of what is heritage. These value differences are largely responsible for the major issues in the heritage field, and four are examined here: the questions of access; of authenticity; of appropriation; and the related question of gentrification. The chapter finishes with a look at the costs of heritage, and with two short case studies where some of these issues come alive, one based on the French ecomuseums and one based on major changes in Marrakesh, Morocco.

Heritage seems to be always in dispute. Battlefield sites are the most glaring illustration that heritage is dissonant. Tunbridge and Ashworth claim that all heritage is dissonant, and the locus of dispute.[1] Certainly there are very few elements of heritage conservation that are not disputed by someone. All sites of national identity are certain to be uncomfortable for those who object to that state's existence. Germans and Jews cannot be expected to feel similarly about Auschwitz, Russians and French about Austerlitz or northerners and southerners about Gettysburg. Some Welsh may feel less than happy about maintaining the great castles of north Wales, which can be seen as symbols of English oppression. Other Welsh object to having the Welsh language imposed upon them. In the British Isles the classic case is Northern Ireland, where two heritages are in direct opposition, though people from each side attempt to allow the other their identity. Most obvious recently has been the case of Afghanistan where fundamentalist Muslims cannot be expected to feel the same about statues of the Buddha as do the Buddhists or, for that matter, western aesthetes.

Figure 8.1 Wells Cathedral's west front. The statue of Christ at the top, with the two flanking seraphim, caused considerable dispute between those who thought that the old wrecked sculptures should remain and those who wanted an undisfigured Christ over the door, and between those who wanted to copy medieval sculpture and those who wanted twentieth-century imagery.

The reason heritage is so often in the news is that it is always in dispute, between countries, between regions, between different stakeholders. Local people want access to a nature reserve, which conservationists seek to deny; archaeologists want to excavate an interesting site thereby frustrating development; indigenous populations object to their heritage being displayed other than by themselves. Even restoring a statue on a cathedral can become a focus of real anger, artists wanting a twentieth-century sculpture, while the church and the architects may have a totally different agenda (see Figure 8.1).

A basic principle of heritage management is to seek the disinherited. With every heritage action some people will feel excluded or ignored. They need to be found.

Values

People put different values on things. Apart from the roles which we all play as owners, visitors and insiders, as discussed in Chapter 5, we each have factors that affect our views. The best analogy is with the older kind of optician, who would place on one's nose a set of spectacles with room for several different lenses. Each lens altered your vision a bit more. Some of the lenses that we have in considering our heritage values include nationality, gender, ethnicity, class, religion, poverty, insideness, expertise and age.

Nationality

We have met the national lens before, in terms of both golden ages for particular countries, and golden places. Each country even tends to define 'heritage' in its own way. The particular concentration on the country house and its garden is a British feature, whereas concern for the conservation of wilderness is distinctively American. Germany seems to be peculiarly concerned with the built heritage of the small German town (see Figure 8.2). This may not only impact on what is considered 'heritage', but also how it is treated. In Japan, perhaps because of it being largely a wood culture rather than a stone culture, buildings are not much conserved. Rather, the most precious buildings are rebuilt periodically as a mark of respect. Where the heritage can be considered in the care of a single nation, such differences may be merely interesting, but where they impinge on more than one nation, then real difficulties can occur. In many parts of the world changing borders have meant that one nation's heritage is being conserved by another group with perhaps quite different values. The Serb treatment of Croat heritage was a particularly well publicized example of this.

Religion

Closely related to the national lens is that of religion, which may not apply merely to active supporters of a particular faith, but also to those who have inherited those values without quite knowing where they come from. Religion has clearly been the primary motivation in the creation of vast amounts of

Figure 8.2 A particularly German interest is town centres. After the war, towns were carefully restored to their former appearance. Limburg is typical of many for the care taken over its medieval appearance.

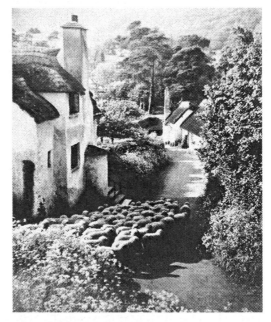

Figure 8.3 Sheep in an English village. The picturesque significance of sheep, rather than cows or pigs, lies in Christian iconography.

heritage, cathedrals and mosques, music and art, carnivals and crafts, but there have been significant disputes also. The destruction of the Afghan buddhas is very reminiscent of the Puritan iconoclasm obvious on the outside of so many cathedrals (see Figure 7.10, p. 206). These different views of life extend well beyond the actual religious products. In Islam, for example, there is a different attitude to the desert. What to western eyes may be a wasteland, though with interesting fauna, may be the home of God to other eyes. Some groups, for example native Americans and Aborigines, have been successful in their insistence that their holy things should be conserved only by themselves. This is not yet the case in Jerusalem, nor is it the case with the exhibition of Christian artefacts in western galleries and museums.

Ethnicity

The ethnic lens is often closely associated with the national and religious lenses, but with a much more diverse population in many countries it is now very obvious. The right to take charge of one's own heritage is only one issue. Ethnic groups may well see fixed heritage in a different light. This may be connected to the use of colour on building façades, or the kinds of landscape preferred, which Harrison has studied.[2] If managers of national parks are concerned that so few members of the ethnic minorities use our moorland national parks, the answer may be concerned with opportunity, but it also may be about choice. Perhaps we are not conserving the kinds of landscape that all the different ethnic groups of Britain may favour.

Class

Perhaps this author's Englishness is apparent with the selection of class as a major factor. However, in all countries the combination of status and income will have a major influence on the way heritage is perceived, which, as cultural capital, is a thing to be acquired specifically to increase class or status. The problem of gentrification is addressed later, and remains a root problem of all heritage management, not only in the built environment. In exactly the same way, there is a market for expensive old cars – veteran or vintage – which is a rich man's hobby. Poorer men (almost always men) conserve more recent and lower-status cars, but as time goes by, these are bought from them by the rich

Figure 8.4 This is the annual meet of the South West Counties Static Diesel Engine Society. Doubtless in due course such small engines, like car and traction engines, will become the toys of the wealthy.

and thus there is a constant cycle of the discovery of heritage from the bottom up.[3] As the middle class continues to expand, and to acquire income that allows them to devote some time and money to the acquisition of cultural capital, so they will need more and more heritage. This is often only too willingly provided by people who possess the old things, but who are anxious to demonstrate their improvement by acquiring new things. One of the places where such exchanges are made is the car boot sale.

Insideness

We have seen the different views of the insider in Chapter 5. The clash between the insider perception of importance and that of the visitor can be quite extreme, and quite inexplicable. The most outstanding feature of this difference is the insider preference for a heritage that commemorates events, people and activities of significance. Saving the local football team may be much more important than subsidizing the museum, or even conserving the stadium.

Figure 8.5 A small band practises on a Sunday morning in Bad Bevensen, Germany. Such things are, for insiders, as much part of the heritage as the surrounding buildings.

Gender

An understanding that our entire culture is shot through with various issues of gender has perhaps been the defining critical insight of the last quarter century. Heritage is no different in this respect, and organizations like Women in Heritage and Museums (WHAM) have drawn attention to the major gender imbalances demonstrated in our museums. The French word for heritage is *patrimoine*, and the concept of 'patrimony' has indeed underlain much heritage conservation, and indeed much cultural creation. The case that most official heritage, certainly in the built heritage and museum sector, has stemmed from a male-dominated agenda is a powerful one. But there is also a 'matrimony', and Pearce has demonstrated that the private heritage is often run by the women members of the family.[4] So the gender issue may relate, as does the insideness issue, to a public and private heritage difference. As women now take a greater part in the public sphere, the negative impact on the maintenance of the private heritage, largely at home, may be as obvious as their positive contribution to the public heritage.

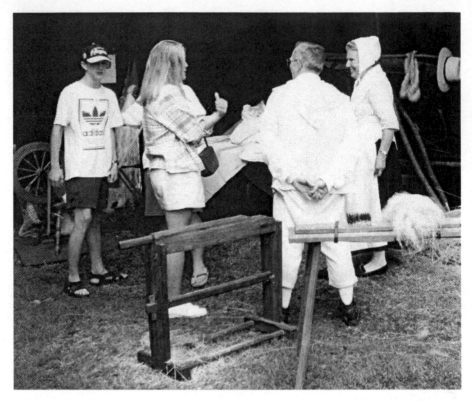

Figure 8.6 At the Hans Herr House, Pennsylvania, costumed enthusiasts demonstrate the processes of turning flax into linen, and thence into woven hangings.

Expertise

As with the insider, the position of the expert has been examined in Chapter 5, as academics are also a clear market for heritage. Public heritage has largely been designated by a combination of the expert and the government, mainly according to an expert agenda. Animals may be conserved and buildings listed following an expert appreciation which is often quite unapparent to other people. An animal that may be locally quite abundant is carefully protected because it is rare on a world scale. Or great sums are demanded to conserve a plant that may be a different species, but which it takes an expert to differentiate from the common variety, and which in any case has no flowers or other features of interest. Buildings may be conserved not because they are attractive but simply because they are historically interesting, or typical of their time. There are now plans for the demolition of the Princesshay in Exeter

Figure 8.7 Princesshay: this pedestrian street was built in the 1950s as part of the rebuilding of Exeter after World War 2. It was included in a conservation area, with the active consent of the City Council, but there is now a scheme, supported by the city council, to demolish it and build a new centre. Expert opinion wants to conserve the buildings, but public opinion is by no means so sure of the value of 1950s architecture.

to make way for new shopping development. But experts have designated the area a Conservation Area for its interesting type of postwar town planning.

Age

Cultural heritage is inevitably concerned with age, and people of different ages inevitably portray different attitudes. Their nostalgia is related to different times, usually the times of their childhood.[5] While the public British heritage may have a golden age in the time of Queen Victoria, this writer's personal golden age lies roughly between 1955 and 1965. These personal nostalgias are probably most obvious in the field of music and the media, rather than the built environment, but there is an 'inside' quality to being of a certain age. Visiting Prague, the memorial to Jan Palach and the 1968 rising is a poignant memory for this writer, best maintained by an unofficial memorial. Younger students regard it as part of history-book history, not essentially very different to King Wenceslas on horseback behind.

Figure 8.8 Prague: the memorial in Wenceslas Square to Jan Palach. Attitudes to this vary with the age, as well as the politics, of the onlooker.

Time

Studies of people's preferences for landscape have clearly demonstrated not only that the kinds of landscapes people consider attractive vary significantly with different people, but that they also vary dramatically over time.[6] Landscape places and features once considered attractive do not disappear completely from the catalogue of attractive things, but they become much less important. Their position in that catalogue becomes downgraded, and the place becomes rather *passé*. Such landscapes are replaced by new kinds of landscapes, previously ignored, which in turn go through a cycle of being immensely fashionable among the elite, then progressively less 'classy' until they become quite vulgar in taste. So the fascination of moorland only became apparent around 1870, as the preference for wooded valleys declined, and the

attraction of villages and farms dates from about 1920. Only in very recent years has there been a vogue for vegetable gardens and suburban landscapes.[7] One can assume that the appreciation of all other areas of heritage – of habitats, of buildings, of music and literature, of archaeological discoveries and of diet – will be similarly influenced. If this change over time does indeed occur also in other fields of heritage – and there is every reason to suppose that it will – then conservators are doomed for ever to conserve things for future generations, in which they will no longer be much interested, while accusing their own ancestors of destroying the things they would have liked to have preserved. Just as the immediate postwar architects showed a zeal in pulling down Victorian buildings, so we are only just beginning to take an interest in the buildings of the 1950s. The same is surely true of the heritage of most of the arts, including literature and music. Heritage, therefore, is always being invented anew, and old heritage is being consigned to the filing cabinet – available still, but not in active use.

Exercise
Study the change over time in the attitudes to conserving a particular area of heritage at a local level. The reference library's back copies of local newspapers are very valuable here, and a content analysis of heritage stories at various intervals over 100 years will soon reveal many changes of emphasis. A long run of annually published city guidebooks, or of county magazines, is also a source for such work.

Costs

Having dealt at some length with issues of value, to few of which the heritage manager will be able to assign a simple cost in terms of money, the complexities of costing should also be considered. The financial profit-and-loss account for any heritage product or place is, inevitably, highly complex, and the costs are by no means straightforward. They include the following:

1. *Direct costs.* These are the costs that are obviously involved with the maintenance of the heritage, set against the direct income from visitors, owners or grants.
2. *Opportunity costs.* These are the benefits that can accrue to the non-visitor. Many people may be keen to ensure that the national park remains accessible or the local church in good repair, though they have little

intention of using them in the foreseeable future. Nevertheless, they are prepared to spend money to retain the opportunity to do so. It is always necessary to consider the non-visitors, and any sensible evaluation system will spend at least as long questioning the people who are not visiting the site as it will those who are.

3. *Indirect costs.* These are the costs and benefits that accrue considering this heritage product as part of a package, for example, a new museum within a town. The visitors to the museum may add substantially to income generally. They will stay in hotels, buy petrol and clothes, perhaps, and they may visit other visitor attractions. At the same time they may lead to new costs; they might overload the sewage system, or finally make a new motorway necessary. Just as there is not much point considering the financial implications of a new acquisition for a museum without seeing it in the context of the whole collection, there is also little point in seeing one heritage attraction without looking at the others, and some may be quite remote, because visitors are not restricted to one kind of purchase. They may visit the cathedral today, the zoo tomorrow and they might lie on the beach the day after.

4. *Property costs.* Entirely apart from the costs of the heritage itself, other property owners in the neighbourhood probably benefit from the prestige of being associated with the heritage. Heritage is good advertising, as the number of car adverts against the background of the built heritage, or those using art works to sell whisky, readily attest. So the legal practice with views across the cathedral green expects to benefit from that position, both through enhanced value of the offices should they decide to sell that asset, and by the class of customer and the richer pickings they hope to acquire.[8]

Heritage organizations, however, are by no means simple economic entities. Some are simply profit-making organizations, and others are charitable bodies. In between there is a large range of organizations, such as the inhabited country house, which may resemble small business structures, but where there are many more important aims than making a profit, not the least common being simple survival. It is dangerous to apply the same management theory to these as to profit-making enterprises.[9]

Issues

These differences in values are at the heart of many of the major issues in heritage today. Four are briefly discussed here – the questions of access, authenticity, restitution and gentrification.

Access

In many fields of heritage there is a constant conflict between allowing access to people and conserving the heritage. The nature sector shows this particularly clearly. Of course, nature conservators in zoos and museums accept visitors, but because so much nature conservation in the wild is motivated by the need to protect the species, public access may easily be seen as unnecessary, and there are certainly many cases where the conservation is directed against people, especially egg collectors and plant collectors for example. Nature conservancies do not advertise where the rarest species are. But most sectors of heritage have unwanted visitors, intent on removing the heritage from its proper location and acquiring it, whether these are treasure-hunters, egg collectors or thieves. In most sectors there is a conflict between curating and access. There are caves, as at Lascaux, which have had to be closed to prevent human breath ruining the paintwork; there are restrictions on visiting Stonehenge; many popular parts of gardens or national parks and even some ancient cathedrals have to restrict visitors to protect erosion of the pathway, or accept the very substantial reinforcement of that pathway. In most cases the academic discipline involved with that area of conservation will tend to favour protection at the expense of public access. Their motivation might well be to hand the thing on to the next generation – of scholars as well as general public – in a state worthy of study. Their concern for authenticity will also revolt at the idea, for example, of widening a door to allow more visitors.

In the case of the natural heritage the presumption that the provision of public funds must also allow public access, a presumption almost universally held in the built heritage, is much less strong. Where a protected habitat is sufficiently off the beaten track, a common solution is to provide no on-site interpretation and certainly not to advertise the site's whereabouts or importance. This is self-selected restriction, as only those with a serious interest will go there, and most of those can be trusted. There are cases that

are made in all sectors of heritage for silence rather than interpretation. However, such a policy will not work where the site has commercial value, as in the case of rare birds' eggs, some rare plants or geological specimens. Determined and knowledgeable thieves will not be deterred by mere lack of signage.

Access, of course, is good public relations. Keeping rare pig embryos in a test-tube does less for public support than having real pigs of rare breeds at the local show. Nature reserves already suffer from the fickleness of natural things, so that the visitor who comes to see the wolves will be disappointed, and even the rare plants are dormant at the time, so a nature conservancy which restricted public access more than necessary, however carefully explained, would soon find itself starved of tax-payers' funds. In considering the many arguments by various groups in favour of free public access, controlled access, expensive access or a complete ban on access, the future generation may be one group not too often considered.

Exercise

Write an essay on the theme 'Should museums charge for admission?' Free admission is often defended on the grounds that museums should be available to everyone, including the poor. But actually, the visitor profile, even of free museums, shows that they are frequented by the comparatively wealthy, so poorer tax-payers may be subsidizing the hobbies of the better-off.

Authenticity

Perhaps because the monuments sector was where most of the academic debates were located in the nineteenth century, the question of authenticity has been placed at the very centre of heritage studies. One major figure was Viollet-le-Duc, in France, who influenced much restoration both there and abroad. Perhaps his most famous work was the walls of Carcassonne, though he also restored Notre-Dame and many other buildings. In England he was followed, for example, by Pugin at Cardiff Castle. This became known as restoration *à la mode*, and the basic premise was to restore or even complete the building according to an idea of how it might have been originally intended. This inevitably led to highly fanciful and usually romantic rebuilding. His position was later attacked by John Ruskin and William Morris, who

opposed such restoration (which was at that time completely altering the interiors of many English churches) and who championed the cause of repair rather than restoration, or renovation. Buildings should be repaired to the minimum level needed to prevent them falling down. Organizations such as the Society for the Protection of Ancient Buildings (founded by Morris) lay down guidance as to the degree of alteration which is acceptable – and it is their school which has largely won the argument, so that the most recent preference is to 'preserve as found'. There should be no attempt to replicate what might once have been there, and the necessary repair should not be hidden. Pretence and pastiche are quite unacceptable – to the experts.[10]

The professional wish for honesty – that all modern repair should be clearly seen to be modern, and should not ape the old or be deliberately aged ('distressed', in the parlance of the antiques trade) – is largely out of sympathy with the view of the general public, who often show themselves perfectly happy with restorations and renovations, and even complete rebuilds, whether they retain the patina of age or not. In Hildesheim (see Figure 7.9) the citizens voted for an exact replica of the ancient building to be built in the main square, despite the unavailability of original techniques or sufficiently cured

Figure 8.9 This vernacular property in the Black Forest has been restored as a museum, though *in situ*. Problems of modern living, health and safety are thus circumvented. Few people today would tolerate living where the smoke from the fire simply finds its way through the thatch, curing the sausage and bacon *en route*.

timber. In Wootton Bassett, in England, the local people have not welcomed the removal of the Victorian 'medieval half-timber' and its replacement with 'authentic' lime wash.

The problem is, as has been elegantly described by Ashworth, that there are numerous kinds of authenticity (see Figure 8.1).[11] Where a monument comprises a building erected largely at a single time, it is possible to use that first-build date as datum, and all attempts to restore or repair could be seen in reference to it. This is very uncommon in other areas of heritage, as well as with many buildings. So the authenticity usually referred to by the building conservator is that of originality. Was this item part of the original build or not? This is the authenticity of date. Closely coupled with this is the authenticity of materials. Is this stone to be used for repair from the same quarry as the original? At a recent visit to a house first built in about 1400, but altered every century since, the archaeological guide slapped a huge stone fireplace and said, 'Of course this isn't real' – meaning that it dated from the eighteenth century using materials common then. Modern regulations had resulted in the injunction not to penetrate the ancient walls, so the attempt to build a kitchen and other facilities suitable for twentieth-century residents had actually resulted in a freestanding construction of plasterboard, which was completely out of keeping in a building of quality.

Almost everything shows elements of authenticity. Disney World is an entirely authentic twentieth-century theme park. Equally, very little is perfectly authentic. Few conserved motor cars, for example, will never have had a spare part fitted. If they were, indeed, exactly as they left the factory, and had never driven a mile, then what kind of authenticity is that?

Violet-le-Duc would claim he was seeking an authenticity of style, not of materials. There is an authenticity of place, too. Is a building, or any other heritage, which has been taken from its original place and transplanted somewhere else, such as London Bridge, erected in western USA, authentic? There is also an authenticity of function, and many museums would now recognize that exhibiting a hand axe as if it were a work of art detracts seriously from the object's authenticity, as is clearly the case with a medieval church converted into offices, or even a museum.

There may also be an authenticity of experience. It is at least possible to imagine that a theme park could produce an experience of living in a Viking house that was much more realistic than actually staying in one. Similarly, however strenuously one makes the effort to reproduce fifteenth-century musical instruments and their style of playing, the experience of listening to

Table 8.1 Versions of authenticity

Authenticity of the ...	Descriptor	Example in the built heritage sector
Creator	'Hand of the master'	It can be proven to be by a specific architect
Material	'The original material'	It is formed of the original stone, etc.
Function	'The original purpose'	It is still used as, e.g., a church
Concept	'The idea of the creator'	It is what the architect intended, even if this means restoration
History	'The history of the artefact'	It is of the correct period, and all changes to the building are properly maintained.
Ensemble	'The integrity of the whole'	It comes complete with all its outbuildings, gardens, etc.
Context	'The integrity of the location'	The building is still on its original site, and its surroundings are the same as they were originally
Experience	'The original emotion'	The user of the building still has a similar experience to that originally intended
Style	'It looks right'	It reproduces the original appearance

Source: Adapted and developed from the diagram by G. Ashworth, in G. Ashworth and P. Howard, *European Heritage Planning and Management* (Exeter: Intellect), 1999, p. 45.

them is inevitably inauthentic as we are listening with twenty-first-century ears.

In the natural world authenticity has seemed, until recently, to be a less important debate, as habitats can be man-made, but this has now been questioned. Some modern scholars consider that the biological diversity of a newly made oak wood or wetland will take so long to reach that of a natural one that the concept of authenticity should apply equally to such operations as to renovating buildings.

Restitution

Probably the most important issue facing museology at present is the issue of the appropriation and repatriation of artefacts, with the great test case being whether the Elgin Marbles should be returned to Greece from their present home in the British Museum. The issue is sometimes referred to as Elginism.[12]

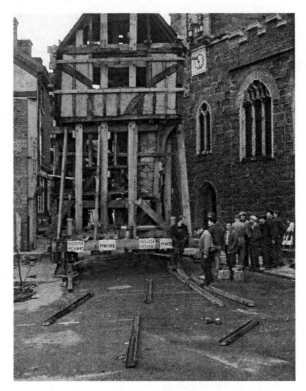

Figure 8.10 This building stood in the way of a new road, so it was moved to a new site, bodily, in 1961. Some material authenticity may be retained, but that of place has been lost.

The problem extends to the whole of the movable heritage, of course, but is particularly acute in the museum world, and deserves considerable debate. At present there seems to be a steady move towards repatriation, and there are carefully argued, and impassioned, debates on both sides of the argument. All that is offered here are a few pointers towards the issues that might be considered in any particular case.

1. Context. The greatest academic strength of repatriation is to put the item into context, e.g. to see the marbles on the Parthenon. The case loses heavily when it is merely a matter of transfer between one museum and another.
2. Original acquisition. Was the original acquisition legal by the standards of the time or by today's standards? Was it theirs to sell? Europe, at least, is awash with war booty, little of it legally or honourably acquired. The recent admission by the Russian government that it possesses a large

number of Trojan remains taken by force from museums in Berlin in 1945 is such a case, though whether Germany's acquisition was itself acceptable remains open to doubt. Some acquisition took place so long ago that records cannot exist. There is also the question of unfair trading. African carvings with an enormous sale value may have been acquired for an artificially low price. When people are hungry anything may get sold, and Germany in 1945, Kosovo in 1999 and many parts of Africa over the last 50 years have been ripe for heritage exploitation.

3. Ownership. The case of shipwrecks is the most obvious problem of which country owns what (see Figure 8.11). The wreck of the *Titanic* is a case in point. The ship was built in Northern Ireland and registered in the UK, sunk in international waters but closest to the then independent Dominion of Newfoundland, now part of Canada, with passengers from many countries, certainly including Germany, the UK and the USA. Who owns the *Titanic*? One answer is an American company. By what right did the US courts do this? Boundaries also change. In what way does the present-day Belgium represent the Spanish (later Austrian) Netherlands, in which territory lived Rubens?

4. Tradeable commodities. Can we apply the same rules to pictures as to monuments? Should all Rembrandts be in Holland? Portable heritage is, of course, moveable and much was intended to be moved. Some of it was made for export to others, or commissioned by them. To return all works of art to the country where they were made would be an action severely in restraint of trade. A 2001 gift to a French museum, however, seems to suggest that works by French artists ought to be in France.

5. By what right does a government claim ownership over private property? In what way does the current government of Greece reasonably represent the Ancient Greeks? Can the current government of Germany claim rights over many items made and owned by German-speaking people in, for example, Poland, perhaps at a time when that place was part of Germany?

6. How far up or down the identity scale do we go, or is this just a matter of nation-states? Can we say that the Lindisfarne Gospel should go back to Lindisfarne? Perhaps at a larger level we could claim that the Elgin marbles are simply part of European culture, and are now housed in a European museum?

7. Visitors' rights. Modern air travel has certainly made visiting foreign countries easier, but not universal. The rich can fly all over the world to see heritage in context. The poor cannot.

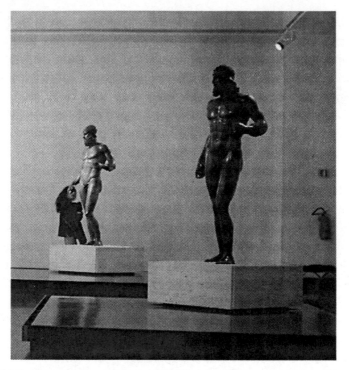

Figure 8.11 In the museum at Réggio di Calábria are these splendid sculptures, which were found in a wreck in the Straits of Messina. They probably were made by Greek-speaking Hellenistic craftsmen, in Alexandria, and were *en route* in a Phoenician ship to the colony at Marseilles when they were wrecked. Who has the best claim?

8. International harmony. If each country simply guards its own heritage, without displaying that of the rest of the world, will that lead to better international understanding, or not? Does that matter?

9. How does this apply to other heritage sectors? Do we repatriate from zoos? Should morris dancing be forbidden outside England? This argument takes place in a rapidly globalizing world, where the Guggenheim Museum has a branch in Spain. Are the collections there to be national, regional, international or corporate?

10. Some items carry a completely different set of meanings for one group than for another. This has been the central issue in the case of native Americans and original inhabitants of Australia and elsewhere. Most typically, the western curator has put an aesthetic label onto items that actually have a religious significance. This is done, of course, equally with items of Christian religious significance.

Gentrification

If heritage is not portable, the transfer between current owners and future owners is likely to be going up-market. There is a considerable literature by geographers, sociologists and others about the problem of gentrification, the way in which a place can be colonized by people in a higher-income group than that which was previously there.[13] Perhaps the example in England that is best known is Islington, and also – for gentrification is far from being a merely urban phenomenon – many Cotswold villages. There is no need here to go into this debate and theory to any depth, but it is vital to note that heritage (and not merely the built heritage) is deeply implicated in gentrification. It is not necessary wholeheartedly to accept the view that heritage is a conspiracy by the rich to defraud the poor, and to steal their cultural capital, but it is difficult to deny that there are major problems in this direction. A very similar process has been studied in relation to old cars.[14]

Gentrification should be a matter of deep concern for all heritage managers. As the heritage value of comparatively minor buildings (or indeed objects) is recognized so they become desirable, at least by that educated group who are concerned about heritage issues; and over time, the present inhabitants, perhaps quite poor, will be displaced by the comparatively wealthy, and the poor will have to find other less desirable housing. Of course, there are occasions when this suits the poor admirably, and the housing that is less desirable to the wealthy may be more desirable to them. The situation where the tenant of an old, thatched cob cottage is entirely happy to give up the lease if offered a comparatively new house with all 'mod cons' is far from unknown. Even if they preferred to stay in the old property, they were probably well aware that they were unable to maintain it. There have been many well-meaning attempts to restore and conserve smaller properties while attempting to prevent the gentrification process, but they can scarcely be successful in the long run. Some British national parks will now only give planning permission for new properties if retained by those who work locally, but any system that restricts the number of people to whom the house can be sold will inevitably depress the price and thus act against the interests of the sellers, the very people it was designed to help. So the process can be slowed, but, in a free-market economy, it is probably ineluctable.

So gentrification will proceed both in the city and in the countryside. Older houses in inner-urban districts will be bought by wealthier families, and the whole area will rise in status, in tidiness and in value. If the houses are 'done

up' with public funds they will probably be purchased before long by people who could have afforded to do it themselves. Quite often such districts have gone through cycles before, and may well have contained properties, built for professional people in the nineteenth century, that have since fallen on hard times, and have been divided into multiple occupancy. Heritage is part of the process of rehabilitation of such areas into new communities. In the countryside the homes of the rural cottager are now the preferred residences of wealthier people either commuting to town or using the property for weekends, or working from home using electronic communications. The love of being in a cottage can be dated back even before Marie Antoinette's famous attempt at Versailles, and there are 'gentlemen's cottages' in many English villages, such as just outside the gates of Powderham Castle. In fact, the classic English cottage on the Christmas card is probably a gentry product, as at Selworthy (see Figure 8.12).

Every time a conservation area or a national park or an Area of Outstanding Natural Beauty is designated, or every time a private property is listed or scheduled, there will be an economic impact. The heritage planner needs to be fully aware that such designation is likely to lead to the displacement of some

Figure 8.12 These cottages near Minehead are on the large Selworthy estate, formerly belonging to the Aclands, now owned by the National Trust. They were deliberately built to be picturesque, not built by rural labourers simply as their own homes.

and the advancement of others, and that the advantage will probably accrue to the already advantaged. In Český Krumlov, in south Bohemia, the designation of the city as a World Heritage Site led to the rehousing of many poorer people from the middle of the town in apartment blocks on the outskirts. The fact that many of these were Roma gave the incident an ethnic as well as a class angle. In Zaragoza, a district inhabited largely by immigrant minority groups is now being rehabilitated, and the artists, usually the shock troops of the bourgeoisie, are moving in.

Figure 8.13 Streets in the west of Zaragoza, Spain, are being renovated and bought by artists and young professionals.

Figure 8.14 The main square of Marrakesh, with activities such as snake-charming, which may not be acceptable to modern liberal sensibilities.

Figure 8.15 A restored 'riyad' house with a courtyard. Beautiful workmanship, belonging to a Swiss organization.

Case Study: Marrakesh

Marrakesh lies in southern Morocco, quite close to the Atlas Mountains. It now sprawls over a considerable area, but the heart of the city, and a World Heritage Site, is the medina, a complex network of streets and squares. There is no doubt that much of the built environment in the medina – private houses and public buildings and spaces – is being badly eroded and even destroyed. Some of the houses are being saved, however, and there is now a considerable number of wealthy foreigners, mainly from Europe, and foreign organizations and institutions that are buying property in the medina and restoring and repairing it with the greatest care. Many local residents are happy to sell their properties and move into the suburbs where they will have room to park their cars. In addition, western organizations, such as Arts Restoration for Cultural Heritage (ARCH), from Austria, are supporting the restoration of much of the public built areas. The lesson of Figure 8.16, the restored fountain behind a fence, has now been learned. But there are so many voices in Marrakesh, and so few with influence:

- local tradesmen who manufacture their products inside the medina, but who fear that more rich settlers might push them outside;
- Moroccan tourists, for whom Marrakesh is an important shopping trip;
- overseas tourists, for whom Marrakesh is an exciting, rather fearful, exotic experience. A neat and tidy Marrakesh will inevitably remove a substantial element of that apprehension;
- the Islamic authorities, concerned that the medina is now being taken over by non-Muslims, and changing its nature;
- local people with property in the medina who want to sell it for the best price;
- wealthy foreigners looking for somewhere exciting to live;
- the Moroccan government, and Marrakesh local authority, hoping for greater tax revenue but very keen not to lose tourists; and
- local women and children, whose voice is difficult to hear.

In one sense, there is not a problem. In a few years' time, Marrakesh medina will be superbly restored, by private and by western money. The Muezzin will call the people to prayer, but the muslim population will not be able to hear him, because they will now live outside. It will look superb, but to what extent it could be called 'authentic' is quite another matter. Compare Venice.

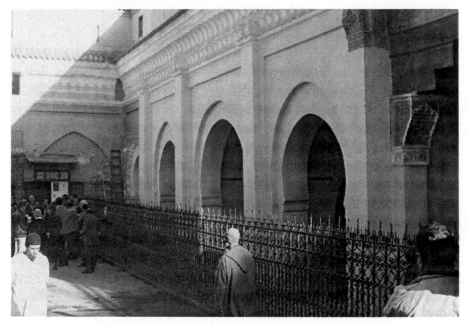

Figure 8.16 A beautifully restored fountain, yet the fence ensures that people are unable to approach it and use it for its original purpose.

Figure 8.17 Many of the products sold in the souks are also manufactured in the city.

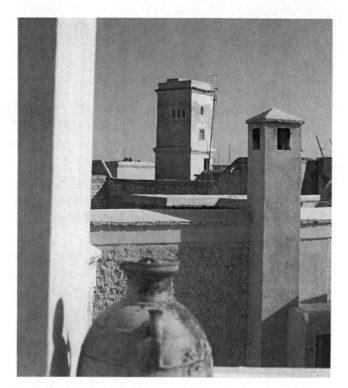

Figure 8.18 Marrakesh roofs. The voice of the muezzin may soon ring out over a non-Muslim city.

Figure 8.19 Walking around Marrakesh can be quite fearful for the visitor. Should it all be made clean, hygienic and overtly safe?

Ecomusées

The French have devised a slightly different solution to some of the issues discussed in this book, in the form of the ecomusée. Although the term itself is used only in the Francophone countries, including Belgium and Quebec, there are similar ideas elsewhere, in Scandinavia, for example, and the development of the Trevithick Trust in Cornwall is not dissimilar. They are used as starting-points for development, either in run-down industrial districts, for example, in the Nord, or in Le Creusot, or in rural areas with depopulation and loss of income, such as the Cévennes.

These have been determined attempts[15] to develop museums that work across all the fields of heritage, promoting activities as well as nature and artefacts. They have tried to present the local heritage to the local people, staffed by the local people. They have developed the idea of networks of linked sites, some natural, some cultural, all within the umbrella organization. Their success has been quite clear in some ways. Le Creusot certainly does not feel like a run-down industrial centre these days. Tourists are increasing the incomes in the valleys of the Cévennes. The publishing achievement of the

Figure 8.20 The Mas Camargues is owned by the Ecomusée de Mont Lozère and is one of a network of sites. This networking is one of the characteristics of an ecomusée.

Figure 8.21 The locomotive shed at Le Creusot is now the university library. Stairs to the stacks emerge between the rails. Large organizations, such as universities or national parks, may be necessary for survival.

Figure 8.22 France: St Hippolyte du Fort, the Silk Museum. The Silk Route appears to have no reality apart from this sign and a very expensive book.

Figure 8.23 Museum at St Jean du Gard. A collection of local material, largely assembled by local people, but nearly all of the visitors at St Jean du Gard are tourists.

Parc National de Cévennes, in co-operation with the Ecomusée de Mont Lozère, is most impressive. Despite their obvious success, the analysis by different markets and values still reveals issues:

- Local farmers in the Cévennes resent some of the policies and advice emanating from the combination of national park and ecomusée. At Le Creusot the university occupies many of the buildings, which are superbly restored, but not always publicly accessible.
- Visitors to the ecomusées are, twenty years on, almost exclusively tourists not locals.
- The network at the Ecomusée des Vallées Cévenols has broken down, and staff at one site are unable to direct visitors to the others. Clearly local animosities are at work.

Figure 8.24 A typically French suburban house in the hills of Lozère, complete with swimming-pool, of a type resisted by the management of the ecomusée, which can easily be perceived as the voice of authority.

Figure 8.25 Pont de Montvert: a museum which also acts as the community centre, but which rather dominates the rest of the town.

- Although the ecomusées were established using largely local support, the next generation has virtually lost interest.
- The main site, the museum, of the Ecomusée de Mont Lozère rather dominates the town of Pont de Montvert, and its displays use very professional museological techniques where they might be considered inappropriate.

Conclusion: public and private heritage

Many of the elements in this chapter and in the study about markets for heritage and levels of identity have underlined the distinction between public and private heritage. This is not far from the distinction between the high arts and popular culture. Indeed, the word 'culture' is frequently used in two senses – either as an understood set of international artistic values, with a clear hierarchy of value, or as a variety of ordinary ways of life, each equally valuable. No distinction between the two is entirely satisfactory, especially as high culture may be very popular. Certainly there are many museums which stand as temples to popular culture. Also the concept of a vernacular or folk culture opposed to the high arts is far too simplistic, largely an invention of the artistic establishment, and will not fit into an age of global pop music, Kentucky Fried Chicken or universal espresso coffee. If there was ever a time when a distinction could be drawn between an upper-class interest in the high arts, international in scope, and a popular interest in local crafts, it has long since gone. Today the local carnival in a European village will probably have displays of the Wild West, of American soap operas and Disney animals.

Nevertheless, with all those and many other caveats, heritage artefacts in museums, national parks, nature reserves, listed buildings and scheduled monuments – the official heritage recognized by government organizations at many levels – may well touch the emotions of the majority rather less than the final two categories of heritage – activities and people. Visitors to the professionally organized display of high art paintings are likely to come from a wealthier social group, a dominant group who more closely represent the 'official' heritage if only because it is the same group that determines that heritage. In the list below, globalization may have made the international and local dichotomy unsafe, but many of the others can still be defended:

international	*local*
outsider	insider
public heritage	private heritage
professional management	amateur caring
high art	popular art
self-conscious	unself-conscious
aesthetics	meanings
things and sites	people and activities

NOTES

1 J. E. Tunbridge and G. J. Ashworth, *Dissonant Heritage: The Management of the Past as a Resource in Conflict* (Chichester: Wiley), 1996.

2 C. Harrison, M. Limb and J. Burgess, 'Recreation 2000: views of the country from the city', *Landscape Research*, 11(2), 1986, 19–24.

3 N. Shore, unpublished dissertation, University of Plymouth, 2000.

4 S. Pearce, 'The construction of heritage: the domestic context and its implications', *International Journal of Heritage Studies*, 4(2), 1998, 86–102.

5 D. Lowenthal, *The Past Is a Foreign Country* (Cambridge: Cambridge University Press),

6 P. Howard, *Landscapes: The Artists' Vision* (London: Routledge), 1991.

7 P. Howard, 'Artists as drivers of the tour bus', in N. Lubbren and D. Crouch, *Visual Culture and Tourism* (London: Berg), 2002.

8 G. Ashworth, 'Conservation, designation and revaluation of property: the risk of heritage innovation', *International Journal of Heritage Studies*, 8(1), 2001.

9 B. C. Williams and C. S. C. Bradlaw, 'An economy of country houses', *International Journal of Heritage Studies*, 7(3), 2001, 273–94.

10 Society for the Protection of Ancient Buildings (SPAB) website, http://www.spab.org.uk/ 30 October 2001.

11 G. Ashworth and P. Howard, *European Heritage Planning and Management* (Exeter: Intellect), 1999, p. 45.

12 J. Greenfield, *The Return of Cultural Property* (Cambridge: Cambridge University Press), 1996.

13 Including particularly N. Smith and P. Williams (eds), *Gentrification of the City* (Boston: Allen & Unwin), 1986.

14 Shore, dissertation.

15 P. Davis, *Ecomuseums: A Sense of Place* (London: Leicester University Press), 1999.

9

Interpretation in Practice

SUMMARY

'Interpretation' covers the various means of communicating heritage to people. This includes both live interpretation, using guides and other human intermediaries, and interpretation using design. Nevertheless, some heritage can speak for itself and one option is always to use no interpretation at all. There are also major dangers of interpretation slipping into indoctrination, especially within the interpretation of landscape and nature. This can only be countered by a moral stance of honest dealing.

A great deal of this book so far has been involved with theoretical ideas concerning what heritage is, and why it might be conserved. But heritage studies are generally, and rightly, regarded as a practice as well as a theory. There are three main areas of practice: conservation, management and interpretation. In this account we are not dealing with the various practices of conservation that differ between the fields of heritage. Likewise, the major issues of heritage management have been discussed in Chapter 8. There remains, however, the issue of interpretation – which can be defined as deciding what to say about the heritage, and how, and to whom, to say it. So this chapter is involved with discussing the broad issues of live interpretation, and design interpretation, and with trying to discover criteria for deciding what tale to tell at a heritage site and how best to tell it. This will usually mean negotiating with other specialist practices such as actors or designers. But first we look at the case against interpretation – for there is every reason to suppose that in many situations the best option is no, or minimal, interpretation.

The case against interpretation

Much of the work on interpretation, from Tilden onwards, has assumed that interpretation is always a good thing, and more interpretation is even better.[1] There are good reasons for challenging this view, and for ensuring that the minimalist option is always considered. This case can, perhaps, be usefully addressed under three headings.

The curatorial case – Keep 'em out!

Although we have generally accepted that heritage is for people, some of those people have not yet been born. Many today would accept that the point of a museum, for example, is largely educational, and may even be for entertainment, but there are surely some cases where all of us might accept that conservation for future generations dictates lack of human access. If the last of a species of orchid in the world lies in a particular field, or (as with Lascaux) the item can be destroyed or damaged by human access, then the exclusion of visitors may sometimes be justified. To have major interpretation panels drawing attention to the field, attracting people right up to the Keep Out signs, might seem contrary to good management. Of course, there may be occasions when even that may be necessary – and the protection of the Loch Garten ospreys in Scotland has attempted that, accepting that so many people are interested that mere silence will not suffice. If people are going to come anyway, then the birds are probably better protected by interpretation rather than by silence. Indeed, as the potential thieves undoubtedly know where the nest is, then having honest folk watching the nest for as long as possible might help survival. Nevertheless, there are many sites, especially nature conservation sites, where authorities have deliberately chosen not to advertise the location, and to keep all interpretation to a minimum.

A second blanket reason against interpretation is that a great deal of it encourages people to travel, and is therefore inevitably part of the tourist industry, which, it can certainly be argued, is among the worst industries in terms of environmental damage, if only through the expenditure of fuel. This has been recognized in the past. The country parks, recreational areas close to towns, were introduced, at least in part, with an eye to relieving pressure on the national parks, which had become very popular. If the dog-owners of

Figure 9.1 In Florence, as in many places, nothing is likely to dissuade visitors from coming, and the economy depends on them continuing to do so. In such cases, the case for good interpretation, which is used also as a management tool, is overwhelming.

Sheffield could be persuaded to walk their dogs close to the city, that would relieve pressure on the much-interpreted, much-promoted, nearby Peak District. Although tourism may be regarded as vital to the development of individual areas, the promotion of yet more car and air journeys should always give cause for pausing. Much interpretation has no intention of acting to promote more visits, but the distinction between interpretation and advertising is never easy to define, and usually the panel or the leaflet is part of a wider promotional campaign. The National Trust, in their development of Prior Park at Bath, have deliberately opted against having a car park, and if it results in fewer visitors, at least that will not harm the building. A large organization such as the Trust can afford to cross-subsidize properties in a way that single properties cannot. In some cases, of course, the damage is already done, and all that interpretation does is inform existing visitors.

So a first rule may be: ensure that the consequences of interpretation will not compromise the conservation of the heritage for future generations, or create unnecessary extra pressures on the world's resources.

The communications case – Let 'em in but don't rot their brains!

The problem with communicating information is that it can be a limiting experience. Many heritage organizations, such as national parks or museums, carry immense authority, and hence not only an enormous potential to inform, but also a considerable power to deceive, if only unintentionally. Such an organization compromises its authoritative voice at its peril.

In particular, the interpretive planner usually selects only one storyline, or a very few, and usually from one paradigm or one disciplinary position. When the interpreter decides that the appropriate story to tell about a church is about its architecture, other possibilities become immediately obscured. At the site of the Battle of Sedgemoor the story is a military historian's story, not one about the ecology of the moor, nor indeed about the lives of the combatants, nor even about the rights and wrongs of the opposing sides' cases. Indeed, many battlefield interpretations studiously avoid taking sides, and the resultant failure to discuss the ethical dilemmas involved can itself become an amoral position. Occasionally, a completely extraordinary interpretation can show how many facets there are to many heritage sites, such as the interpretation of a graveyard from the viewpoint of geology.

Only telling one story can stultify future knowledge. For example, there is surely a good case for the county museum to house a collection of all the rock types and fossils within its borders, and similarly, a reference collection of all the birds and reptiles. The more these are packaged as an educational experience for the school or other visitor, the less they are available to be reinterpreted. Often new understandings come about because a scholar was able to say, 'No, we have been looking at these things in the wrong way, in the wrong sequence; if you look at them in another sequence a completely different story emerges.' Even without such high-flown motives, there are times when the visitor does want to check quite simply on the nature of what he has seen, using the museum's authoritative reference collection to decide that the bird he saw really was a spotted flycatcher and not a pied flycatcher. Many things are difficult to show clearly in two dimensions in the guide book, and can only really be properly defined in three dimensions, or by feel, sound or even smell. But the reference collection is hard to find in the modern museum.

In fact, the new developments in many disciplines depend on people having their own new interpretations of the world. A primary reason for conserving

fossils, say, is to allow future scholars to look at them in a different way and produce a different theory to account for their variations. Is that to be a privilege reserved only for scholars? If we insist that *this* is the order in which these fossils should be examined, then we are seriously constricting future thinking. In the case of a series of ammonites on show to the general public, there may be a good case for explaining the current thinking of the relationships between them, provided that it is recognized merely as current thinking which might change.

At least some people, some of the time, expect to do it themselves. Some parents might regard explaining things to their children as being among the normal duties of parenthood. Merely standing and reading a board reduces them to spectators rather than participants. On one occasion, at the wonderful Roman amphitheatre at Saintes in western France, where the interpretation was limited to a simple drawing of the ruins as they once were, with dotted lines to represent that which was missing, I witnessed one Dutch woman explaining to her friend where the wild animals were kept. She did so by crawling out of the area and roaring like a lion while her friend took the gladiator's part. I doubt whether interpretation would have helped them.

Figure 9.2 The great Roman amphitheatre at Saintes has minimal interpretation. There is one panel showing the current site, and what it once looked like, but otherwise, people make up their own stories.

There are many occasions when one has to ask 'Whose view is this?' 'To whose agenda are we working?' On some occasions this might be the very simple question, at a battle site, for example, of the sympathy of the writer. There can be little doubt, at the site of Culloden, near Inverness, that the writer was not a great supporter of the House of Hannover. Such obvious biases may easily be spotted and probably discounted by many viewers, but the question can be much more subtle. Many national park authorities, for example, use interpretation not only as a management tool – which itself might be considered to be slightly estranged from education – but also as a public relations tool. There are several occasions when one is entitled to ask, 'Is this panel or guide interpreting the landscape of the national park or the policies of the national park authority?'

Some places need to be discovered without assistance. There is ample evidence in the field of landscape perception that mystery is a most important ingredient of interesting landscapes, and there is no reason to suppose that it is any less true in other areas of heritage.[2] We enjoy not knowing what is round the next corner, as well as the process of finding out. Interpretation that tells us everything can easily destroy these subtler senses. Do we really want to know the mundane, demonstrable truth about the Arthurian legend, or the Loch Ness monster? Some places really do 'speak for themselves', and that may equally be the case with a cathedral as with a mountain. A particular instance of this need to allow self-discovery is the place which takes a bit of finding – the standing stones out in the middle of the moor, for instance. People set out to find the stones, through the mist, and set themselves a challenge. When they finally arrive they will be very pleased with themselves. A small acknowledgement that they have indeed discovered the proper place will probably be welcomed; but a large display panel, reminding them that this is a highly managed place, with many visitors a day, will not be (see Figure 9.3).

Even some museum collections are so astonishing that curiosity is aroused with little or no assistance. One of the author's favourites is the collection of minerals in the Czech National Museum in Wenceslas Square, Prague. Bohemia is famous for its metal mining, and the museum has a vast reference collection, which is carefully lit and labelled, but which features very little other information. The scale and the perfection of the exhibits are such as to arouse awe and curiosity, which could very easily be jeopardized by interpretive intrusions.

Neither can one be sure that the message carefully put forward by the interpreters will be properly received by the visitor. Because those who

Figure 9.3 Chun Quoit lies on the hills above St Just, and is not easy to find, especially in the all-too-common mist. Most visitors enjoy the challenge, but have no wish to be given an archaeology lesson on their arrival.

designed the interpretation at a site of atrocity – at Verdun, for example – intended the visitors to leave mourning for the sins of all mankind, it would be very rash to assume that such was the received message. Some French or German visitors may easily leave the site hardened in their dislike of 'the other side'. By no means everybody shares the liberal and democratic view of the human condition that is widely shared by those who write such panels.

This problem of individual self-discovery is closely related to the problem of self-consciousness. We have noted on several occasions the problem of the vernacular heritage, whether under that name or as folk art or as the cottage garden. The affixing of interpretation panels, perhaps to a small vernacular building or to an allotment garden, can create the same effect as putting a folk group in a theatre instead of in the pub. The whole context is changed. The little cottage immediately loses an element of its character that was the charm of self-discovery. Up until now we had thought it was our particular favourite little cottage that no-one else knew about; suddenly it is 'front page'. Obviously, locals often feel particularly upset by such a move. Also, it is now expected to compete with polite architecture on the latter's terms. Again, it can be like putting the local folk dance group on the stage of the theatre, and

following them with the Royal Ballet. If there are already twenty tour buses a day turning up to look at this cottage or garden, then that changes the argument. The author knows of one small part of Europe where the local people have an extraordinary social life, lived largely in cellars, and where, on an entirely amateur basis, they share wine, stories and songs. This is a most rich local tradition. It is thankfully quite uninterpreted and apparently unknown to the tour companies.

The cultural case: Don't let 'em think they know!

The final case is directed particularly at live interpretation and, more specifically, at first-person interpretation, re-enactment and living history; but several of its points are relevant to other forms of interpretation also. Living history, however, is a very powerful interpretive tool, and there are even more reasons for ensuring that those exposed to it have a healthy realization of its limitations.

The first problem might be termed the 'Grange Hill' syndrome, after the British TV series set in a school. Nothing as boring as learning and teaching ever took place there; each episode had to be more exciting than the one before, and the logical end of the process was, presumably, a massacre, as in the film *If*. Throughout most of history, the lives of most people have been fairly mundane most of the time. The English Civil War was a very small part of English history, and most people would have been largely unaffected. Many servicemen from World War II remember the boredom above all else. Interpreters have a very human wish to enliven the story, but the result is that the past is shown to be much more exciting than it could possibly have really been.[3]

We have already noted that empathy cannot exist. The music critic who pointed out that we might listen to music which, technically, exactly matched the sound produced 500 years ago, but that we hear with twenty-first-century ears, could have been referring to all the other senses also. This, of course, is only a problem when it is not frankly admitted. One of the most common cases is that of religion. It must be almost impossible today, even for religious people, to think in the same way as the majority of people in Europe thought throughout much of the last 2000 years, i.e. with an absolute belief in the literal existence of both heaven and hell. The practical element of this problem

is to ensure that no words such as 'step into the past', or 'where the past comes alive', disfigure the interpretation; they are not merely picturesque turns of speech, they are lies. The argument that advertisers use such phrases all the time does not affect their essential mendacity.

One of the particular problems to do with authenticity and empathy is that we must, legally and morally, insist on the standards of our own time being applied. This may be as simple as ensuring that the risks of death on a re-enactment battlefield are less than the original ones. We would, presumably, expect the health and safety code to be applied as rigorously in the museum as anywhere else. It may be much more subtle. Do we accept that schoolchildren learning about Victorian schooling should be given the same punishments? Do we apply all the same standards of discrimination on grounds of age, religion, sex or disability to all our interpretive models, so accepting that perhaps half the soldiers in a sixteenth-century army could be women, or that the person playing the part of the English governor in a re-enactment, such as that at Colonial Williamsburg, might properly be Afro-Caribbean and perhaps female? If hunting with hounds is banned in the UK, how easy would it be to re-enact this charming old heritage tradition? In order to be authentic it would be necessary not only to have red coats, and horses, but also a pack of hounds and, presumably, a fox.

So one option should always be to consider having no interpretation, or making do with the minimum number of descriptive signs – as is often the case in gardens. Without doubt, however, some things need interpretation, and so do some people. The site that is already too busy will need interpretation that would be unnecessary if it were largely empty. An example is Belchen, a hilltop in the Schwarzwald of southern Germany (see Figure 9.4). This has recently been interpreted most carefully by specialists from the University of Freiburg, with a series of interpretation panels to explain both what is to be seen, and the management of the place. The views are so superb that on a clear day in winter, with about 40 visitors, very few bothered to read the panels. But not all days have such excellent visibility, and in high summer there may be 4000 visitors, not forty. On those occasions there is no question of the boards interfering with the solitude; the need to inform people becomes much greater. At the very least it gives them something to do in the queue!

But the boards of Belchen do raise another issue concerned with the audience for interpretation. Throughout this chapter we shall note the need to cater for different audiences, from the specialist to the young child, and also

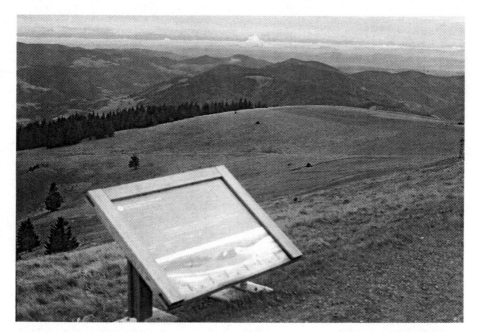

Figure 9.4 The panels at Belchen interpret the view, less important on a perfect day with few people, than on a misty and crowded day.

for the person who does not want interpretation at all. There may be a fewinstances where people should be made to read the material, or should be forced to listen to a guide, but simple liberty might lead one to suppose that it should not be compulsory. If someone simply wants to picnic or to walk the dog, or enjoy the scents, then that is a perfectly proper activity, and there is no requirement to insist on them being shepherded. This happens much more in some countries than others, and especially in large buildings where the only option is the guided tour (often, of course, in a language which cannot be understood). In these cases the guide is there as much for security as to impart information, but enthusiastic guides may find it difficult to remember that some people don't wish to listen. Oddly, also, interpretation seems more compulsory in places where one has paid to gain entry than for free-admission museums or open-air sites. One might suppose that one had more rights to being left alone at such places, but perhaps proprietors want to demonstrate that the money is well spent.

So interpretation planning can start with two clear objectives: first, that the option of no interpretation should always be considered; and, second, that people should be given the opportunity to ignore it if they so wish. The next major decision is the choice between methods of live interpretation, or systems

for design techniques. Most often the decision, in a major development, will include elements of each.

Exercise

Describe examples, one indoor and one outdoor, of over-interpretation, where the visitors are loaded down with unnecessary information, or forced to listen when they may not wish to. Consider whether different audiences might feel differently about what is provided.

Live interpretation

Live interpretation involves the use of people. At the simplest level these will act as guides, but even this category varies, from the room steward who is prepared to answer questions, through to the safari guide who is your sole human contact for a week in the wilderness. This is third-person interpretation, where the guide does not act any part but uses normal language, and usually wears normal, contemporary clothes (though sometimes a uniform). Some third-person interpreters will be costumed to appear as a person of the appropriate time. First-person interpreters are usually costumed and live the role, to greater or lesser degrees of reality. The search for authenticity by some first-person interpreters, historical re-enactors and living-history participants leads them not to clean their teeth for weeks and to deliberately to take on all the details of the past. They will usually attempt speak in the language of the time. In recent years such re-enactments have become popular in television programmes such as *The Victorian House* and *The 1940s House*. Such living history can indeed suggest solutions to some historical problems, but the link with theatre needs to be constantly borne in mind.

There is a small group of interpreters who are not quite in either group; these are reality interpreters. At Buckfast Abbey, in Devon, school parties are guided round the Abbey by a monk, and not by a young volunteer or professional actor dressed up as a monk. He can hardly be regarded as a first-person interpreter, nor can a Yeoman Warder at the Tower of London, nor perhaps can the owners of a country house who personally show visitors around their home. Some military museums are staffed by military personnel, and such reality usually gives the experience a flavour which cannot be imitated even by the best actors. At Big Pit, in Wales, and at Le Creusot, one

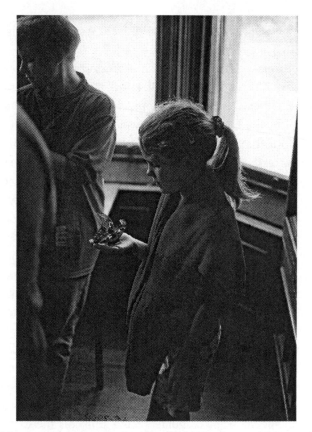

Figure 9.5 Live interpretation works. The look of rapt attention on the face of the little girl (the author's daughter) with the butterfly on her hand makes it very clear that she is completely 'hooked'.

major problem now is that there are not many ex-miners still sufficiently young to be employed as guides, and the next generation will have to learn the trade of interpreter.

Guides are effective

There can be little doubt that well-trained and conscientious guides can be outstanding interpreters. We have all surely experienced those occasions when our appreciation of a place has been entirely transformed by the efforts of a dedicated and knowledgeable person. The best reason for using guides is that they work – they do succeed in conveying information and giving pleasure without fixing panels to walls. They add elements of amusement and personal

touches, and at the same time are able to prevent visitors from destroying the heritage or stealing it.

The advantages make a long list, which also serves as a curriculum for the training of guides. Although guides will know their material, they may not always stick to it. They will be able to approach the same site from a variety of perspectives. Out in the countryside they will be able to identify and discuss the fauna and flora that is actually there today, not that ought to be there according to the textbook or the panel. Even indoors this flexibility is an enormous asset. Guides will often interpret the repairs taking place in a house, often to a very attentive crowd who so often seem able to identify with dry rot more easily than with eighteenth-century sculpture. Gardens, too, are full of ephemeral effects and landscapes of short-term crops, where only the knowledgeable guide can be useful. Knowing one's limitations is also a precious asset. Somewhere will be the visitor who knows more about a plant or a kind of thatching than does the guide, who can only benefit from an exchange of information. No fixed interpretation can approach the flexibility of the expert guide.

Guides are often local people, and have a set of personal anecdotes that may have little to do with the official script, but which enliven the visit. Often the stories are about other groups of visitors. In Exeter one of the most effective means of interpretation has been the redcoat guide scheme. Overcoming the greatest disadvantage of being a guide (being unpaid), these volunteers are mainly people who have lived in the city for much of their, usually long, lives. Almost by definition they have a love of the place and of its history, so that a tour with one guide may be a quite different experience from the same tour with another, or even with the first one on another day. They are able to mix academic knowledge with personal stories, and to give to both an air of authority.

Not only are guides individuals, they also can give individual attention. Good guides will adjust their delivery, the information given and their voice (and perhaps even their language) to the group in front of them. The best can deal with different kinds of group, and groups with a vast range of knowledge. They can have a party consisting of real experts as well as those who are simply there for a day out, without anyone feeling patronized and with everyone being able to take away the level of information he or she needs. In some circumstances it may well become a two-way conversation, with the guide being ready to pick up information from the visitors, whether they be experts in the subject or locals with a story to tell. Though guiding is by far the most flexible of all techniques, there are disadvantages.

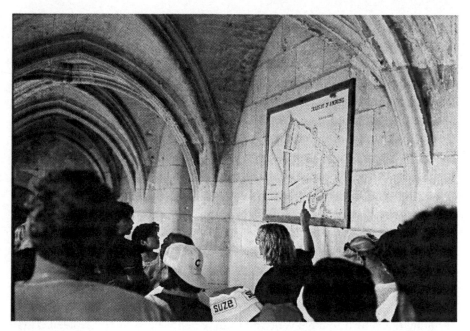

Figure 9.6 This guide, at the castle at Amboise, simply spoke to a prepared script. If guides are used so inflexibly then one wonders whether a panel would not be cheaper.

There are certainly occasions when the guide is so flexible as to be dangerous. Some are so adept at 'spinning a yarn' that the result is all yarn and no product. This seems to be particularly the case in the interpretation of caves. Perhaps geology and archaeology are not easy subjects to describe to a public audience in a show cave, so the story becomes one of witches, spirits and spooks, and of what that particular shape of stalagmite reminds one. This can then develop into a fascinating discourse on life (especially the guide's life), the universe and everything. This may be fascinating, but the relationship with the heritage becomes curtailed, and one is sometimes tempted to suggest that the guide could make much more money being a stand-up comic in the theatre. At the other extreme, flexibility can lead to difficulties regarding the guide's own prejudices, especially if he or she is a volunteer. Some guides are not as careful in their choice of language as one would wish. So the temptation for the management to write a strict brief and a narrative for the guides to use, and to insist that it is slavishly followed, is quite tempting, especially as it means one can probably hire anyone who can read, and thus save on wages. This tends to be at its worst in large, built properties in popular tourist areas where students on vacation take parties round quite frequently with a very obvious lack of commitment. This may have the effect of keeping the visitors

under control, but to destroy the flexibility of the guide is to lose its most important advantage.

The major dangers concerning re-enactment and living history, the costumed end of live interpretation, have already been discussed. Despite the dangers there is no doubt that this is very often a most effective method. Children, in particular, find the excitement of pretending to be someone else most attractive and there can be little doubt that many are 'switched on' to history by these means. Dressing-up was a favourite game for most children and it remains so. The participants in mock battles and living-history events are clearly enjoying themselves immensely, and they might be inclined to think that everyone else does, but this is not so. There are many people who hate being 'on stage', for whom their worst nightmare is to be dragged out to perform publicly. They will scrupulously avoid any stage event that might demand audience participation, except under the most traditional rules (e.g. a pantomime). Such people – and there are many of them – may merely feel slightly embarrassed at other people dressing up in role, but they would certainly not return to any event where they might have to be involved. There are others who can be easily offended. The American Civil War remains too close in the minds of many to be entirely without emotion, though perhaps one might argue that emotion was authentic enough. Some people, too, find the re-enactment of events of religious significance, for example a re-enacted Catholic mass by a 'priest' who is not ordained, rather offensive. The same is obviously true of authentic reconstructions of how women or blacks or disabled people might be treated.

Within the re-enactment organizations, especially those that are militarily oriented, there are two very clear tendencies. On one side is the scholarly group, who seek greater and greater authenticity, though authenticity tends to mean better simulacra rather than genuine items. Authentic uniform does not mean that it is a genuine seventeenth-century piece, merely that it looks like one, and is as good a copy as possible using appropriate materials. This group has been dominant recently, and the organizations' publications, such as the Sealed Knot's *Orders of the Daye*, are largely dominated by such views. They oppose what has been called the 'Booze and Bash Brigade', who unashamedly enjoy weekends dressed up, drinking rather heavily and having a fight. Perhaps this group has realized that the search for authenticity is completely vain unless done with seventeenth-century minds and with death on the battlefield a real possibility! If re-enactment is an exciting and amusing way of spending one's spare time, and if some people discover the fascination of

Figure 9.7 This re-enactment commemorates the signing of the Peace of Exeter, but however authentic the costumes, the setting and the scenario are quite unreal. For example, the fine Chile pines (*Araucaria araucana*) had not been introduced at the time, so presumably they should be felled to provide an authentic context.

history in taking part or spectating, then that is a worthy result. But having fun is a perfectly worthy objective, and perhaps the problems only arise when they start thinking that it is real, that one can 'step back into the past'.

The theatre has developed techniques over many years, represented by the Proscenium arch in most recent western theatre, which serves to distinguish reality, on one side of the arch, from make-believe on the actors' side. Actors and playwrights have often tried to break down this division, but probably most theatre does require something of the sort; if not an arch then a stage, or a traditional format, such as that used in Greek tragedy, from which the play did not normally stray. Audiences may want to be vicariously excited by the battle, but they want it to stay vicarious, and they want to stay safely in their seats without being threatened by an armed warrior. Similarly, a religious person might feel quite happy with someone playing the part of a priest on stage (and where would the drama be without them?) but distinctly uneasy with an actor as a robed 'priest' wandering around the theatre proffering blessings.

Live interpretation, whether by a guide or through re-enactment, is accepted to be very effective and flexible. Guides really can show people how to see things – and they have been doing it at least since the Ancient Greeks

Went to visit the Pyramids.[4] Just occasionally there are situations where a guide is not wanted. Certainly, this might be the case in the stone circle in the middle of the moor referred to above, and it might also be the case in places imbued with considerable emotion. To be greeted by a guide at a war cemetery, for example, or even in a church or temple, might be difficult, not least because people's emotions vary at such places. A survey of visitors to parish churches in England showed that most visitors would welcome the presence of someone to whom they could address questions if they wished, but that they were firmly opposed to the concept of a guided tour telling the official story. Some churches, however, have developed a master stroke of interpretation, which is the practice of lighting a candle. This invitation to use the church for its spiritual purpose by remembering someone may not, strictly, be live interpretation, but very cleverly manages to link the church building with the visitor's most personal life. All good interpretation aims at such a connection.

Exercise

Visit a living history event or a re-enactment. Study people's reactions to being involved and their, and your, understanding. Discuss the aims of various members of the group, and whether they were achieved. Was any contribution made to historical knowledge, or to the dissemination of historical knowledge?

Handling design

While live interpretation is a sensible term for the kind that employs people as guides, it would be unfair to refer to other kinds as dead interpretation. Here the term 'design interpretation' is used, because this is the field in which the skills of the designer are most likely to be deployed, especially in large, professional heritage displays. Even so, the range of techniques available to the interpreter is very considerable and includes material aimed at all five senses. Interpretation panels and exhibitions, leaflets, labels, video/slide show/film, IT systems, sound systems, music, waxworks, models – the wealth of systems available is extraordinary, and the heritage manager is going to need help for all but the smallest jobs. There is an overlap here between the role of the interpreter and the role of the designer. Essentially, the job can be thought of in three stages: strategic, tactical and execution. Strategy is the

realm of the manager and interpreter, execution is in the hands of the designer and tactics is the area of co-operation.

The strategic plan sets the broad parameters. What is to be interpreted and to whom? Much of this will be concerned with deciding what parts of the conserved heritage are to be exhibited or interpreted and to what end. Some elements may be too fragile or too easily eroded to encourage more visitation. There may be issues of security or ownership involved. These situations may occur in any type of heritage. In a building, a stairway may be too narrow or not sufficiently strong; in a natural park an ecosystem (such as a dune system) may be too fragile or an animal too shy; in a museum some artefacts will disintegrate if brought to light; many garden paths are simply unable to take more than a few visitors. There may be some management objectives also – to restrict numbers or to ensure that the shop is on any route planned, or even to ensure that the objectives of the management are clearly enunciated. Government agencies are bound to be guided by government policy.

Figure 9.8 Many heritage sites use interpretation to help management objectives. Here, at Lidice, near Prague, an atrocity site, the museum, the interpretation panels and the 'eternal flame' are close beside the car park. It is a 500-metre walk to the site of the tragedy, and a further 500 to the cemetery. This effectively separates different kinds of visitor.

The tactical stage requires design involvement. Not to involve the designer is to waste a considerable amount of money and designer training, and yet, in the heritage field, this is done all the time. The training of a graduate designer in Britain today involves a great deal of knowledge, far beyond the technical ability needed to produce an appropriate drawing. The designer is trained to know about reading levels and readability, about whether to choose a slide show or a video, and why, about the layout of exhibitions and signage, as well as costing and executing the finished product. Above all, they have been trained to be creative and to devise imaginative solutions. The best information graphics are usually astonishing in their simplicity and power, and three books by Tufte give a vast range of extraordinary examples from ballet to geology.[5] All too often one sees interpretive work where an unimaginative manager (possibly a scientist trained to be unimaginative) has clearly asked a designer to 'draw me a tiger there, and put a border round it'. This is the equivalent of hiring Capability Brown and asking him to dig over the cabbage-patch! Nevertheless, designers do need to be pointed in the required direction and the writing of a design brief is a critical skill.

This design brief is an ongoing discussion document, but should leave the designer with some clear guidelines on which to base his or her ideas. How much money is available? Who are the various target audiences? What technical conservation standards have to be applied? What it should not do is tell the designer what illustrations or graphics are required.

The founder of interpretation is sometimes quoted as Freeman Tilden, and his six principles are still often quoted as being the essential requirements of good interpretation. But we need to remember that Tilden was writing in the United States in the 1960s, and was concerned with outdoor environmental matters. Each of those qualities is important, though nothing can take away from the value of Tilden's work, not least in inspiring many interpreters ever since. The work is American, and, especially at that time, the United States (and not least the National Park Service) was interested in creating a single, national story, to weld together Americans from many backgrounds. The determination to select a storyline is very powerful in Tilden, but was always less applicable to the European scene, where it is almost impossible to describe any element of heritage, even in the natural sphere, without the dissonances being obvious. Since then, of course, America, too, has become painfully aware that there are many truths. In the 1960s also, even in Europe, there was much more of an agreed set of understandings among academics in many subjects, environmental and cultural. The postmodern revolution later ensured that

even environmental and ecological truths became debatable. It was largely taken for granted that the greatest threat to human survival was over-population, a threat that seems now more distant. Lastly, Tilden was writing about the ecological heritage and, more specifically, about wilderness. Not only is wilderness rare in Europe, but other fields of heritage are necessarily more contentious, and it would be completely wrong to suppose that a museum collection of artefacts, or an historic town conservation area, can be subjected to a single story, let alone a battlefield site.

Wherever people take it upon themselves to teach others, or to influence the thinking of others, there is the danger of indoctrination, which differs from education in that unfair advantage is taken of the authority and power of the teacher. All colleges of pedagogy take this very seriously, and would-be teachers are carefully taught to allow for dissent, to present a balanced view and to give time for questions. For similar reasons teachers are very cautious indeed of government interference. Those who write books are expected also to conform to a code of practice that demands that statements are backed by evidence, either by reference, by experiment or by statistical analysis. Even the media in many countries are expected to conform to good practice, demanding a balanced output, although this is perhaps more honoured in the breach than in the observance. The two glaring exceptions are the pulpit and the interpretation panel. Both the priest and the interpreter might argue that the audience is not obliged to listen, but in both cases it is difficult to get the desired product (whether that is the mass or the heritage) while avoiding the lesson. In both cases we should properly expect the highest standards of probity and professional honesty. Most churches would surely claim that the standards of training are such as to provide those safeguards against what would be popularly known as brainwashing. Can interpreters claim the same, especially when, in many cases, they are the agents, at whatever remove, of the state or of local government?

The answer, of course, cannot lie merely in being completely neutral in one's interpretive stories. It would be unrealistic to expect a Catholic abbey to give a view other than its own. Similarly, there may be a need to take a moral stance, however difficult that is for many academics. Heritage interpreters are not obliged always to presume that there was equal fault on both sides, nor that war and peace are equally moral options.

The way is probably shown at Bayeux, where the Norman version of the meaning of the great tapestry (that it is essentially a truthful account) and the Saxon view (that it is blatant Norman propaganda) are both given and both

given in English and in French. But even where neutral balance is impossible (and there are many occasions when it could be very boring) we can at least insist on intellectual honesty. If we are only telling one of the possible truths then we should say so.

Exercise
Study an interpretive display and write a critique of the message, particularly revealing those elements where a different story could have been presented. Is the interpretation honest about the biases which are incorporated? How could it have been done differently, to be more inclusive to more people and more points of view?

Case studies

High Moorland Visitor Centre, at Princetown

This is a large heritage centre converted from an existing building. Designed primarily with schoolchildren in mind, it has a mix of 'teaching aids', such as the perspex transparency overlays to show those parts of Dartmoor covered with forest, for example, through to 'fun' items such as the masks for children to wear to re-enact one of the Dartmoor myths. The former come first. There is a great deal of use of sound and touch – place your hand inside and see if you can tell what object you are touching, or listen to these bird songs and see how many you can identify. The displays do deal with controversial subjects, such as the use of the moor as military training grounds, and Dartmoor National Park plans and policy documents are made available for consultation. Although there are elements where the interpretation of this moorland sometimes becomes intertwined with the public relations policy of the National Park Authority, the centre works very well. An exhibition hall, for temporary exhibitions, ensures that local people come quite often (the centre is free), and many family groups and casual visitors seem to be quite happy with the unashamedly didactic nature of the displays, while picking and choosing those they wish to deal with.

Both video and a slide show are used, the former in the general displays, the latter in a separate, dark theatre. There are often three choices: video, film or slides with tape. A major problem with the first two is the standards of

production that are necessary. People's expectations of the quality of film production are derived from Hollywood; with video they expect the technical excellence of the BBC; with a slide show their point of comparison may be dimly remembered geography classes. It is easier, and cheaper, to compete with the latter. However, both slides and film have the disadvantage of needing to be shown to discrete groups in the dark, whereas a video can be on continuous play on a television monitor.

Figure 9.9 Princetown Centre

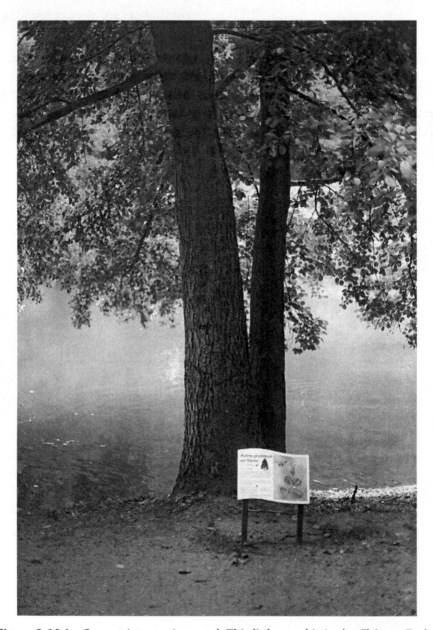

Figure 9.10 Le Creusot interpretive panel. This little panel is in the Château Park at the Ecomusée of Le Creusot, where most of the trees have similar panels. Plant drawing is a very complex art, requiring the artist to know what constitutes a 'typical' alder in shape, and what the distinguishing features of leaf and fruit are. In this industrial town there is no need for other languages, although the use of sans serif type for the body text might be criticized. Serif faces are usually more easily read, although sans serif, or grotesque, letters do well for display. The little conceit of appearing like a page from a book may help to give authority. Interestingly, in a public park in an industrial city there is no sign of vandalism to these little panels.

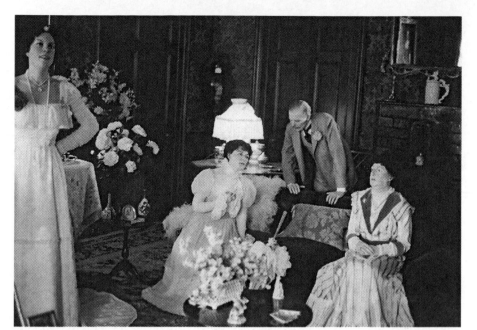

Figure 9.11 Waxwork display at Warwick Castle. At its best, a waxwork display, carefully arranged in natural poses, can provide at least some of the personal element normal with live interpretation, without actually paying wages. In this case the waxworks represent actual people present during a weekend house party in the castle in Edwardian times. They are sufficiently life-like to cause confusion, especially when entering a dressing-room containing a half-clad female.

Figure 9.12 Borre. At this new and rather forbidding visitor centre at Borre National Park, Vestfold, Norway, some very advanced video techniques are used, attempting to demonstrate that the origin and purpose of the mounds at the site are still disputed.

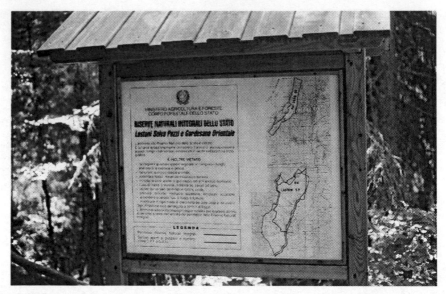

Figure 9.13 Italian nature reserve map. This is an example of addressing the wrong audience with the wrong tool. The map is beautifully drawn and includes an enormous amount of information. Unfortunately, it is the only route guide available and it is very difficult to remember a route for more than a few turnings, and most of the information is ignored at the start of the visit, when people are anxious to get on. This particular case is on Monte Baldo, near Lake Garda, where most visitors are German or British, though only Italian is used. This is a very steep walk indeed, but only those well-versed in contours would pick this up from a very academic style of map. This should be replaced by a leaflet, although that does tend to produce a litter problem.

Figure 9.14 Shropshire Hill fort. This is situated at the bottom of the path leading up to this hill fort –what a very neat way of giving a three-dimensional image of what had once been there.

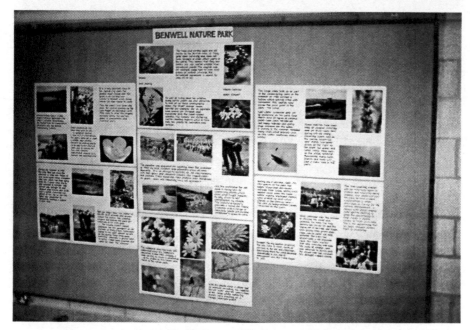

Figure 9.15 Tyneside Country Park. Any display using photographs or pictures has to beware of the 'art trap'. If they are displayed in ways that ape an art gallery situation, such as carefully framed and surrounded by lots of white space, viewers will make judgements about them as if they were works of art, concerning harmony and proportion, colour balance and technical perfection. If the pictures are being used solely as historic documents, then they are better presented in less aesthetic ways, when people will discuss them in terms of what they show.

This display perhaps falls between two stools. Certainly there are displays that have a charming naïvety of the amateur about them, obviously done by a local enthusiast. This display seems to fall between that charm and the expertise to be expected of a professional design team.

An honest conclusion

Throughout this book heritage has been seen to be in dispute. Some authors believe that heritage is always dissonant, almost by definition. This book may not take such an extreme position, but there is no doubt that heritage, poorly handled, can lead to a lack of identity, resentment, dispute, rebellion and war. Heritage management is serious stuff, and a management position that simply puts profit as its sole purpose shows a seriously unprofessional understanding of its importance. Of course, a very great deal of heritage management is done by organizations that are not involved in profit, and even those that consider

Figure 9.16 Some things need very little interpretation. At Niagara Falls thousands of tourists go on the *Maid of the Mist* up into the Horseshoe Fall. One is issued with blue plastic coveralls, and one gets very wet. A certain amount of hard information is given on the short trip up to the Falls, but once you start to get wet, any further interpretation would be pointless. There is an old theatre adage about never appearing with children or animals, because you cannot upstage them. This is a good guide for interpreters, and it also applies to the greater works of nature.

Figure 9.17 Lenin's mausoleum in Red Square, Moscow, with people hurrying by, is a reminder that heritage is the stuff from which wars are made, but that, however it is intended to last, it will probably be superseded before long. Our grandchildren may not be impressed with what we have saved for them.

themselves to be profit-making will often retreat from the consequences of such a decision.

This makes management much more difficult. Making a decision about a car-parking policy or an interpretation strategy then becomes a matter of weighing their probable effect against the 'bottom line'. This may not be simple, but success can be measurable. It also avoids many difficult moral decisions, always provided that what is suggested is within the law.

But the capacity of heritage to be so divisive forces a different strategy, which can only be predicated on a determined attempt to minimize or eradicate division and, wherever possible, to provide cohesion. The heritage manager in a globalizing world has to bear a significant share of the campaign for understanding between peoples. That cannot, of course, mean that all dissent is to be glossed over or avoided, but it does mean that honesty of purpose and execution are required. A proper question to ask of every heritage event, conservation action, society, exhibition or collection is, 'Has every effort been made to include all people, to be aware of wider issues, to present different points of view with integrity, aware of the agenda both of the organizers and of all the visitors?' Heritage managers can never assume that enthusiasm for their subject, however indispensable, is enough.

NOTES

1 F. Tilden, *Interpreting Our Heritage* (Chapel Hill: University of North Carolina Press), 1967.
2 R. Kaplan and S. Kaplan, *The Experience of Nature: A Psychological Perspective* (Cambridge: Cambridge University Press), 1989.
3 D. Uzzell (ed.), *Heritage Interpretation* (London: Belhaven), 1985.
4 K. Dewar, 'An incomplete history of interpretation from the big bang', *International Journal of Heritage Studies*, 6(2), 2000, 175–80.
5 E. Tufte, *Envisioning Information* (Cheshire, CN: Graphics Press), 1990.

Index

Page numbers in *italics* refer to figures.

Lightning Source UK Ltd.
Milton Keynes UK
13 May 2010

154119UK00001B/49/A